The Medieval Cook

Bridget Ann Henisch

THE BOYDELL PRESS

First published 2009
The Boydell Press, Woodbridge
Reprinted in paperback 2013

ISBN 978-1-84383-438-0 hardback
ISBN 978-1-84383-826-5 paperback

The Boydell Press is an imprint of Boydell & Brewer Ltd
PO Box 9, Woodbridge, Suffolk IP12 3DF, UK
and of Boydell & Brewer Inc.
668 Mt Hope Avenue, Rochester, NY 14620–2731, USA
website: www.boydellandbrewer.com

The publisher has no responsibility for the continued existence
or accuracy of URLs for external or third-party internet websites
referred to in this book, and does not guarantee that any content
on such websites is, or will remain, accurate or appropriate.

A CIP record for this book is available
from the British Library

Designed and typeset in Lucida Blackletter and Adobe Jenson by
David Roberts, Pershore, Worcestershire

Papers used by Boydell & Brewer Ltd are natural, recyclable
products made from wood grown in sustainable forests

Printed and bound in Great Britain by
CPI Group (UK) Ltd, Croydon CR0 4YY

The Medieval Cook

Contents

List of Illustrations

Illustrations

✦ ✦

✦

For

Heinz

April 21st, 1922 – March 21st, 2006

&

Peter

June 16th, 1928 – April 16th, 2008

Preface

The aim of this study is to consider medieval cooks in the context of time and circumstance, to show how they were presented in the art and commentary of the period, how they functioned, and how they coped with the limitations and the expectations which faced them in different social settings.

The past is a very different country, but periods separated by centuries can be linked with a bridge constructed from shared assumptions, common concerns. Throughout history, food has been valued not only as a necessity for survival but as a symbolic celebration of joy, a comfort in grief, a pledge of good fellowship. Surface details in the way this precious essential is handled in the kitchen may change over the course of time, but the job-description's core stays constant. Cooks have always had to temper extravagance with economy, and cope with the challenge of supply and storage. Provisions and procedures, timing and techniques pose daily problems, and cooks of every generation have devised remarkably similar strategies to solve them. In any age, incompetence and indifference can spoil the finest ingredients and the best-laid plans, while flair and experience may conjure memorable meals from very modest means.

Certain aspects of medieval beliefs and behaviour may now seem strange, indeed disturbing, but even the most bewildered time-travellers will feel the shaky ground beneath their feet grow firm when they come across familiar guidelines such as these, old as time yet valid still today: 'An excellent way to cook eggs in their shells is to simmer them until just set ... See that they are removed from the heat while the centre still quivers, before it has hardened.'

Acknowledgements

A<small>RMCHAIR</small> enthusiasts owe debts which can never be repaid to the explorers who have gone before them, clearing trails through the thickets, opening up vistas on to bright new prospects. The present work could not have taken shape without such guidance, both from scholars of the present day and from those of long ago who, in their books, are still 'alive and busie'. As Hazlitt once wrote: 'To have lived in the cultivation of an intimacy with such works, and to have familiarly relished such names, is not to have lived quite in vain.'

For their advice, affection and encouragement, I am very grateful to Anna Auer, Priscilla Bawcutt, Diana Gregson, Jean Halberstadt, Anna Ross, Lorna Walker, Peter and Phoebe Wilsher, Carol and John Wood, Erich Zettl, and Vickie Ziegler. Special thanks are due to Mercedes Lakhtakia, who never failed to read the mind of a recalcitrant computer, and coax it from sullen resistance into sunny co-operation. The greatest debt, as always, is to my husband, who did not live to see the book limp across the finish-line, but for whom every word, from first to last, has been written.

Material in 'A Selection of Medieval Recipes' is quoted from *The Goodman of Paris*, edited by Eileen Power (London: George Routledge & Sons, 1928); reproduced by kind permission of Taylor & Francis Books UK.

✦ ✦
✦

1

The Cook in Context

We may live without poetry, music and art;
We may live without conscience, and live without heart;
We may live without friends; we may live without books;
But civilized man cannot live without cooks.

Owen Meredith (E. R. Bulwer Lytton), 1831–91

The Dilemma

THE medieval cook stood in danger of double jeopardy. Whether damned for his skill or damned for his incompetence, he was assumed, always and in either case, to be working hand in glove with the powers of darkness. Moralists claimed that the Devil sent the good cooks, while lesser mortals grumbled that he groomed the bad ones. Gluttony was dangerous enough in itself; no one needed a reminder of the havoc caused by one bright apple in Paradise. Gifted cooks compounded the problem by leading their happy captives ever deeper into trouble. In skilled hands, raw ingredients were glamourized, spiced, sauced, and transformed into irresistible temptations. As one terse sentence in an early Tudor book of Latin exercises puts it: 'Sauce was founde by gluttony.'[1] A swarm of social problems buzzed around every splendid feast, as anxious hosts, each trying to out-do the other, spent too much time, effort, money, on the competition. The more succulent the dishes, the greater was the temptation to linger too long at the table, to eat too heavily, drink too deeply, and replace the golden rule of moderation: 'Eat to live', with the siren call to self-indulgence: 'Live to eat!' The Dominican preacher, John

Bromyard, summed up the sorry state of affairs for his audience: 'At the begynnynge of the worlde mannys fode was bot brede and water. [but] now the metys schul be y-sode [simmered] with grete busynes and with craft of cokys, more for lykynge of mannys body than for susteynaunce of mannys kynde.'[2]

Lip service was always paid to such reflections. They were received, unchallenged, as self-evident truths, with grave nods of approval. The problem, as always, lay in turning theory into practice. Food is not simply an essential source of nourishment but also a most engrossing preoccupation. It has the power to give joy and comfort, at every stage of life, and in every period. In the ninth century, Walafrid Strabo, abbot of Reichenau, described with affection the glee of little boys harvesting apples in the abbey orchard.[3] In 1219, as the great William Marshal, Earl of Pembroke, lay dying at Caversham, too ill to eat, he was coaxed into keeping up his strength for the last rites of preparation for death with a spoonful of breadcrumbs mixed with his favourite mushrooms.[4] In 1448, in the midst of a property dispute which had escalated to siege warfare, Margaret Paston wrote to her absent husband, and advised him to get hold of some cross-bows and pole-axes. As an aside, she slipped in another request, 'to don bye for me i li. of almandys and i li. of sugyre'.[5] Even in such a crisis, everyday life had its imperatives.

Much-loved ingredients and skilful cooking sustain the body and (something just as important) they raise morale. Food, when good, is always a comfort, but when it is bad it dims the spirit and casts a pall over any enterprise. Even future saints are not entirely immune from depression when the diet is not to their liking. St Waldef, the twelfth-century abbot of Melrose, was the stepson of King David of Scotland. He grew up in a royal court, accustomed to fine dinners and ample portions, so the first shock of life as a Cistercian novice was considerable. Heavy manual labour, endless services and rough

clothes were all bad enough, but the meagre, monotonous meals made everything so hard to bear that for a while he seriously considered giving up the whole attempt.[6] An Arthurian hero on a quest can lose heart too when far from home comforts. As Gawain journeys onward through the wilderness in search of a mysterious challenger, his mood is bleak, because everywhere he stops for refreshment he finds the food as uncongenial as the landscape: 'ther he fonde noght hym byfore the fare that he lyked'.[7]

Hospitality

FOOD also had a principal part to play in the public and private relationships of medieval society. Generosity, one of the most endearing human traits, often expresses itself in the free sharing of food with others, and is shown from the first, in the loving impulses of childhood: 'A chyld gevyth largely of his breed to his felawys, and to houndys and to cattys.'[8] The innocence of such good fellowship was inevitably modified by the needs and demands of the grown-up world. The idea of hospitality was woven into the texture of medieval society, and generosity as a host was one of the defining characteristics of a great man. An inscription on the memorial brass for John, the second Lord Cobham (d. 1355), asks the passer-by to pray for the soul of this 'cortays viaundour' [courteous host].[9] Renown for hospitality was as precious as renown for courage. The two were bracketed together by Sir John Clanvow, in late fourteenth-century England, when he deplored the false values of his own society: 'For the world hold them worshipful that been great warriors and fighters … and that dispenden outrageously in meat, in drink.'[10]

Hospitality was both a demonstration and an exercise of power. The maintenance of a household in style and splendour was evidence, for every eye to see, of standing in the world. Invitations offered or

withheld were clues to shifting alliances, the ebb and flow of power. Bonds of mutual service and obligation were strengthened by the image, and reality, of the shared feast. Its position at the heart of day-to-day affairs, and of the organization of society, gave the feast importance, and that charge of energy which comes with a sense of occasion. It also offered many other kinds of pleasure to be relished. The quality of the food and drink served, the touch of theatre in the presentation, the gossip and the laughter, all created a glow of excitement, and heightened the drama of the event. Dante first met and fell in love with Beatrice at a feast, and this came as no surprise to Boccaccio, his biographer, for 'at feasts, the sweetness of the music, the common joy, the delicacy of the meats and wines ... can make the hearts of mature men – much more of young people – more open to be caught by whatever pleases them'.[11]

The feast even made its own contribution to the Church's teaching on moderation, which was driven home by the patterning of each week and each year with an alternation of feast and fast, for how was it possible to feel the full spiritual benefits of abstinence, without having some abundance from which to abstain? Voluntary acceptance of denial in the midst of plenty was a better teacher of the soul than grinding poverty and inescapable hunger.

The feast was important, not simply as a source of pleasure but of power. That is why people fussed and fretted over each occasion, spent too much on the ingredients, paid far too much attention to the details, tried to outshine their peers with ever more elaborate entertainments. Sharp-tongued preachers pinpointed the feast's mesmerizing ability to distract its devotees. From the first plan of campaign to the post-mortem, hosts were preoccupied: 'first, in busynesse of getynge and dightynge of mete, afterward in the lust and delite in etynge, and the thridde, whan thei recorde how wele thei beth fed, the whiche is veyn glorie'.[12]

4

The social significance of feasting, and the prestige accorded to fine dining and refined dishes had one minor, interesting consequence. Many men whose position in the world made it unthinkable for them to cook for a living, nevertheless paid knowledgeable attention to cookery itself. Even so grand a figure as Henry Grosmont, Duke of Lancaster (1310–61), included a detailed recipe for rose water, and another for a rich chicken broth, in his own book of devotions.[13] Another aristocrat, Canon Pietro Casola, of a noble Milanese family, made the pilgrimage to the Holy Land in 1494, and at Venice, on the eve of departure, having invited his fellow-travellers to a dinner party, rolled up his sleeves and himself cooked the meal 'Milanese fashion, especially a pasty', a last taste of civilization before the rigors of the journey began.[14]

The Consuming Passion

FOOD, and taste, likes and dislikes, the horror of hunger and the joy of plenty, were all such engrossing concerns for everyone, indeed, that an alert awareness of cooking methods and techniques showed itself at every stage of life, and surfaced in a hundred chance allusions. Hot fire, sharp knives, the murmur of a simmering stewpot, the hiss and crackle from a frying pan, the smells, the colours, the conjuring tricks which turned raw ingredients into delicious dishes, all added their own touch of theatre to the most everyday routines. It is no wonder that children loved to get as close to the action as possible. The border of the calendar scene for December in a Flemish manuscript, the Grimani Breviary (c. 1517–18) shows one small child warming its hands at a bright, hot oven while the mother bakes a batch of bread, and other, older boys watching as the bristles of a slaughtered boar are singed away, before the carcass is cut up into joints. An English contemporary, Alexander

Barclay, could explain just what everyone was dreaming of at such a moment:

> They have great pleasour supposing well to dine,
> When men be busied, in killing of fat swine.[15]

Cooking and chemistry are cousins. Both are satisfyingly messy in process and magical in result. Medieval children could not enjoy the pleasure of chemistry sets, but miniature stewpots and make-believe ovens filled some of the same needs, and guaranteed some of the same excitements. The children of the nobility might be too grand ever to see the inside of a working kitchen for themselves, but they certainly liked to play at being cooks. Toy pots and pans, jugs and bowls, have survived from the fifteenth and early sixteenth centuries, and there is a record in a royal account book from late fourteenth-century France of a little brass cauldron, bought for a boy prince.[16] From the same century comes Froissart's poem, *L'Espinette amoureuse*, in which he lists fifty-one games which children enjoy, and one of them is to play 'Let's pretend', by happily popping mud pies into imaginary, improvised ovens.[17]

One particular kind of kitchen crisis-control was so familiar that it can be found, used as an example, in sources as far apart as an early sixteenth-century textbook for schoolboys and a thirteenth-century manual of instruction for women anchorites. When a pot boils over, the best remedy is to turn down the heat. In a medieval kitchen, that meant throwing a dash of cold water into the pot itself, and pulling away some of the fire brands below. The schoolboys were given the following sentences to turn into Latin: 'Yf the potte renne over: alaye it with a lytel colde water. Pulle away the stickis; and the boylyng wyl abate.'[18] The anchorites were presented with the same problem, the same solution: 'If a pot is boiling vigorously, does one not put a lid on it or throw cold water into it and remove some of the brands?'[19]

This little vignette, drawn from everyday experience, was used by the anchorites' instructor to drive home a spiritual lesson. In much the same way, Bede, in the eighth century, writing a commentary on the First Book of Samuel, helped his reader to grasp that there are several different ways to understand a text, by describing three distinct cooking techniques: 'We are being nourished on food cooked on a griddle when we understand literally, openly and without covering those things which have been said or done to protect the health of the soul; upon food cooked in the frying-pan when, by frequently turning over the superficial meaning and looking at it afresh, we comprehend what it contains ... we search in the oven when, by exerting our minds, we lay hold of those mystical things in the scriptures which as yet we cannot see, but which we hope to see in the future.'[20]

The sights and sounds and smells of the kitchen world were coins in a common currency, used and recognized by everyone. When Gower wants his readers to hear a snore, he compares the sound to the sizzle of batter as it drops into hot fat:

> He routeth with a slepi noise.
> And brustleth as a monkes froise [pancake]
> Whanne it is throwe into the Panne.[21]

When a storyteller wants his audience to get some idea of the effort behind apparent ease, as an acrobat gives the performance of his life, in a dazzling display of leaps and somersaults, he says that sweat dropped from him 'like fat from roast meat on the spit'.[22]

Food, vital as a necessity, powerful as a symbol, always attracted such sharp-eyed attention. There was a somewhat less focused awareness that behind every good dish stood a good cook. In a debate poem, 'Als I lay in a winteris nyt', written towards the end of the thirteenth century, Soul taunts Body in death, about the

loss of all the world's pleasures, and sneeringly asks what has now become of those 'cokes snelle [busy]' who used to 'greithe [prepare] thi mete?'[23] Despite such generalized acknowledgements of the cook's contribution to the good life, no great interest was shown in the cook himself. He was thought of sometimes as a workman, sometimes as a craftsman, always as a servant. He was a member of the behind-the-scenes crew which staged the show; he mounted the drama, but played no starring role. Unlike those idealized figures, the Good Shepherd and the Good Ploughman, he was never presented as a model for emulation.

This may have been due in part to the fact that cooking of a simple kind demands no high degree of expertise. Something more or less edible can be produced by men, women, or even children, whether they have been taught the basic skills by a professional master, or merely by life's stern imperatives. Indeed, just because cooking was essential, and so much an answer to everyday needs that anyone, at any level of competence, might be called on to attempt it, there was some feeling that no special qualifications were required for the job. In the early eleventh century, Aelfric, Abbot of Eynsham, wrote a textbook designed to help his English novices become fluent in Latin. The book, *Colloquy*, is arranged in the form of a conversation between teacher, pupil, and representatives of various occupations, who are questioned about their work. Amongst these is the Cook, who is given a very cool reception. He is told that he is not really needed, 'Because we ourselves can simmer what has to be simmered, and roast what has to be roasted.' In his somewhat limp self-defence, the Cook rests his case on just two points. He can make at least one special dish, 'a rich broth' which, by implication, his critics cannot, and he does have his uses as a servant to the company. If he is indeed dismissed, then the group will have to make its own meal, because there will be no one there

to make it for them: 'Then all of you are servants, and no one is a master.'[24]

The Cook as 'Character'

ELFRIC'S cook is rather meek, and very much an exception to the rule in the conventions of medieval theory. There the cook comes in two or three characteristic 'types', each shaped by long tradition, and each instantly recognizable. Whatever the chosen form might be, the cook as a character was always male. In this, theory followed life, for whereas in small households the cook might well be a woman — indeed at times the housewife herself — the kitchens of any large establishment were staffed entirely by men, from the head cook to the scullery boy, and the same rule applied to the caterers whose services could be called on for wedding parties and other special occasions. It is this professional cook, not the amateur one, who has a role to play in literature and art.

Bodily appetites and functions, while rarely discussed in polite society, have always made people laugh, and so cooks and comedy have been partners for a very long time. Chatty, conceited, and extravagant, cooks in the world of classical Greek and Roman comedy delighted the audience while driving to distraction their exasperated fellow characters in the play.[25] The comedy 'type' for the medieval cook bears a family resemblance to his classical forebear, but the two are not identical. The medieval counterpart is not so much conceited as cross. His kitchen is unbearably hot; fires burn, tempers flare. An unsavoury rabble of assistants, jerked to and fro by bellowed commands, is perpetually engaged in ineffectual crisis control, as pots boil over, fat sizzles, roasts char. Everyone is shiny with sweat, greasy because of handling food, and grimy from grappling with smoke-blackened equipment. A tenth-century play, *Dulcitius*,

has fun with this particular fact of life. Its lordly Roman villain, in pursuit of the three Christian heroines, stumbles into a dark kitchen and passionately fondles by mistake the pots and pans instead of the girls. When he strides back in triumph into the light he is covered in soot, a terrifying figure who is first hailed by his soldiers as a devil, and then ignominiously kicked downstairs.[26]

The cook and his team can also be presented as dishonest. In Alexander Barclay's poem *A Ship of Fools* (1509), they help themselves to choice morsels prepared for their master's table, and are bold enough at times to add a little too much salt or sugar to a favourite dish, to make sure that it will be sent back almost untouched to the kitchen, for instant consumption by the shameless crew:

> Some for the nonce their meat lewdly dress,
> Giving it a taste too sweet, too salt, or strong,
> Because the servants would eat it them among …
> And with what meats soever the lord shall fare,
> If it be in the kitchen before it comes to the hall,
> The cook and scullion must taste it first of all,
> In every dish the caitifs have their hands,
> Gaping as it were dogs for a bone.[27]

The cook is a figure of fun, and there are lots of laughs at his expense, but there is also something formidable and menacing about him. The dark side of his nature and occupation is caught in a character study by John Earle in his *Microcosmographie*. This was written in 1628, but the description taps into the medieval convention: 'The kitchen is his hell, and he the devil in it.'[28] Although the cook was only a servant, he was an exceptionally privileged one. Armed with dangerous equipment, he had a license to use it, not against some marauding intruder but in his own heartland, inside the household itself. He worked in hazardous conditions. Red-hot fires can brand, boiling broth can scald, and accidents can happen in a second, even

to the experienced professional: 'the cook yscalded, for al his longe ladel'.[29]

There are many unappetizing stages in the transformation of raw ingredients into elegant dishes presented at table, stages vividly brought to mind by a fourteenth-century sermon writer's tiny word-picture of 'the bocherys dogge' with his 'blody mowth'.[30] In order to feed the living, the cook dealt in death, chopping, stripping, degutting. One early fifteenth-century medical text likens incompetent surgeons to 'evel cokes', because of a shared contempt for the bodies of their victims. They 'foulen [damage] or renten [tear], breken or frusshe [crush]', and then 'throwen oute' the waste matter.[31] As John Earle put it in the character sketch previously mentioned, there was something devilish about the cook, and hellish about his kitchen: 'He is a pitiless murderer of innocents.' In a reversal of this image, hell itself was sometimes pictured as a busy kitchen, where devil cooks hovered over gigantic cauldrons, prodding the damned souls as they boiled for all eternity. One of Chaucer's unscrupulous friars harrows his victims with just such a picture

> Ful hard it is with flesshook or with oules [spiked irons]
> To been yclawed, or to brenne [burn] or bake ...[32]

Very sensibly, when the towns of Beverley and Chester produced their cycles of mystery plays, the local Cooks' Guild was given the responsibility for staging the *Harrowing of Hell*, as its members could so easily provide the right props: the stewpots, the flesh-hooks, and the long-handled ladles.[33]

Death and destruction lurked in the shadows of the kitchen, and stray comments convey this latent menace. The proud possessor of a Book of Hours, determined to send a chill down the spine of any would-be thief, wrote these words of warning on the first page: 'He that stelles thes boke he shal be hanked [hung] upon on

hoke behend the kechen dor.'[34] The hook referred to was the one on which a meat carcass was suspended, to await dismemberment. Gower, with one phrase, makes the reader sense the manic power of Medea as she hacks to pieces a black ram, 'And hiewh [chops] the fleissh, as doth a cok [cook].'[35]

Such characteristic tools of the cook's trade as the ladle, the cleaver, and the flesh-hook (the fork used to pull meat out of a cauldron) could also be frighteningly effective weapons in a brawl. In a 1609 collection of stories about household fools, one is about a certain Jack Oates, who 'could never abide the cooke, by reason that he would scald him out of the kitchen', using a long-handled ladle to splash him with red-hot broth.[36]

When Hereward, the Saxon hero of popular early romance and legend, slipped into the camp of the Norman king to spy out the enemy's plans, he disguised himself as a potter, and went into the kitchen to sell his wares.[37] The cooks and their staff failed to detect the hero hidden in the potter's clothes, and unwisely thought that they could make fun of him: 'They wanted to shave his head and pull out the hairs of his beard, and to blindfold him and so make him break his own pots which they put all about the ground for the purpose ... One man drew near and gave him a severe blow. But Hereward returned the blow under the ear to such effect that the man fell to the ground as though he were dead. His companions seeing this, all rose against Hereward with flesh-hooks and pitchforks, so he seized a brand from the hearth and defended himself against them all, killing one man and wounding many more.'

As the story shows, kitchen crews were notoriously rough, handy with their tools, and distinctly unendearing in behaviour. They were also unappetizing in appearance. Chaucer's Cook, with the nasty sore on his leg, is the best-known example in English literature, but

there is also a runner-up in Lydgate's drunken, dishevelled kitchen boy, 'Froward Maymond', with his 'wet mouth' and his 'iousy [soggy] pate', 'son and cheef eyr [heir] to dame Idylnesse'.[38] Life found no difficulty in following art, to judge from the stern order, issued to the cooks at Hampton Court in the first years of Henry VIII's reign, to clean up their act, and take steps to ensure that their underlings did not go 'naked or in garments of such vilenesse as they now doe'.[39]

These associations with death and devils, blood, waste matter, and squalor, lowered the status of the cook in the eyes of the world. However much the fruits of his skill may have been relished, he and his team clung to a very low rung on the social ladder. A passionate book-collector in fourteenth-century England, Richard de Bury, shuddered even at the thought of some grimy kitchen boy creeping into the study and pawing one of his treasures: 'Let the clerk take care also that the smutty scullion reeking from his stewpots does not touch the lily leaves of books, all unwashed.'[40] Even women anchorites, who cut themselves off from the world and its affairs as part of their spiritual education, had to be reminded that in this new way of life old social prejudices, even the most engrained ones, must be set aside: 'If you incur disdain from Slurri, the cook's boy, who washes and dries the dishes in the kitchen, you should be happy in your heart.'[41] In 1487, as a mark of contempt for a pathetically ineffectual pretender to the throne, Henry VII ordered Lambert Simnel not to the scaffold but to a job as scullion in the lowest depths of the royal kitchen.[42]

Because there was something contemptible about the cook, he could be used on occasion as an instrument with which to brand any knight who broke the code of honourable conduct, and committed the unforgivable crime of treason. In the *Chanson de Roland*, the traitor Ganelon is first handed over to the cooks in Charlemagne's

army, to be roughed up and shamed, before the formal trial and execution.[43]

A grim reminder of retribution to come was set into the English ceremony of knighthood. To mark the moment when the candidate became a knight, a pair of spurs was fastened to his heels. At a later stage in the proceedings, the Master Cook of the King's household accosted the new knight, claimed the spurs for himself, and carried them off to the kitchen quarters. The point of the strange little drama is explained in a fifteenth-century chronicle: 'The reson is this, that in case that the knyght do afftar eny thynge that be defame or reproffe unto the ordre of knyghthode, the master coke then with a gret knyfe, with whiche he dressethe his messes, shall smyt of his spurrs from his heles; and therfore in remembraunce of this thynge the spurrs of a new knyght … shall be fee unto the master coke.'[44]

That this was no idle threat, no colourful flourish in a fossilized ceremonial, is demonstrated by the story of Sir Ralph Grey, trapped on the wrong side in the Wars of the Roses in fifteenth-century England. Grey, convicted of rebellion against Edward IV, was sentenced to be disgraced in this way before his execution: 'The King hath ordained that thou shouldest have thy spurs strucken off hard by the heels with the hand of the Master Cook, the which he is here ready to do, as he promised at the time when he took off thy spurs and said "an thou be not true to thy sovereign lord, I shall smite off thy spurs with this knife hard by the heels". And so was shown the Master Cook ready to do his office, with his apron and his knife.'[45] The execution itself was duly carried out but, at the last moment, the King in his mercy spared Sir Ralph the searing degradation, a punishment more painful for the proud to bear than death itself.

Such associations as these, with death and dishonour, choler and confusion, shape in bold outline the traditional portrait of the cook. This, established over the centuries as an instantly identifiable 'type'

is, nevertheless, more eye-catching than convincing. Like those other staples of comedy, the henpecked husband, the nagging wife, or the skinflint father, the cook's 'character' has a grain or two of truth in it, but it is a likeness slanted to catch laughter, not to show truth. Everyone who has had to put food on the table day by day knows that the assembling even of a simple meal, let alone an elaborate feast, has something in common with the mounting of a theatrical production. For each to run smoothly, and satisfy its audience, planning, order, timing and co-ordination are required. How could such discipline have been achieved amidst the melodramatic sound and fury of the sketch? Viewed by the outsider, the routines and conventions of any job seem confusing, without pattern or purpose. The eye of ignorance always finds it hard to see the wood for the trees, the method in the madness. These images of black farce distort reality. To look now at the cook and his work through very different lenses will help to correct the balance of the picture.

The Ideal Cook

SEEN through the eyes of one particular practitioner, the cook's approach and attitudes are poles apart from those of the wild-eyed, grimy, quarrelsome figure of tradition. Master Chiquart was head cook to the Duke of Savoy for thirty years or so, in the first part of the fifteenth century. In the book of recipes which he compiled at the Duke's command in 1420, the emphasis falls again and again on the importance of clean working surfaces and clean equipment at every stage of the work in progress. After a boar's head has been glazed, it must be 'set on a good, immaculately clean work table to dry'. A mixture of cooked chicken meat, almonds and broth is to be pounded 'in a mortar which does not smell in the slightest of garlic'. In one recipe for apple sauce, the word 'clean' is used four times in

as many lines: 'A fine good clean earthenware pot' having been chosen, 'put good clean water in it'. Prepare the apples on 'good clean work tables', chop them 'with a clean little knife', and then keep up the good work by cooking them over 'bright smokeless coals'.[46]

Another sketch of the cook as a fastidious perfectionist is to be found in a book which, first published in Rome in 1474, went on to become widely known and admired throughout Europe, appearing in several editions and translations over the next two hundred years.[47] Its title was *De honesta voluptate et valetudine* ('On Right Pleasure and Good Health'), and its author was Bartolomeo Sacchi de Piadena, known to his friends and admirers as Platina. He was a humanist philosopher and man of letters in Rome, and became the Vatican Librarian in 1475. His work begins with reflections on good food and good health, drawn from classical and Arabic sources, and ends with two hundred and forty recipes from the kitchen of Martino de Rosi, former cook to Cardinal Trevisan, the most discriminating epicure in Rome. Chapter xi in Book 1 offers a pithy description of the ideal cook.

First and foremost, he must be clean: 'He should lack all filth and dirt.' He must have a thorough knowledge of ingredients, know which cooking technique to choose in any particular case, and 'understand what ought to be roasted, boiled, or fried'. A sensitive palate is essential, so he will be 'alert enough to discern by taste what is too salty or too flat'. Far from being explosively temperamental, he should be a quiet, confident professional, 'trained … with skill and long experience, patient with his work'. Nevertheless, behind this decorous, disciplined facade there had to burn the ambition of a true artist. It was not quite enough for a cook to cook well. He must want 'especially to be praised for it'.

Interestingly, the same emphasis on the need for hygiene in the kitchen and ambition in the cook is to be found also in the Islamic

tradition. A thirteenth-century Arabic cookery book[48] says that the cook 'must keep his nails constantly trimmed, not neglecting them, nor allowing them to grow long, lest dirt collect under them … It is of the greatest importance that the pots and utensils are washed as thoroughly as possible.' In the following century, it is stipulated that the cook should be not only 'intelligent, well versed in the rules of dishes and discerning in making them', but 'vainglorious' too.

East and West made common cause, in the search for a cook with just the right balance of temperament and technique, because it was known to everyone who relished fine food that, once the perfect combination of skill, experience, and proper pride had been achieved, then miracles could be performed: 'a good Cooke can make you good meate of a whet-stone'.[49]

Mercury's Child

THIS power to bewitch palates and transform ingredients raised the gifted cook above the level of the ordinary workman, and earned him not only respect but even, at times, affection. Although he dealt with gross materials and ministered to the body's comfort, by the late Middle Ages he had won himself a place among the artists, and cookery had come to be regarded, in cultivated circles at least, as one of the great inventions which had shaped society.

Medieval scholars inherited from the classical world an old and enjoyable tradition. They loved to make lists of the great 'Discoverers' who had given the fruits of their inventions to the human race. In the late fourteenth century, the poet Gower drew on this convention when in one passage he named a number of these gift-givers, and included amongst them 'Verconius', who

> of cokerie
> Ferst made the delicacie.[50]

The identity of Verconius has not yet been discovered. It may be that Polydore Vergil could have filled in the blank for us if he had not chosen to be irritatingly discreet at this point in his own version of the list, *De inventoribus rerum*, of which the first three books were published in 1499. In Book III, chapter 5, he tantalizes his readers with the following remark: 'We could at this point show and declare many inventors of these pleasures of the palate, but I think it is better that we leave them buried and forgotten in the shadows than list and subject them to all the damning they deserve.'[51] The ambivalence in this comment shows very well the age-old, never-ending tug-of-war between appreciation of the cook's skills and contempt for them.

In these medieval directories which name the benefactors of the human race the old, classical gods were often included, and given credit for particular discoveries. By the early fifteenth century, a new iconographical image was becoming established, in which each god was shown surrounded by his 'children', men and women engaged in occupations specially associated with his characteristic powers.[52] Mercury presides over artists, and the skilled craftsmen whose work makes the arts possible, and on occasion the figure of a cook is included in his family (see Chapter 6).

In the old black farce tradition, the cook's hot temper, ferocity, and disarray are the defining characteristics, but in this later development the emphasis falls on his expertise. As Chaucer puts it in his *Pardoner's Tale*, 'Thise cookes, how they stampe, and streyne, and grynde' (l. 538). In some texts, both classical and medieval, the Roman poet Martial was given a nickname, Coquus, or 'Martial the Cook'.[53] The origin and significance of this is obscure, but the Scottish poet Gavin Douglas made use of it in *The Palice of Honour* (c. 1501), as an image with which to capture Martial's versatility and technical skill as a poet: 'Martiall was Cuik till roist, seith, farce and fry' (l. 1231;

'Martial was a cook who could [do anything], roast, simmer, stuff, and fry').

Professionals v. the Rest

I T has always been possible to think of cookery not as a calling but a necessity, an everyday task which can be carried out by anyone, in some way, at some level. Without a touch of inspiration it may be hard to create a tempting meal, but it is easy enough for incompetence to concoct a merely edible one. Professional cooks, needless to say, have never found merit in this argument, and in the Middle Ages, as in every other period, they did their best to distance themselves from amateur upstarts. The greatest chef in late fourteenth-century France, Guillaume Tirel, known as Taillevent, was chief cook to two kings, Charles V and his son, Charles VI, and compiled a collection of recipes, the *Viandier*. In this, he refused to set down any practical instructions on how to cook such vegetables as cabbages and beans in simple, straightforward ways, with the chilly comment: 'women are experts with these, and anyone knows how to do them'. There are other deliberate omissions, on the same grounds: 'as for tripe, which I have not put in my recipe book, it is common knowledge how it is to be prepared'.[54] Such matters are beneath his notice. Instead, he gives directions on how to prepare, and present, the kinds of subtle and sophisticated dishes which only a master cook with a team of expert assistants, not to mention a big budget, could hope to achieve.

Even within the charmed circle of professional cooks there was hierarchy, not equality, and many distinctions were drawn between one practitioner and the next. Naturally enough, far more was expected from a cook who served a royal master than from one employed in a less exalted establishment. A prosperous and well-

connected householder in late fourteenth-century Paris was tempted by the thought of one particular recipe, but then had to dismiss any dream of actually getting his own cook to make it, with a sad, sensible conclusion: '*Farced Chickens, Coloured or Glazed.* They be first blown up and all the flesh within taken out, then filled up with other meat, then coloured or glazed ... but there is too much to do, it is not a work for a citizen's cook, nor even for a simple knight's; and therefore I leave it.'[55]

For the most part, the collections of recipes which have come down to us seem to have been intended to be consulted as records of current, accepted practice. The style is terse, and little or no attempt is made to describe any particular process, let alone to explain it. The entries are designed as notes for experienced fellow-craftsmen, not as lessons for beginners.

The life of a master chef in a royal household was worlds apart from that of a short-order cook with a stall on some busy city street but, at least in the later medieval period, there was one common thread to link the two together. Each, in order to be allowed to practise his craft, had to be a member of a professional organization, a local Cooks' Guild. The one in Paris had been established by 1268,[56] and the recorded activities of two fraternities of cooks in London can be traced throughout the following century. In 1393, the Master of the Cooks of Eastcheap and the Master of the Cooks of Bread Street were both sworn in to office on the same day.[57] Formal apprenticeship, followed in due course by some kind of certification, gave members the right to cook for the public, and distinguished them from all those who merely prepared meals, of necessity, in their own domestic setting. The brotherhood of professional cooks shared trade secrets, which were not readily to be revealed to the outsider.

Cook and Physician

A<small>N</small> age-old platitude, much relished by moralists, maintained that good cooks were bad for the soul. A counter-argument, which began to be heard more and more in the later Middle Ages, pressed the claim that they could, nevertheless, be very good for the body. The more comfortable circumstances become, the more freedom of mind there is to worry about aches and pains, ailments and alleviations. During the fourteenth and fifteenth centuries, it became fashionable in the most courtly and sophisticated circles to talk about diet, and to pay lip-service at least to the importance of finding the right balance of foodstuffs to suit one's own temperament and state of being at any given time.

According to the current medical theory of the day, everything edible was made from four elements: fire, air, earth, and water. These, combined in an infinite variety of ways, made up the distinctive character of each kind of food, and ensured that each would have a different effect when it entered the human digestive system. Men and women were formed from the same four elements, and individual temperaments were coloured by the way in which those elements were combined. One person might be inclined by nature to be cheerful, another to be gloomy, one quarrelsome, another withdrawn and cold. Any food each chose to eat would either reinforce an inborn characteristic, or act as a counter-balance. It could enflame an already irritable temper, or calm it down.

The task of the physician was to determine the temperamental constitution of his patient, and then devise a personalized diet plan, which would ensure well-being in times of good health, and relief in times of illness. It was the job of the cook, in turn, to translate the physician's instructions into dishes so delectable that the advice would be accepted with alacrity. Doctors and cooks were experts in

their own fields, and for best results they had to work in concert. As Andrew Boorde, in the sixteenth century, remarked: 'A good coke is halfe a physycyon. For the chefe physycke [the counceyll of a physycyon excepte] doth come from the kytchyn, wherefore the physycyon and the coke ... must consult together for the preparacion of meate for sycke men.'[58]

This idea of cook and physician working hand in glove for the good health, if not of society in general, then at least of certain cherished patrons in particular, helped to raise the prestige of the most eminent practitioners, and may even have added a much-needed touch of polish to the image of the craft itself.

Cook and Patron

HOWEVER grand a particular cook might seem to be, either in his own eyes or in those of his public, he was never his own master. He was, at best, a craftsman-artist, in service. If he worked in some great household, he was answerable to his master; if he owned a pie-shop in town, his business was regulated by the city fathers, and by his fellows in the local company of cooks. 'We aim to please' was the unwritten motto. To give satisfaction was imperative, for displeasure could have very nasty consequences. There is a hint of this in a sculpture on the west exterior wall of the Cathedral of Notre Dame in Amiens.[59] Carved *c.* 1220–5, the scene is an illustration of a verse in the Old Testament book of Malachi (chapter 3, verse 5): 'I will be a swift witness against ... those that oppress the hireling in his wages.' It shows a serving-man who, having knelt to present a dish to his mistress, is being brutally kicked away. Something, quite clearly, has not been to the lady's liking, and we may be sure that the ripples from that outburst of anger will surge back to the kitchen, and lap around the feet of the cook himself.

Even to this day, the Cooks' Company in London is the only one of the city's companies and guilds to elect two Masters for the same year.[60] The reason for this exception to the general rule is rooted in a deeply embarrassing conflict of interest in the fifteenth century, when the one and only Master Cook of the time was summoned for duty by the King and the Lord Mayor on the same day. Nightmarish clashes of this kind were averted for ever afterwards by the diplomatic decision to appoint two Masters, one to attend the Royal Table on special occasions, and the other to supervise the Royal Kitchens, but to be on call to serve the Lord Mayor whenever the need arose.

Fact and Fiction

ALTHOUGH the influence of his work was felt everywhere, at the core of everyday existence, the medieval cook himself makes only fleeting appearances in the written records, whether those of fact or fiction. Even so, a mosaic portrait assembled from these tiny pieces offers an impression of the real cook in the real world which serves to soften the bold outlines of the caricature 'type', and subdue the glow of the idealized self-portrait.

Few clues to the personality of any particular cook have survived, but now and then a name has been preserved, caught for ever in a tangle of household accounts: the neutral 'John Goodrich', the descriptive 'Blowebolle', and the tantalizing 'Fast and Lous' – a joke perhaps, its point long buried in the sands of time.

A cook was at the mercy of his master, treated with genial contempt or cherished and esteemed. Edward II tossed his cook a lavish tip, 'because he rode before the King … and often fell from his horse, at which the King laughed greatly'.[61] At the other end of the scale, Taillevent, the greatest French chef of the fourteenth century, was rewarded for service to his royal masters with a knighthood and a

coat of arms on which a line of three cooking pots forms part of the heraldic design.[62] It is understandable to suspect that there might have been a touch of condescension in the choice, by the official designers, of those cooking pots, but equally humble, workaday objects did find their place in heraldic designs for far more exalted figures. In England, the Garter Stall Plate of Sir Lewis Robessart, Lord Bouchier, who was made a Knight of the Garter in 1421, includes, as a pun on his name, four 'bougets', or water-skins.[63]

Traces of appreciation, even affection, can be detected here and there, glints of colour to brighten sober records. One day in the 1470s, when the Duke of Norfolk's cook fell ill, his master gave him the handsome present of 6s. 8d. to speed recovery.[64] For the reader today, the generosity of the gesture may be slightly marred by the knowledge that, as the Duke's own pocket was empty at the time, he had to borrow the money from a friend. Even so, it cannot be denied that, despite this temporary embarrassment, the Duke did make sure that his cook's purse was plumped up with coins, not promises.

One of Richard II's cooks was treated with great generosity. Master Thomas Beauchef came to the end of his working life in the royal kitchens in 1383, because by then 'he was an old man and not able to labour as he used to do'. At that point he was allowed to retire on his full wages, with all the extra privileges he had earned, and told to 'go away for recreation and return when he pleases'.[65] Beauchef had cooked for the King's father as well, and the long years of service may have made him a familiar figure at court. Despite the engrained respect for hierarchy in medieval society, there was also a sense that a master and his household formed a family unit, in which each member was bound to all the others by a web of obligations. There was no unbridgeable gap yawning between master and men, and so Sir Geoffrey Luttrell, who died in 1345, thought it perfectly

appropriate to stand as godfather to two of his own cook's children, and undertake the duties of that position.[66]

Every now and then, just for a moment, one particular cook will be caught in the spotlight, as the steady course of a chronicle slows down, and time is found for a thumbnail sketch. Henry VII's daughter Margaret was married to James IV of Scotland in 1503. On Maundy Thursday during the next year's Easter season, the fifteen-year-old Margaret took part in the beautiful ceremony for the day, and duly washed the feet of fifteen poor women. Twenty-three shillings were spent on the four ells of 'Holland cloth' which were used to dry them. After the grand, time-honoured service had come to an end, the royal cook stepped into the story, thriftily to recycle the linen for domestic use: 'the maister cuke maid towales for the King of it'.[67] The endearing image of this cook, snipping and stitching in a pause between preparations for one demanding meal and the next, can be matched by that of a fellow professional who also knew how to make good use of a spare moment. In 1290, John Brodeye, master cook in Edward I's household, built a toy castle for the King's six year-old son and heir. The castle was painted, and filled with 'other things', an unhelpful phrase which may have covered bright pennants and miniature soldiers.[68] When finished, the small masterpiece won so much attention and so many compliments that it was moved out of the nursery and presented as a spectacular centrepiece for a very grown-up occasion, heavy with politics: the special feast to celebrate a royal wedding.

It was not considered seemly in the Middle Ages for people to sing their own praises; the work had to speak for them. Attitudes slowly shifted as the centuries slipped away, and by the end of the period it had become more acceptable to express some pride in one's calling and one's competence. William Canynges was a great merchant in Bristol, and five times elected mayor of the city. Immensely

rich, he was a devoted and generous patron of St Mary Redcliffe, one of Bristol's splendid churches, so it is not surprising that his cook, William Coke, was buried there in 1467.[69] On the gravestone, perhaps at his master's request, perhaps at his own, was incised in outline a large meat knife and a skimmer, two of the characteristic tools of the cook's craft.

Because kitchen work did not rank high on the social scale, no hero of romance ever crowns his career by stepping into a cook's shoes, but he may show his mettle at some early stage of the story, bent over a sink or sweating at a spit, before moving onward and upward to more appropriate adventures. Arcite, in Chaucer's *Knight's Tale*, disguises himself as a labourer, and spends some time as an odd-job man in the heroine's household: 'wel koude he hewen wode, and water bere' (l. 1422). Havelok, hero of the thirteenth-century English romance which bears his name, is a model kitchen boy, capable, cheerful, co-operative, and tireless. He is the stuff that every employer's fondest dreams are made of, and it is no wonder that the cook who first spots his potential treats him very well.[70]

Fact and fiction conspired to conjure from the career of one fifteenth-century businessman a legend which has lived on into the present time. Richard Whittington (*c.* 1358–1423) was the youngest son of a Gloucestershire knight.[71] Sent to London, he became one of the city's richest and most powerful merchants, and was three times elected to be Lord Mayor. All this is impressive enough, but what has charmed the public's imagination throughout the centuries is the story which embellished, and then smothered, history. In this, no longer well born or well connected, the boy is Dick Whittington, a poor, brave orphan who, with his pet cat, trudges to London and finds his first job in the household of a wealthy citizen. There he makes his mark as an exemplary kitchen-boy, his cat shines as a champion mouse-catcher, and the two are launched on a series of

exploits which leads to the pinnacle of success, the Lord Mayor's office. Dick Whittington and his cat are known to every English child, and their adventures are still sometimes chosen as the skeletal plot-line on which to hang a pantomime extravaganza during the Christmas season today.

Such tiny stories and sightings give us a slight impression of the various ways in which the cook was treated, and regarded, by society. Now it is time to turn away from theory and anecdote, and consider how all sorts of cooks, from harassed amateurs to confident professionals, functioned in very different contexts, as they faced very different demands.

2

The Cottage Cook

Ill huswiferie pineth,
not having to eate.
Good huswiferie dineth,
With plentie of meate.

Thomas Tusser, *Five Hundred Points of Good Husbandry* (1573)

T HE medieval period covered many centuries and was moulded by many changes, of climate and circumstance, far-rippling cycles of economic expansion and retreat, spikes and troughs of localized prosperity and decay. With few personal memoirs to offer glimpses of private responses to public events, it is easy to present the history of the times as a roll-call of calamities, a police record of crimes and cruelty, brutal wars and devastating plagues. In any age, however, life manages to limp along for society at large, if not for the individual victim. For men and women on the lower rungs of the medieval social ladder there was a thread which ran unbroken from one generation to the next, and tied them with a common bond – the need to devise strategies for survival in straitened conditions. Those least padded against misfortune were always at risk, perched precariously on a knife-edge from which they could be toppled by a single ill-timed blow, whether the death of the family's main provider or the failure of a crop. How to keep body and soul together, in bad times and good, was an ever-present concern throughout the Middle Ages. The ways devised by cooks to cope with the problems of scarce resources and scanty equipment form the subject of the present chapter.

Some information about the pots and pans and the ingredients available with luck to the cottage cook can be found in written records and in the interesting if unappetizing evidence of seeds, bones, and blackened shards recovered in the archaeological excavation of midden heaps and refuse dumps. Not very much about actual cooking techniques and improvisations is preserved in such sources, and nothing at all about the relish or resentment felt by those who had to digest the results. The most vivid impression of what it was like to cook and eat in humble households is to be gleaned from the occasional vignettes which crop up here and there throughout the centuries, embedded in sermons and saints' tales, fables, fantasies, and those bewhiskered jokes whose refusal to lie down and die in the course of time is a testament to remarkably unchanging human reactions in an ever-changing world.

The Problems

To set beside the portrait of the hot and harassed cook described in Chapter 1, there is another standard 'type', that of the hot and harassed housewife. Mistress of an establishment far too humble to support any kind of paid professional help, this unsung heroine had to cope by herself with the unpredictable demands of every day. By and large, her plight was treated as the stuff of comedy. On a Norwich Cathedral misericord, carved *c.* 1480, the housewife is shown in vain pursuit of a vanishing fox, which holds her prize rooster clamped between his jaws. Taking advantage of the uproar, a plump little pig methodically licks her stewpot clean. After this, dinner clearly will not be served on time; indeed, if the pig has really known his business, it may never be served at all.[1] Occasionally, comedy is set aside, and the frustrations of the daily grind are dwelt on with grim relish. In *Hali Meidenhad*, an early thirteenth-century

treatise for young women on the joys of the convent, a cloister's calm is contrasted with the chaos of married life: 'The wife … hears, when she comes in, her child scream, sees the cat at the flitch and the hound at the hide. Her cake is burning on the hearthstone, her calf is sucking up all the milk, the earthenware pot is boiling over into the fire, and her husband is scolding.'[2]

Both the professional cook and the peasant housewife were pictured working under pressure, but the two faced entirely different challenges. For the professional, cooking was the defining task which he had been hired to perform. His job was to prepare food, and he was judged on his ability to do so. The hours were long, the work demanding; the pains and pleasures of his private life were of no interest to anyone but himself. They were not expected to impinge on his daily routine. For the housewife, the making of a meal was just one scrap in the day's patchwork quilt of tasks, to be stitched in somehow between its other duties and distractions. She bore and brought up children, looked after both husband and household, and played her part in the outside world as well. She was expected to take charge of the family garden, to be ready to work when needed with her husband on the piece of farmland allotted to them in the village, or labour in their lord's fields at weeding time or harvest. If her family was lucky enough to own livestock, some poultry, a pig, or a cow, hers was the prime responsibility to keep them fed and out of trouble. When her cow strayed on to forbidden territory, she was the one who had to spend precious time vainly trying to persuade a village official not to impose a fine: 'She has to say nice things to the hayward, call him names when he impounds the cow, and yet pay damages nonetheless.'[3]

The housewife was, in short, a partner in the family enterprise, and pulled her weight in every venture. Above all, she had to be prepared to change course at a moment's notice, and cope with

any one of a hundred unexpected interruptions. In the story of St Bridget's life, as told in an early fourteenth-century manuscript of *The South English Legendary*, Bridget is born just as her mother comes home from milking the cow, and steps over the cottage threshold:

> hure a vot withinne was
> And hure other vot was withoute

(one of her feet was in the house, and the other was still outside)[4]

There may be just a touch of melodrama in the telling of the tale, but the tiny detail forcefully drives home the hazards in the housewife's working day. Any baby, whether future saint or sinner, demands a distracting amount of care and attention. One picture in a Flemish psalter of the early fourteenth century shows a young mother as she juggles two jobs at the same time. She stirs the contents of her stew-pot with a spoon held in one hand, while clutching a large, energetically wriggling baby in the other. An older child, a little boy, tries to help by blowing up the fire with a pair of bellows almost half as big as he is (see Fig. 8).

The conflicting claims of cookery and child-care posed problems which are still familiar to the housewife today. What that modern figure would find strikingly, shockingly different about the facts of life faced by her medieval counterpart is the amount of preparation and lead-time required before even the most rudimentary meal-making could begin. A fire had to be not simply made and maintained; its fuel had to be searched for and stored. Kindling to start the blaze had to be improvised and kept ready. Strips of old rags and dried toadstools were known to be reliable: 'I shall gette me drye tode stooles or fyne lynnen clothe halfe brent [half charred]: to make tynder of.'[5] Before its virtues could be put to the test, however, that toadstool first had to be found, and then to be dried. Water for

the cooking pot had to be brought in, not through a kitchen tap, but carried in buckets from some outside source.

To clear such hurdles every single day, over and over again, was a challenge, one not for the faint-hearted. Far more intractable problems regularly threatened to disrupt the annual flow of provisions, the cook's raw materials. Even in a good period, when no regional or national catastrophe occurred, to ruin crops or ravage neighbourhoods, the year was patterned as a chequer-board of feast and famine. High summer and autumn brought their harvests of grain, fruit, and vegetables. Late autumn saw the main slaughter of livestock for the meat supply. All this abundance could be enjoyed at the time, and preserved as far as possible for later use, but by the early spring stocks were running dangerously low. Then there was a very lean stretch indeed, before any new crops could be gathered in. As a bleak snatch of verse explains, the larder was bare because:

> Winter alle etes
> That summer begetes.
>
> (Winter eats everything that summer makes.)[6]

These perilous weeks posed a problem for society as a whole but, inevitably, the pinch of hunger was felt most sharply by the poor. They, even in the best of times, lived from hand to mouth and, in the worst, stared starvation in the face.

This thumbnail sketch indicates in faint outline how serious were the pitfalls faced by the housewife of very modest means, and how frighteningly narrow was the gap between sufficiency and destitution. Worry about supplies never eased entirely. Even in the pleasant stretches of the year, the calamity of crippling illness or a husband's sudden death could in a moment darken the brightest prospect.

There are more than enough descriptions in medieval literature which dwell with relish on the squalor of poverty, the consequences

of pinched resources and defeated spirits. In the thirteenth-century Welsh romance, *The Dream of Rhonabwy*, weary travellers arrive at a 'black old hall', and step inside, in search of dinner. They find there at first no hearty, warming welcome, just one lone peasant, a cross old crone hunched over a smoky fire, who offers them nothing better than rudeness and the cold comfort of 'barley-bread and cheese and watered milk'.[7]

Fortunately for the digestive comfort of the human race, not all cooks are created equal, and from time to time in the records a glimpse is permitted of an alternative model. This is of the capable housewife who creates order and ease in her own domestic world. She is the amateur counterpart of that cool, competent professional who was the second main 'type' of cook discussed in Chapter 1. In *The Lay of Havelok the Dane*, a romance probably composed in the late thirteenth century, the wife of Grim the fisherman knows just how to bring a starving little boy back to life:

> Y shal the fete
> Bred and chese, butere and milk,
> Pastees and flauns; al with suilk
> Shole we sone the wel fede.

> (I shall bring you bread and cheese, butter, milk, pasties and flans.
> With all such things we shall soon feed you well.)[8]

It is sometimes possible to find such a figure in person, and sometimes just the fruits of her labours, as in those traditional calendar scenes for the winter months which show a bright fire blazing, a stewpot simmering, and the head of the household toasting his toes by the hearth, contentedly waiting for dinner.[9] By tracing the strategies employed by this kind of housewife, a plausible case can be made, to show that, at least on a good day, a peasant's life did not have to be all gloom and gruel. With competence, experience, and a

touch of imagination, it was possible to turn scanty resources into sustaining, even at times attractive, meals.

The Materials

THE basic foodstuff was grain of one kind or another: wheat, rye, barley, oats, or some combination of these, depending on local conditions. This was supplemented with peas and beans, either fresh or dried. Monotony and blandness could be countered with fruits and vegetables, grown on a private plot, harvested on a larger scale, bought at a market, or found in the wild. Milk and cream, cheese and butter were all readily obtainable in the spring and summer months. Eggs were not scarce, because it was easy to keep a cock and some hens contented in a small garden.

The one item conspicuous by its absence is meat. That absence was deeply regretted, and bitterly resented because, quite apart from any nutritional value it might have been thought to possess, meat had an undisputed place at the very top of the medieval prestige pyramid. The dinner tables of the powerful were laden with meat dishes of every kind; on fast days fish, the accepted substitute, was offered in the same variety and abundance. However, for reasons which will be outlined later, while animals themselves were familiar figures in the peasant's landscape, their meat was in frustratingly short supply.

Considered from a safe distance, a diet of milk and bread, fruit and cheese, eggs, cream, herbs and vegetables sounds quite agreeable, and more than one elegant poem was composed at the time, in praise of the peasant's enviable lot. The most famous of these, *Franc Gontier*, was written in very comfortable circumstances by the Bishop of Meaux, Philippe de Vitry (1291–1361). He dwelt lovingly on the details of the meal enjoyed by Franc Gontier and Dame

Helaine as they picnicked 'under the green leaves', enjoying 'fresh cheese, milk, butter … cream, curds, apples, plums, pears; they had garlic and onions, and crushed shallots, on crusty black bread, with coarse salt, to give them a thirst'.[10]

A hint of what was really going through the mind of such a peasant as he cast his eye over such a feast is dropped in the late thirteenth-century play by Adam de la Halle, *Le Jeu de Robin et Marion* (*c.* 1283). Hero and heroine are shepherds, and Marion invites Robin to share her picnic of bread, cheese, and apples. Robin is delighted, but cannot help murmuring to Marion that this blameless meal would be brightened considerably by the addition of a slice of the bacon he has happened to notice in her grandmother's kitchen. With regret, Marion explains that Grandmother (who clearly has not lived to a ripe old age without learning a thing or two along the way) has hung the bacon high up in the rafters, well out of reach and harm's way.[11]

The pent-up longing for meat pours out in *The Land of Cockayne*, a poem copied in a manuscript some time before 1350. In the dream world of ease and plenty it describes, geese, already roasted, fly through the air, ready for the taking, and pipe their own praises as they go: 'Gees! al hot, al hot.'[12] No comparable vision is included, of cabbages bobbing along like balloons before gently floating down to mouths wide open to receive them. For a modest household in real life, meat was a luxury, a rare touch of welcome extravagance to break the monotony of a somewhat insipid diet. The housewife cook, working within severe constraints of time and resources, was forced to devise those strategies for survival which have proved tried and true in every century. She had to stretch scanty provisions, find ways to blunt the sharp edge of appetite with plain, substantial fare and then, on a lucky day, add a morsel of some special treat to brighten an all-too-familiar menu.

Methods and Equipment

E VEN in a very simple household, it was possible for the cook to
choose any one of the basic techniques which are still familiar
to us today. Food could be simmered or stewed in a large cauldron,
which might stand on its own support legs in the heart of the fire, or
be suspended from a chain over the flames. Small quantities of soup,
gruel, or some drink might be heated or kept warm in a long-handled
saucepan, set to stand on its own trivet beside the fire. Ingredients
were fried in a pan, grilled on a gridiron, turned on a spit. Naturally
enough, not every household was lucky enough to have all this basic
equipment at hand. Limited means called for ingenuity and impro-
visation: 'For lacke of belowes: blowe with thy mouthe' ('If you don't
have a pair of bellows, blow up the fire with your own breath'); 'A
soudear for lacke of a broche or a spyt rosteth his meate upon his
wepon made lyke a broche' ('A soldier who doesn't have a spit roasts
the meat on his dagger').[13]

To bake something in an oven was another well-known method,
but here there was a problem. Most poor families did not have a
full-scale oven on their own premises. It was possible to mix up the
raw ingredients, and then take them to be baked in the village oven,
but that had its disadvantages because this solution was expensive
in more ways than one. Payment had to be made to the baker for
services rendered, and another payment had to be paid in time, time
spent on the journey to and from the oven, and time wasted await-
ing the baker's convenience. All this being so, there was an incentive
to try another approach. A small, improvised oven was put together
and set in the heart of the fire. The food to be cooked was placed on
a bakestone or metal plate, covered with a lid, and then pushed into
position, with the ashes piled around and over the lid. Such a con-
trivance was too small to cope with large quantities, but it had two

virtues. It made economical use of heat from an existing fire, and it could be reached for at will. No extra expenditure of time or money was required.

Feeding the Youngest Members of the Family

Throughout the medieval period, the protective affection felt by all normal parents for their babies was sharpened by the haunting fear of infant mortality. As a result, much attentive care was lavished on the first year or so of childhood. Once they had been weaned, babies were introduced to the staple diet of porridge, or 'pap', made from hulled grain, flour, or breadcrumbs, cooked in water or milk until the mixture had thickened into a sustaining soup. An early fifteenth-century medical recipe for grown-ups prescribed a combination of cow's milk and fine white flour, cooked 'in the manner of children's pap'.[14] In a few Nativity scenes, painted over a period stretching from the late fourteenth to the mid-fifteenth centuries, Joseph can be found, stirring just such a soup in a little saucepan for the baby Jesus.[15] One of the shepherds in the fifteenth-century *Chester Shepherds' Play*, has the same idea. He brings a flask of soup as his present for Jesus, and thoughtfully hands over his own spoon for the baby's use:

> to eate thy potage withall
> as I my selfe full oft hath done.[16]

Jesus was a very special baby, but he was fed on standard fare. A late fifteenth-century French manuscript on the Ages of Man shows, in the scene representing Infancy, a baby cradled in its mother's arms, while the young father carefully spoons out soup for the child from a long-handled container.[17]

Once babies had a tooth or two to chew with, they were

encouraged to keep themselves busy, gnawing away at a crusty chunk of bread. Soon after that adventure, they were tempted with new tastes and textures. In the thirteenth century, an apple was recommended as a safe choice by Walter de Bibbesworth, but he warned that care had to be taken to peel it and cut away the core before it was given to the child. He also praised the virtues of the egg. The yolk of a soft-boiled one was delicious and easy to digest, while a hard-boiled one was not only good to eat but fun to play with as well.[18] Fun sometimes led to disaster. One little boy, just eighteen months old, bent down to dip his hard-boiled egg into a pool of salt brine on the Lincolnshire coast. The egg slipped through his fingers into the water, and the child tumbled over and drowned as he tried to retrieve it.[19]

Feeding the Rest of the Family

Fruit and Vegetables

AFTER the first year or two of life, children began to eat the same dishes which were prepared for the whole household. Of all the materials with which the cook had to work, fruits and vegetables held out the best hope of variety in a monotonous and limited diet. They also shared one feature which must have made them specially precious: they could be eaten raw. Rawness was neither admired nor approved of by the physicians who advised those able to afford their services, but had distinct advantages for the hard-pressed poor. On those days when there was no fuel, no time, and certainly no officious doctor anywhere at hand, the sweetness of a parsnip, the crunch of a turnip, the pungency of an onion, could add not merely nourishment but zest to any meal.

Everyone loved fruit. Children liked to play games with cherry-

stones, and what better way has there ever been to build up a stock-pile of the stones than to eat the cherries first?[20] As a schoolboy, the poet John Lydgate spent happy hours stealing fruit from other people's property: 'Ran into gardeynes, apples ther I stall'.[21] The beauty and brevity of the fruit season was used as a universally understood image of life's fleeting pleasures: 'Farewell, this World is but a Cherry Fair.'[22]

Herbs and salad stuff, whether grown in a garden or gathered in the wild, added relish to a basically bland diet. They could even take the place of salt, to some degree, by lending their own sharp flavours to the mix. This virtue was noted by a missionary, Gabriel Sagard, who spent some time in Canada in the early seventeenth century. Having sampled the kind of corn pudding prepared by the local Indians, he made his own improved version by adding: 'small herbs such as wild marjoram and other things (purslane and a certain kind of balsam) to give it taste and savour, in place of salt and spice'.[23]

Of all vegetables, members of the onion tribe provided the most pungent pleasures, and were at their potent best when eaten raw. Many a meal of plain porridge or coarse bread must have been cheered by the addition of an onion to the menu. Onions, leeks, and garlic were much-loved standbys, eaten with relish even though their tell-tale aroma lingered on long after the last mouthful had been swallowed. In his poem *Les Contredis Franc Gontier*, François Villon (1431–*c.* 1463) mocked the rustic idyll depicted a hundred years earlier by the Bishop of Meaux, and claimed that if Franc Gontier and Helaine were ever given half a chance to lead a more comfortable life, they would abandon in a moment their diet of black bread with those intrusive onions 'qui causent forte alaine' ('which make the breath smell strong').[24] With no such hope of escape, peasants were prepared to put up with the smell for the sake of the savour.

When it came to cooking vegetables, the simplest method was

to simmer them in water. This is a way to cook chestnuts recommended in one manuscript of the health handbook, *Tacuinum sanitatis*, copied in Rouen *c.* 1400. The illustration shows a pot set over an open fire beside a tree, and a nut-picker pulling a chestnut out of the pot for his young helper.[25] Besides being cooked on their own, vegetables could be tossed into the pot in any combination, depending on what happened to be available at the time, and then simmered together into a soup, with a handful of herbs added for piquancy: 'A few herbes wel chopt to gether wyl make a messe of good pottage to an hungry man.'[26] The soup could be thickened with oatmeal or some other grain but, as an Elizabethan writer pointed out, it was more economical to achieve the desired consistency by simply adding more leeks and dried peas. In this way: 'thou sparest both otemell and bread to be spent'.[27] Sustaining soups could be made from this and that, leaf vegetables like cabbage and root vegetables like parsnip, with each making its contribution to the whole. As with all such hit-or-miss recipes, the result could be dispiriting or remarkably tasty; much depended on the cook's judgement and flair. The method itself was so basic that Taillevent, the great chef to the royal court of France in the fourteenth century, declared that there was no need for him to dictate any instructions whatsoever.[28]

The economical way to get the most out of the large pot in which such soups were made, and the fuel needed to heat it, was to cook more than one item at the same time. When suitably wrapped and protected, several things could be set or suspended in the pot while the soup was simmering. Room might be found for a side of bacon, a sausage in its own casing, or a container filled with eggs to be hard-boiled. One special favourite was the bag pudding, for which the ingredients were securely wrapped in a cloth, suspended in the warm liquid inside the pot, and left there to steam. Of all such concoctions, the Pease-pudding was the best-known. Dried peas or beans

were first soaked overnight, then bound in a cloth with some herb flavouring and, perhaps, a dab of butter or dripping, and so cooked until ready.[29] Over the centuries, and indeed right up to the present time in the north of England, the substantial, grey-green cannonball which in due course emerged has proved to be a sure-fire way to blunt the edge of appetite, and satisfy the heartiest trencherman.

Such staples as pease-pudding and vegetable soup might be supplemented from time to time with agreeable morsels, prepared in quite different ways. While one manuscript of the *Tacuinum sanitatis*, as we have seen, recommended that chestnuts should be cooked in water, another said that they could be 'roasted, stirring them over a lively fire of seasoned wood'.[30] Several fruits and vegetables could be cooked in the ashes of the fire, either while it was heating the big, all-purpose cauldron or while it was slowly dying down after its main job for the day had been completed. Apples, pears, parsnips, leeks and onions lent themselves well to this method, which transformed all-too familiar items into tempting little treats: 'The nightes be prety and colde now. A roste apple ye shal have, and fenell-seede.'[31] In order to make sure that autumn's apple crop did not rot away before winter's chilly nights arrived, the fruit had to be set out in a cool, dry place, and each apple protected from contact with its neighbour by a wisp of packing material. Chaucer had just such a store-room in mind when he composed his lines:

> Hir mouth was sweete ...
> As hoord of apples leyd in hey or heeth.[32]

(Her breath was as sweet as apples laid in hay or heather.)

Another cooking method was to wrap an onion, for example, in a scrap of dough, and bake this turnover in the warm embers of the fire, inside one of those small, improvised ovens which have been mentioned already. The same kind of morsel, dipped into an

egg batter, dropped into a pan and fried in hot, sizzling fat became a fritter, whose crackle and succulence made it a prime favourite. Probably because of their inborn sweetness, apple and parsnip fritters were specially popular variants on a much-loved theme.[33] Frying has always been a way to add a spark of interest to the boringly familiar. By the early sixteenth century it had become the custom in northern England to fry dried peas and beans as a special treat on the day known as Carling Sunday, the second Sunday before Easter, to cheer the weary as they faced the last two weeks of the long Lenten fast. The first of the references collected under 'carling' in the *Oxford English Dictionary*, is dated 1530, and so it is not clear that the custom had its roots in the medieval period, but it seems very likely. Certainly the materials, the method, and the incentive had all been in place for centuries.

It was possible to gather in provisions from many different sources. Herbs could be searched for in the hedgerows, mushrooms collected in field and forest, watercress plucked from a stream. An item might be found in the local market, although it was never wise to be over-confident: 'There be no herbis in the herbe market.'[34] Ideally, there could be friendly exchanges between neighbours, but here again it was best to be braced for disappointment. Christina of Markyate, a recluse who lived near St Albans in mid-twelfth-century England, was a very holy woman who sulked like an all-too-human one because the owner of the next-door garden: 'out of miserliness, had denied her a sprig of chervil when she had recently asked for it'.[35] Because of all these pitfalls, the most reliable source of fruits and vegetables, naturally enough, was the family's own small garden plot. The importance of this private holding can be judged from the care with which conditions for its use were spelled out in wills. When such a property passed from the widow of its owner to the heir, or when it was handed over by an elderly father to his son,

there was often a formal stipulation that the widow or former owner would have the right for life to part of the garden's produce.[36]

Grain and Bread

G RAIN, even more than bread itself, was the staff of life for the peasant household. Depending on region, locality, and circumstance, the principal crop in any one place was wheat, rye, oats, or barley. Peasants grew grain on their own allotted strips of land in the village, and they could be paid in grain for the work they did each year on their lord's properties. They might winnow the chaff from the grain themselves, but that grain, in order to be turned into flour, had to be carried to the local mill for grinding, a service which, needless to say, was not performed for nothing. The mill, indeed, was a considerable and coveted source of income for its owner, and for the miller himself, so determined effort was made to discourage any attempt to avoid the official payment by doing one's own grinding with a hand-mill, or quern, in the privacy of the home. The battle to confiscate and destroy such querns, or punish their users, was waged with vigour in every century. The very energy of the campaign suggests that victory was never decisive; hand-grinding was never completely stamped out.[37] However emotionally gratifying it may have been, this defiant, do-it-yourself method was time-consuming and, because it could not yield substantial amounts of flour, somewhat ineffective. Despite rumbles of resentment, and the occasional flare-up of outright revolt, it had to be accepted that grain must be ground at the mill if the aim was to have in store a reasonably ample quantity of flour for some time to come.

Just as grain needs a mill to grind it into flour, so dough needs an oven to bake it into bread. This posed another problem for the hard-pressed family cook to solve. As has been pointed out already,

most poor households did not have an oven. It was possible to mix up the dough and then take it to the village oven for baking, and it was also possible to buy a ready-made loaf from the baker, from a stall in the local market, or from some better-equipped neighbour who did indeed possess an oven of her own, and was eager to earn a little money by baking a batch of bread for sale.[38] One distinct disadvantage to all such solutions was that in each case money, or some payment in kind, had to change hands. Another was that even a plump purse could not guarantee success. In a collection of Latin exercises drawn up for schoolboys in the mid-fifteenth century, one English sentence set for translation reads: 'Ther ys no bred yn towne to sylle but a lytyl lofe for an halpeny, as myche as a man-ys fust, the wheche unnethe wold ful an hongry [boy] at hys deynere' ('There is no bread for sale in town except one little halfpenny loaf, no bigger than a man's fist, which would scarcely satisfy a hungry boy for dinner').[39]

For all these reasons, although a loaf of bread was enjoyed and coveted, and thought of as one of life's essentials, it was not always within the reach of a poor family on any given day. Quickly assembled alternatives helped to bridge the gap between a full-size baker's loaf and no loaf at all. A batch of oat-cakes could be made from a handful of oats, mixed with water and dropped in spoonfuls to cook on a hot metal or stone plate. Writing about the daring Scottish raids into England in 1327, Froissart pointed out that the invaders could travel fast because they travelled light: 'The only things they take with them are a large flat stone placed between the saddle and the saddle-cloth and a bag of oatmeal strapped behind ... They lay these stones on a fire and mixing a little of their oatmeal with water, they sprinkle the thin paste on the hot stone and make a small cake, rather like a wafer ... It is not surprising that they can travel faster than other armies.'[40]

Small buns, with or without some savoury morsel tucked inside, could be baked in one of those useful, improvised ovens, set within the embers of a fire. Even without such a protective covering, it was possible to bake little rolls of dough by placing them right inside the warm ashes, just as a potato is baked today. This method seems to be simplicity itself, but sharp-eyed attention was needed to ensure success. The story of King Alfred who, as a bedraggled fugitive, took shelter in a herdsman's hut and failed to let the wife know that her bread had burnt to a cinder in the heat of the fire, first began to circulate in the late tenth century, and it is still being told today. In 1998, the sign outside the 'Alfred' pub in Burton on Trent, Staffordshire, showed the king enjoying a pint of beer while the cakes, and the housewife, smoulder in the background. One mid-thirteenth-century version makes the domestic drama spring to life: 'The little old wife … had placed some bread in the warm ash to be baked there, and then turned to other necessary chores while the bread was in the ashes. She forgot about the bread until she was reminded of it by the burning smell. The old woman dropped what she was doing … and ran over, and said impatiently to the man whom she saw sitting there: "What sort of a careless man are you, who neglects to attend to burning bread? Never have I seen so negligent a man – one who doesn't even know how to turn ash-baked bread – and yet when it's put in front of you you'll no doubt rush to eat it!"'[41] Incompetence and inattention clearly ruined more than one baking day throughout the long medieval period, for a fourteenth-century Franciscan preacher, John Myrc, explained that the name Ember Day, given to certain special fasting days in Lent and Advent, was derived from the kind of food permitted then, small penitential buns baked in the embers, and all too often blackened in the process.[42]

Bread, in short, was both a pleasure and a problem. For any meal taken out in the open or in the workplace bread was best, because it

was solid, easy to handle, and needed neither knife nor spoon. We can assume that the picnic lunch being carried to harvesters in the field, in a number of calendar scenes for July and August, consisted of a chunk of bread and, with luck, some relish, an onion perhaps, or a piece of cheese.[43] Inside the home, however, it was much easier and more economical to use grain in other ways, to give some body to a soup, or to heat it in water until it thickened into porridge. For hundreds of years that staple dish kept its key position in the diet of the poor. As late as 1819, for example, John Clare in his poem, 'The Woodman', described a man setting off to chop wood for long hours in a frostbound forest, carrying a crust of barley bread in his bag for lunch, having first fortified himself for the day ahead with a bowl of warm porridge.[44]

Porridge has been praised for many virtues, but full-bodied flavour is never on the list. Its basic insipidity, however, has one distinct advantage: the addition of any flavour whatsoever will be instantly noticed and almost invariably appreciated. A touch of salt or honey, a handful of herbs, a nut or two, a slice of apple or of onion, could turn the boringly familiar into a relished treat. The hiding of an almond for good luck in the similarly bland rice pudding which is still served on Christmas Eve in Denmark is a festive adaptation of the day-to-day strategies devised in any country, any century, by any cook whose imagination is alive and well even when her cupboard is almost bare.

Milk, Butter, Cheese

Mılk's smooth, full-bodied pleasures added a welcome touch of richness to the diet. By a rare stroke of good fortune for the peasant, those pleasures could be relished, as many householders kept a cow or two, and led them out to graze on common pasture. Indeed, Chaucer's 'poor widow', in *The Nun's Priest's Tale* (l. 2831), owned three. In spring and summer, the seasons when calves were born and there was plenty of fresh new grass for cows to feed on, milk was easy to come by, and easy to enjoy. Milk was specially precious because, by an accident of timing, it flowed so freely just in the very weeks when everything else, the provisions from the last year's harvests, had almost run out, and there was still a painfully long stretch to be covered before new crops were ready to be gathered in. Langland's Piers Plowman has nothing very filling in his larder with which to fend off Hunger's attack in those anxious days, but to supplement his handful of vegetables he does at least have two cheeses, a few curds, and some cream.[45]

Despite its many virtues, milk has one distinct drawback: it soon goes bad, especially in warm weather. The comment, 'This mylke is sowre or turned', was selected in one set of early sixteenth-century exercises as a very familiar sentence for schoolboys to translate into Latin.[46] How much milk was drunk in its fresh, cold state is hard to tell. As has been mentioned already, Grim's wife, in *Havelok*, lists milk among the items with which she plans to feed a hungry boy, and Chaucer's poor widow, in *The Nun's Priest's Tale* (l. 2844), has two staples in her diet, 'mylk and broun breed', but in neither case are we told how the milk was served. Many recipes do survive for a comforting warm drink, a posset, which was made from milk heated with ale.[47] The addition of rare, expensive spices could transform the posset into a luxurious confection, fit for any lord, but in its simplest

form, with milk and ale heated together in a saucepan, it was an attainable treat for a poor family.

In the making of this drink, deliberate steps were taken to cause the milk to curdle by adding the slightly acid ale. Acid-producing bacteria are already present in milk itself, and once gentle heat is applied their action causes milk to separate into its solid part, the curd, and a watery liquid, the whey. Whey tastes of nothing in particular, but it has some nourishment, and it certainly had its uses as a refreshing drink after a long, hot working day. Curds, or 'cruddes', were eaten on their own, and formed a staple, valuable part of a poor family's diet. Their taste may be most kindly described as elusive but, as in the case of porridge, this very neutrality had its virtues, for any touch of added flavour, whether salt, herb, or honey, made a noticeable improvement.

Curds could also be made into a simple cheese, by being put into a cloth bag, hung up, and left until any remaining liquid had drained away. An alternative method was to set the curds in a rush basket with a weight on top, to press out those last drops of whey. Hard cheeses had a longer shelf life, but the making of them required more time, attention, and expertise, so it is not likely that this would have been attempted by the average small household. Instead, there was always the chance to buy one at a local market, from a specialist cheese maker.

The cream which rises to the top of milk could be skimmed off and relished on its own as an instant treat. If prudence prevailed, it was made to last much longer by being turned into butter. Poured into a churn, the cream was worked with a paddle until the butter pat was formed. One useful by-product of the process was yet another refreshing drink, buttermilk, the thin, skimmed, and faintly acid liquid left behind after the butter had been lifted out

Effort and experience went into the production of butter but, once made, it seems to have been enjoyed for its own sake, not as an ingredient to be folded into some more elaborate dish. At the very end of the fifteenth century, a Venetian, who of course came from an oil-using region, noted down a little street scene which had caught his eye while he was in London: 'The kites are so tame, that they often take out of the hands of little children the bread smeared with butter in the Flemish fashion given to them by their mothers.'[48] Butter also had its uses as a cooking fat. A little goes a long way to enhance flavour and refine texture. Even dried peas and beans, as we have seen, could be noticeably improved once they had been stirred once or twice in the butter sizzling in a hot pan.

Cheese, like butter, had the great advantage that it needed no embellishment. However, though cheese eaten cold is satisfying enough, once heated it turns into a glorious indulgence. Slices of cheese spread on bread will melt when a red-hot shovel is held above them, and be metamorphosed in a moment into that irresistible confection, toasted cheese. According to a joke which was making the rounds in the early sixteenth century, this little luxury proved the downfall of a pack of troublesome Welshmen who had managed somehow to slip into Heaven, and were making life there intolerable for everyone else with their endless quarrels and arguments. God's patience snapped, and he ordered St Peter to take action: 'God sayd to Saynt Peter that he was wery of them, and that he wolde fayne have them out of heven. ... Wherfore Saynt Peter went out of heven gatys, and cryed with a loude voice, "Cause bobe", that is as moche to say as "rostyd chese", whiche thynge the Welchmen heryng ran out of hevyn a great pace. And when Saynt Peter sawe them al out, he sodenly went in to heven and lokkyd the dore, and so sparryd all the Welchmen out.'[49]

Eggs

T HE wonderfully versatile egg must have been a godsend to the cook of modest means, because it was cheap, plentiful, and readily available. Hens were easy to keep in a small garden space, and easy to feed with household scraps. Eggs, in their turn, were easy to like, and delightfully easy to cook.

All the basic ways to treat them which are familiar to us today were known and used in the Middle Ages. Then as now, when a boiled egg was asked for, or the cry went up: 'Serve me with pochyd eggys',[50] the only equipment needed by the cook was a pan of hot water and a spoon. An Italian handbook of the late fourteenth century outlines the methods: 'An excellent way to cook (eggs) in their shells is to boil them until just set … The best way to cook them without their shells is to break them into boiling water.'[51] For those with more robust digestions, eggs were fried in butter or lard or, like so many other little titbits, buried in the embers of the fire and so roasted in their shells.

With scarcely more effort, they could be beaten up, poured into a hot pan, and made into an omelette, flavoured at times with a few herbs. Eggs being at their most abundant and herbs at their most tender in the springtime, the two were combined together in various ways to celebrate the season.

One omelette associated with Easter took its name, 'a tansy', from that particular plant, but in fact the herb of choice must always have been the one which happened to be at hand. Sorrel and mint were two favourites because, like tansy, they had a pungency which added a special zest to the dish. Another very old, and very simple, recipe is for a herb 'pudding'. In this, an assortment of herbs and such spring greens as young dandelion leaves, were blanched in hot water, drained, and heated up again with eggs and butter in a saucepan.

Once this mixture could be stirred together into a small, soft ball, it was spooned out onto a plate.[52]

Eggs themselves are packed with nourishment, and they can also give body to any liquid in which they are cooked. These characteristics made them welcome ingredients in yet another kind of warm, comforting drink, the caudle. Like the posset, a caudle could be as luxurious as resources would allow, but in essence it consisted of ale and egg yolks heated together, with some oatmeal or breadcrumbs thrown in at times for extra measure, to thicken the brew still more.[53]

Whether or not a cottage housewife ever made a pancake is not certain, but it does not seem beyond the bounds of possibility that she sometimes did so. The necessary ingredients, an egg, some flour, and milk or water for the batter, and some fat in which to cook it were well within her means, and so was the equipment, a frying pan. Pancakes were universal favourites throughout the period, whose records hum with murmurs of contentment, or frustrated cries for more; 'Y have noght ete half my fylle of pankakys.'[54] The town of Olney in Buckinghamshire still stages on Shrove Tuesday a pancake race in which housewives wearing aprons and wielding frying pans toss their pancakes and then run for glory to the finishing line. It is said that the race was first staged in 1445 and, although the claim seems to rest more firmly on local pride than on positive proof, it has not yet been refuted.[55] For the moment, then, it is permissible to indulge the pleasant fancy that today's contest is witness to an age-old passion for pancakes.

The Medieval Cook

Meat and Poultry

MEAT posed problems with no easy solutions for the straitened household. It was much enjoyed, both for its taste and for the status which its presence on the table conferred, but it was hard to get hold of in any satisfying quantity.

The farm animals in any village were used for hauling and ploughing, or valued for such by-products as wool, hide, or milk. By the time they were killed, their meat was sinewy and tough, best suited for long, slow stewing. Not very much of this was tasted by peasant owners in any case. As will be discussed in the next chapter, the most sensible course for them was to sell the animal to a local butcher, in exchange for a cash payment which, in turn, could be spent on more pressing needs. Game was officially off-limits, because hunting was a privilege reserved for the powerful.

More promising sources of meat were the poultry which many families managed to keep in their own gardens, and feed on kitchen scraps. Even here, because the chief function of cocks and hens was first to create and then to produce eggs, a bird was usually of a ripe old age by the time it was deemed to be ready for the table. Once again, the most satisfactory way to deal with such vintage flesh was to stew it in some way. A clue to the basic method is embedded in the brisk command: 'Stue me this cocke in an erthen potte.'[56] The bird was put into a tall, earthenware pot and then, once a cover had been tied over the opening, the whole container was made to stand or hang in the cauldron, and left there to simmer in the surrounding liquid until the contents were cooked.[57] On those occasions when the age of the bird encouraged more optimism, the spit-roasting technique could be tried. This required a more extravagant use of fuel, because a higher cooking temperature had to be maintained, but the rare treat was relished, sometimes with excessive gusto. In

a story told by a thirteenth-century preacher, a husband roasted a bird, and licked his lips at the thought of a companionable feast with his wife. Unfortunately, the first mouthful was so succulent that any idea of equal shares was forgotten, and the wife wolfed down every morsel. At this, the much-tried husband exploded: 'There is nothing left but the spit. It is only fair that you should have a taste of that!' 'And with that spit he beat her handsomely.'[58]

By far the most promising source of meat was the pig. Like poultry, he was easy to provide for and, on a diet of household scraps, he was wonderfully easy to raise. Every part of the body, from the head to the trotters, could be eaten, and every part was delicious. The meat kept well, because it could be smoked and cured. In many a calendar picture for January or February, a haunch of bacon or a string of sausages can be seen, hung up above the fire.[59] Even so, the greatest economy had to be used as this precious resource was consumed, in order to make a little go a very long way. Only the wealthiest peasant had the comfort of being able to look round his home and find it 'full of bacon flitches';[60] most families counted themselves lucky to have one. Pork was a particularly suitable meat for a poor family, because there was a very simple, very quick, and very popular way to cook it. A slice or two of bacon, sizzled in a hot pan, either on their own or with an egg thrown in for good measure, made an exceedingly satisfying and tasty meal. Langland alerts the reader to Piers Plowman's desperate state during the leanest, hungriest stretch of the year, when he makes Piers say that he does not have the ingredients for this basic dish:

Y have no salt bacoun
Ne no cokeney [eggs] ... colloppes [fried egg and bacon] to make.[61]

Even when a cook was lucky enough to have meat of any kind in store, prudence and skill were needed to ensure that the family

supply would last for as long as possible. Meat, after all, was not only for eating. There were many other important uses for the by-products of a carcass, and these had to be budgeted for in the housekeeper's calculations. To take just two examples: mutton fat, or tallow, was needed to make candles, and all kinds of fat were used as ointments for people and animals, and embrocations for equipment, as well as for cooking. In the sixteenth century, Thomas Tusser advised housewives to hoard every drop of fat and put it to good use:

> Save droppings and skimmings, how ever ye doo,
> for medcine [*sic*] for cattell, for cart and for shoo.

> (Save your dripping for cattle medicine, and for
> rubbing on to cart wheels and shoe leather.)[62]

Economy was the watchword, and it must have been a rare occasion when meat was gorged on with reckless abandon. Instead, small portions had to be cooked with care and eaten with relish. Like bacon, any meat could be sliced and fried in a pan but, while bacon cooks to perfection in its own fat, other leaner cuts need a little extra lubrication. A sentence devised for schoolboys to translate into Latin points out what goes wrong when shortcuts are taken: 'The coloppis [slices] cleved [stuck] faste to the fryenge pannys bottom for lacke of oyle droppynge [dripping] or butter.'[63]

Another way to cook a small piece of meat was to put it into one of those improvised ovens, set in the heart of the fire's embers, but with this approach there was the danger that, if the meat was lean to begin with, it might become unappetisingly dry. Certainly in yet another schoolboy exercise the method finds no favour, and the grilling of steaks on a gridiron is called for instead: 'I love no meate dressed [prepared] under a bake pan. Caste stekis [steaks] upon the grydyron.'[64]

Even when meat is in short supply, it is possible to enjoy a taste of it without ever cutting a slice from a joint. Necessity is a stern but stimulating taskmaster, and the inventive housewife made sure that every part of a carcass served some profitable end. Tripe, to take one example, is scraped from the stomach walls of an animal, usually a cow or calf. Little prestige attached to it. and it was considered to be a food for labourers. As a fourteenth-century Italian treatise put it: 'Tripe is a cold-weather food, especially for those who do hard physical work.'[65] In the same century Taillevent, the great chef at the royal court of France, refused to note down any advice on ways to handle it, with the dismissive comment: 'As for tripe, which I have not put in my recipe book, it is common knowledge how it is to be prepared.'[66] Tripe needed to be softened by long, slow simmering, but if this were done properly, with the tripe cooked in broth and flavoured with onions and herbs, it could be made into a very acceptable dish. In one of those schoolboy translation exercises, it even becomes a favourite: 'I had lever [rather] have a fatte trype than a capon.'[67]

Effort, economy, and inspiration went in to the making of Brawn, a dish which used all the parts of the pig left over after the body had been cut into joints: head, tail, feet, ears, tongue, bones, and gristle.[68] These were simmered together until the flesh was so soft that it could be lifted from the bones. This meat was then cut into neat, small pieces, seasoned well, and laid in a large pan while the stock in which it had cooked was boiled down and reduced. This concentrated broth was then poured into the pan and left there to set into a jelly as it grew cold. Brawn kept well, was very nourishing, and could be eaten, slice by slice, over a long period.

The handsome, gleaming Black Pudding, which is still popular today in the north of England, is a very old invention, a mixture of pig's blood, liver, oatmeal, and flavourings, all baked together in a

pan.[69] In those medieval calendar scenes for December which show the killing of a pig for the winter meat supply, the collecting of the precious blood in a basin is often featured prominently.[70] For the ever-popular sausage, chopped pork and other ingredients were stuffed into casings fashioned from the pig's intestines. Brawn, puddings and sausages could all be made at home, but skill, time, and equipment were needed to do so, and it seems most likely that these items were supplied by specialists. Either the householder provided the materials and then paid a fee for the making of the final product or, for a somewhat larger sum, the finished article could be bought outright in the market.

Any kind of meat bone will release its flavour and its goodness when set to simmer slowly in some liquid. Because of this, bones were prized for the cooking pot. As one line in a magic charm from Scotland's West Highlands declares: 'The due of a kettle (cauldron) is bones.'[71] The potency of those words in a spell may be a mystery, but there is no mystery at all about the zest which a bone will bring to any soup or stew. In the same way, a marrowbone cooked with cabbage leaves in a pan of broth lent a touch of meat's richness to a wearisomely familiar vegetable.[72]

Even the most careful and ingenious manager can make a small amount of anything go only so far, and hungry minds were always busy, on the alert for ways to supplement the meat ration. Hunting was officially reserved for the king and the landowners. Poaching was forbidden, and poaching was punished, but poaching undeniably went on. The principal reason for such risk-taking was the chance to stock the family larder. The two partridges which a French peasant just happened to find in a hedge and bring home, in a thirteenth-century story, *Le dit des perdrix*, made a significant contribution to the dinner table, a welcome change from the standard bowl of porridge.[73]

The secondary reasons were the thrill of poaching itself, the pride in the skill and nerve which it required, and the pleasure in beating the system. Although the penalties for poaching were severe, in the case of minor offences there was always the faint hope of softening a magistrate's stony heart with a tearful tale of extenuating circumstances. An excuse which must have been dusted off and polished again and again in the course of history can be found in a poem, *The Fox and the Goose*, in which the Fox explains why forces beyond his control drove him to run off with the Goose:

> I have a wyf, and sche lyeth seke [sick];
> many smale whelppis [cubs] sche have to eke [as well].[74]

Another way to supplement the meat ration was entirely legal, and needed only ingenuity and patience for success. Grain crops were precious, and the birds which flocked in to the fields to feast on the seeds were not welcomed with indulgent smiles. Instead, inviting handfuls of grain were scattered in one spot, and covered with a fine net. When the birds plucked up courage and ventured inside, the string was pulled and they were trapped under the mesh. A horrid little boy, in John Heywood's *Play of the Wether* (1523), enjoys the sport with immoderate glee:

> All my pleasure is in catchynge the byrdes ...
> O ... to here [hear] the byrdes flycker theyr winges ...
> I say yt passeth all thynges.[75]

The main aim of trapping was to protect the future harvest, but it is hard to believe that all those tiny corpses were not put to some other use as well. In Robert Henryson's fable, *The Preiching of the Swallow*, the man who has set such a trap brutally slaughters the prisoners. but some 'he stoppit (stuffed) in his bag'.[76] The treasure trove may have been popped into a stewpot, or threaded on a skewer

and grilled, as small birds are still cooked today in parts of Italy. They cannot have added much bulk to the day's dinner, but every little helps when hunger calls.

Fish

WORRIES about the meat supply gnawed at the back of every mind. Fish posed no such problems and stirred no such passions. Except in places where draconian local regulations restricted access, fresh fish was available to those who lived near inland waters or beside the sea. Even for those less conveniently situated, it was possible to buy in local markets fish which had been salted, smoked, or dried.[77] Officially sanctioned eel-traps were set in the stream beside many a water-mill. The catch was the property of the mill owner or of the miller himself, to be sold or disposed of as he thought fit, to favoured customers. Rival, unauthorized traps were tucked away in less conspicuous stretches of water by peasants planning a contraband contribution to the larder.[78]

This kind of poaching was discouraged, but it was never stamped out. Moreover, the savage laws against the poaching of game animals did not apply to fish. It may have been unwise to filch a carp from an abbot's private pond, but to be caught in the act was not a disaster. One culprit who had been seized as he dipped his hands into just such a pond and pulled out a tench, obviously knew *The Fox and the Goose* by heart, because he chose the Fox's excuse in his appeal to the court: 'My dear wife had lain abed a right full month … and for the great desire she had to eat tench I went to the bank of the pond to take just one tench, and never other fish from the pond did I take.'[79] The poaching of fish was, in any case, more of a sport than an act of desperation, because there were many stretches of water where everyone, even peasants, had the right to try their luck.

Fish was not hungered for as meat was, and its presence on the table conferred no special status. Indeed, there must have been something faintly oppressive about the very idea of fish, because fish and fast were so closely associated. On certain days of every week in the year, and in particular throughout the long seasons of Lent and Advent, meat was forbidden, and fish was the approved, official substitute. A fine salmon on the table might do much to raise morale and cushion the rigours of the fast, but such a treat could never be taken for granted, and was in any case far more likely to brighten the diet of the prosperous than of the poor. In an exultant Christmas carol, the hated figure of Advent is driven from the hall, pelted with reproaches for all the mean, miserable fish dinners he had forced his unwilling followers to swallow:

> Thou hast us fedde with plaices thynne,
> Nothing on them but bone and skynne.[80]

There were so many compulsory fast dates that the thought of having to face yet another fish on one of the red-letter meat days was more than a long-suffering schoolboy could bear: 'Y had as lefe be servyd with a cawlestokke as with heryng yn flesche day' ('I would as soon be served with a cabbage stalk as with a herring on a meat day').[81] Oddly enough the poor, just for once, had some advantage in this matter of fasting. The burden weighed less heavily on them than on the prosperous, because they had considerably less to lose. It is not so very hard to abstain from meat on a fast day when very little meat is to be hoped for even on high days and holidays. A poor man's feast certainly looks like a fast to a rich friend in Robert Henryson's fable, *The Taill of the Uponlandis Mous and the Burges Mous*. There, a poor, humble country mouse invites her fashionable, big-city sister to a meal, and brings out the best she has to offer from her cupboard shelves. The plump, sleek little town mouse takes one

look at the 'wydderit [withered] peas and nuttis' spread before her, shudders, and exclaims: 'My Gude Friday is better nor your Pace' ('My Good Friday is better than your Easter').[82] The poor had no absolute need to buy in stocks of fish for Lent, because their normal, daily vegetarian diet fell within the approved guidelines. It is true that the Church also discouraged the use of dairy foods during the season, but this rule was never so strictly enforced as was the one about meat, and many exceptions were explicitly allowed, or tacitly condoned.

Skilled, imaginative cooks, working in a great household, would transform a penitential dinner into a permissible feast of exquisitely prepared and presented fish dishes. In a very modest household, no such refinements could be attempted. Fresh fish might be simmered in a soup or stew, baked in the embers, fried in a pan, or grilled on a gridiron. In the *Holkham Bible* (c. 1330), one illustration shows a disciple on his knees beside a gridiron, blowing on the flames to make the fire hotter as the fish is cooked. This particular gridiron has a ring attached to one side, a clue that it could be hung up out of the way when not in use.[83] Eels, which were much enjoyed for their rich, fatty flesh, were sometimes cut into short lengths and fried, and sometimes wound around a spit and roasted.[84] Delightful dishes can be made from small fishes, and one recipe which Izaac Walton recorded in the seventeenth century may well have had roots reaching back into the medieval period. In Chapter 18 of *The Compleat Angler* (1653), Walton writes with approval of the minnow, which 'makes excellent sport for young anglers, or boys, or women that love that recreation'. After a pleasant hour or two of angling, these housewives take home their catch and 'make of them excellent minnow-tansies; for being washed well in salt, and their heads and tails cut off, and their guts taken out … they prove excellent for that use; that is, being fried with yolks of eggs, the flowers of cowslips, and of

primroses, and a little tansy; thus used they make a dainty dish of meat'.[85]

Imaginative treatments like this can yield delectable results but they do take time. What a comfort it must have been for the hard-pressed housewife to know that for many kinds of fish no cooking whatsoever was required. Shellfish could be eaten raw; smoked, dried herrings were already prepared and ready for the table when they were purchased. Those who lived within easy reach of the shore gathered shellfish for themselves.[86] The less well-situated bought them at a market stall. A tiny saucerful of cockles or mussels was a Lenten treat for the poor:

> a ferthing-worth of moskeles
> Were a feste with suche folk, or so fele cockes[87]

> (a farthing's worth of mussels, or as many
> cockles, would be a feast for such people)

Smoked or dried herrings were easy to store, and easy to eat. The raging thirst their saltiness provoked was also easy enough to quench, with an extra-large gulp of ale. As one fifteenth-century preacher noticed, his flock drank even more in Lent than throughout the rest of the year. When questioned about this, there was always the same disarming, irrefutable excuse: 'Fish must swim!'[88] Shellfish and smoked fish, indeed, were staples in Lent, so much so that when, for a procession in Norwich which took place in January 1448, the figure of Lent was impersonated, the man playing the part appeared: 'cladde in white with redde herrings skinnes and his hors trapped with oyster shelles after him in token that sadnesse and abstinence of merth shulde followe and an holy tyme.'[89]

Dreams, Rewards, and Celebrations

CONSIDERED a person of scant significance in her own time, the cottage cook left few traces in the records. Hard as it is to track her footsteps there, it is even harder to find a hint of what her family was thinking as they dutifully munched the meals she set before them. Only in art does the peasant's dream of the ideal dinner have a chance to show itself from time to time. In *Prima pastorum*, one of the two shepherd plays written in the Wakefield, Yorkshire district sometime in the first half of the fifteenth century, the shepherds share a magical midnight supper as they sit guarding their flock near Bethlehem. Their picnic bag turns into a cornucopia, from which with happy greed they pull a feast of plenty, one quite beyond the wildest hopes of any shepherd living in the workaday world. There is no porridge, no cabbage, no bread, no cheese, and not a single bean. There is just meat, meat in the most glorious profusion and the strangest variety. Not only are there the humble treats which, with luck, a shepherd might lay hands on once in a while, like 'foote of a cowe', 'ox-tayll', 'swyne-gronys' (pigs' snouts), but there are also lordly luxuries quite beyond his reach, and only to be relished in fantasy: poignant sauces, a 'tart for a lord', 'chekyns endorde' (chickens brushed with an egg yolk glaze and roasted to a golden brown). Best of all, these are solid, wonderfully substantial provisions, food to sink the teeth into. Indeed, the most significant contrast between this dream extravaganza and everyday reality is driven home by one tiny, telling comment:

> We myster no sponys
> Here at oure mangyng.

(We need no spoons here at our meal.)[90]

Severe restrictions hemmed in the peasant at every turn. It was

very hard for him in any clash with his betters to get the upper hand. In real life he had to be content for the most part with frustration and muttered resentment, but in art he could enjoy some gratifying victories. The satisfaction of outwitting the law and dining in style is caught in *The Taill of Rauf Coilyear*, a Scottish comedy of the late fifteenth century. Ralph, who sells coal for a living, rescues the Emperor Charlemagne when he finds him lost and wandering in a winter storm, and takes him home for dinner. Ralph's wife rises to the occasion, and produces a splendid feast, crowned with venison poached from Charlemagne's own royal preserve. The Emperor murmurs his appreciation of the meal, and Ralph cheerfully explains that he is in perpetual battle with the forest wardens, but always outwits them, to make quite sure that: 'aneuch sall I have for me and ane gest' ('I have enough for myself and a guest').[91]

Such fantasies are the stuff of very satisfying dreams. In the everyday world, reward and celebration took more sober forms. Peasants had to work on their lord's land at certain times of the year, in particular during the heavy harvest season, and on those days the lord provided the meals. Household accounts record these carefully calculated rewards. The choice of ale or water to drink, of herring, sausage, or cheese to eat, the kind of bread supplied, whether of wheat, rye, barley, oats, or a mixture of grains, was determined partly by custom, partly by circumstance.[92] Nothing in these lists of provisions suggests that any unusually complicated cooking made its contribution to the sense of occasion. During the fifteenth century, there was a marked increase in the amount of meat allotted to each worker, and more care to supply the better kinds of bread,[93] but these pleasant improvements in quality did not really change the character of the transaction. On such days, a measured reward for service rendered was fashioned from the familiar staples of the peasant world.

Every family throughout history has found ways to economize in private when no outsider is there to see:

Good husband and huswife will sometimes alone
make shift with a morsell and picke of a bone.[94]

This discreet tightening of the belt is often called for when resources have to be hoarded for some important future occasion. In the medieval period, as in our own, life's milestones of birth, marriage, death, were marked by feasts, a most agreeable way in which family and community could pay tribute to the significance of the event. Once again, it is hard to find evidence that any special dishes were prepared. Instead, familiar foods were offered in unfamiliar abundance, and in a spirit of unusual fellowship. When, early in the fifteenth century, Katherine Fauconcer was asked to be the godmother of a baby boy, she accepted the honour and then, after the church service, invited the father to her house, 'where she gave him bread, cheese and good red wine, and thanked him'.[95] For a wedding feast in the village of Brigstock, Somerset, in 1306, no details of the menu have survived, but the meal must have been lavish, and offered to many guests, because the bride's father had to pay twenty shillings to cover all the expenses. The sum was more or less the equivalent in value of the goods, including one cow, which he gave to the young couple as they began their life together.[96]

Villagers came together not only for such family occasions but also for communal ones. For the annual saint's day of their church, the parishioners of an obviously prosperous Norfolk village, one year in the fifteenth century, clubbed together to raise money for the feast itself, and for the services of a professional cook to prepare it. This dinner was a hearteningly ample affair, with a heavy emphasis on different kinds of meat, including five lambs, six pigs, and seven rabbits, and on heaping bowls of dairy produce: eggs, butter, milk, and

cream. There was one truly luxurious touch: spices, vinegar, honey, and even sugar were all listed in the record. Tantalizingly, though, there is no hint of how these ingredients were used, or of how many assistants the cook had to help him.[97]

Help and Hindrance

I T has been noted already that, however basic and simple any cooked dish might be, the preparations required to bring it into being laid heavy demands on time and energy. Even more hard work was needed once the food had been eaten. A veil has been drawn, perhaps mercifully, over the aftermath of any meal, but aftermath there must have been. Some attempt had to be made, to clean sauce-pans and wash plates, if only for the reason that when possessions are few they must be pressed into service often. Encrusted pans were scrubbed with sand, or ashes from the fire: 'Take a wyspe of strawe and asshes; and scoure this potte.'[98] Dishes were washed in water. One startlingly modern scene, carved on a fifteenth-century misericord in Rouen's Cathedral of Notre Dame, shows a man and a woman standing companionably side by side, one dipping plates into a tub, and the other drying them with a cloth.[99] Such cloths were not bought ready-made but fashioned thriftily from any old material which happened to be available: 'These raggis (rags) wyll serve for kytchyn clothes.'[100]

No single pair of hands could cope with all these pressing daily tasks. The harassed housewife needed some support, and turned to two kinds of helper for assistance: servants and children. It may come as a surprise to find servants in a peasant's home, but their presence there was quite normal at a time when equipment was scarce and labour was plentiful. Just as it was the custom for the children of a great family to be brought up in someone else's household, so it was

that a village girl often spent a year or two away from her own parents, as a servant in another cottage, usually one nearby, where she could master some domestic skills before embarking on the married life herself.[101]

The 'servant problem' weighed on the housewife's mind in every period, and medieval mistresses sighed just as heavily as did Victorian ones over their maids' deficiencies. In most contemporary descriptions of the maid at work she is feckless, frivolous, and with a deplorable indifference to the duties of the day:

> Damisellis wantoun and insolent,
> That fane wald play and in the streit be sene,
> To swoping of the hous thay tak na tent.
>
> (Silly, impudent girls, who want to get off work and gossip
> in the street, and take no care in sweeping the house.)[102]

Just occasionally, though, a more sympathetic portrait is attempted. There is a thumbnail sketch of a maid's daunting morning round in a little poem copied down in a late fifteenth-century manuscript. She has to spin and sweep, make the fire, milk the cow, knead the dough, and 'fechen worten in' ('bring in the vegetables').[103] It is no wonder that a strong current of wish-fulfilment runs through stories told about household fairies who were prepared, if suitably rewarded, to help with the unending chores. In one Welsh tale the maids, before they go to sleep, leave a big bowl of the best cream on the hearth for their special Brownie. When they wake up the next morning, the bowl is empty and the churn is full of beautifully made butter.[104]

Despite the rare gleam of appreciation which filters through the cloud of disapproval from time to time, the standard 'type' of the maid in sermons and stories is that of a flighty girl who is more of a hindrance than a help to her much-tried mistress. For somewhat

different reasons, the same might be said of children as well. At a very early age, little boys and girls began to help about the house. They were kept busy, collecting eggs, looking for berries, feeding the hens, and so on. With the endearing zest of children in any age, they were enthusiastic, eager helpers, but sometimes the jobs they were given to do were beyond their strength or power of concentration, and terrible accidents occurred. Death by drowning came when a boy, trying to fill a bucket, slipped headfirst into the pond. A small girl spooning hot soup out of a cauldron fatally scalded herself.[105] Such a disaster would shatter the calm of any day, while even minor mishaps could wreck a mother's careful plans for dinner.

Medieval children had to grow up fast and shoulder responsibility early but they were still children, and they loved to play. From time to time, even fun and games can lead to trouble. In one story, told to illustrate the power of St Thomas Becket to save those who turned to him for help, a mother was given a cheese by a kind friend. She handed over the precious gift to her little girl, and told her to look after it. The daughter did indeed store the cheese in a safe place, but then she ran away to play and completely forgot where she had put it. Frantic with worry, knowing full well that at any moment her mother would ask for the cheese to be produced, the child turned to her brother for help. He could not remember what had been done with the cheese, but came up with the brilliant idea that they should pray for guidance to St Thomas. This they did, and the saint appeared to both of them in their dreams that night. Kindly he told them just where to look: 'Don't you remember that you put the cheese in that old pot? Get up, you'll find it there.'[106] Only this miraculous intervention made possible a happy ending to the story. Without St Thomas Becket there would have been lots of thrashing, floods of tears, and still no cheese to set on the table at the appointed time.

Reinforcements

T HE housewife on a very tight budget had to impose some order on the ever-changing confusion of daily life. The basic need to provide food remained a constant, but the questions of how much time there would be for cooking on any given day, and of what ingredients would be at hand could never be answered in advance with any certainty, depending as they did on lucky finds, unlucky losses, and competing claims. Each season posed its own problems, but the lean period between the end of one year's provisions and the beginning of the next harvest taxed ingenuity to the limit. Not only was ample quantity in short supply, but acceptable quality as well. It is one thing to sit down to a meal of sweet cherries and good bread, and quite another to be forced by hunger to swallow 'cheries sam-rede' ('half-ripe cherries')[107] and gnaw on a substitute loaf concocted from a mixture of acorns and dried beans because the grain stock has run out.

Luckily for sanity, the housewife did not always stand entirely on her own. When times were good, and her purse was plump, she could obtain some supplies and services through exchange or outright purchase, and luxuriate in the relief which comes from not having to make absolutely everything from scratch.

The easiest way to supplement one's own stock of provisions was to make a fair exchange with a neighbour. Needless to say, to take someone else's property without permission was not encouraged. Christine de Pisan was very firm on this point in the few words of advice which she addressed to peasant women in the early fifteenth century: 'Wives ought to ... take care not to go, nor to allow their children to go, and break down the hedges to steal grapes from someone else's garden ... nor other people's fruits or any garden produce or anything else.'[108] The friendly

offer of a basket of apples for a basket of pears was quite another matter.

From time to time, sometimes occasionally, sometimes on a regular basis, outside suppliers had to be turned to for certain staples. The only place to find salt was at a local market, if one was not lucky enough to live in a district where it could be mined from the rock, or panned from a pool of brine. Because most peasant kitchens did not have ovens, bread was more often bought than baked at home.

Ale was the universal drink throughout the period. It was quite simple to make, from malted oats or barley and water, but several large pans, ladles, forks, and a kiln were needed, together with a place in which to set them out. The whole process, from start to finish, took several days. A large quantity of liquid refreshment could be extracted from the precious grain, by brewing a very weak ale, but there was one snag: ale did not keep for more than a few days. As a result, it was customary to set up an informal rotation system, whereby one woman brewed a batch of ale, and sold the surplus not needed by her family to neighbours who, in turn, brewed and sold their own supply in due course.[109]

The convenience of buying ale and bread, those two basic items of diet, was considerable, and the practice was widespread. It is noticeable that when, in Chaucer's *Reeve's Tale*, the Miller wants to make a good dinner for his guests, he roasted a goose, presumably in his own kitchen, but dispatched his daughter to buy the other principal features of the meal:

> This millere into toun his doghter sende
> For ale and breed, and rosted hem a goos.[110]

As in every age, prosperity bred more prosperity. The truly poor were barely able to feed themselves from one day to the next, but those who were in slightly more comfortable circumstances quickly

grasped that any surplus in the cupboard could bring in some welcome extra income when sold to someone else. Eggs and dairy produce were often reserved for such ventures, and it may be that the families of frugal housewives were frustrated by the sight of neatly wrapped baskets and bundles, destined not for their own tables but for some stall in a village street. In the story of St Bridget as told in *The South English Legendary*, when the little girl is old enough her mother puts her in charge of the dairy's storeroom, and tells her to keep strict account of the butter and cheeses set out on the shelves. The future saint is so carried away by compassion for the poor that she forgets her instructions and gives away every pat of butter, every round of cheese. A most unpleasant day of reckoning looms, and is averted only by a timely miracle. One moment the dairy shelves are bare, the next they are piled high once more with stock. The maternal tour of inspection passes without incident, and ends with smiles of approval for a job well done.[III]

Markets had something for everyone, rich and poor alike. The next chapter will consider what they had to offer, and the surprisingly wide range of goods and services they could supply to any customer with a need in mind and a coin or two in the purse.

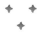

3
ƒast ƒood and ƒine Catering

That that my coke can nat doo: the towne coke shall fulfyll.

William Horman, *Vulgaria* (1519)

The Market Place: Supply and Demand

IN the county of Wiltshire, on the crest of Wick Hill, there stands
an eye-catching monument, a sixty-foot column, built in 1838.
Seated on top is the sculpted figure of a small, determined woman,
with a shopping bag on her arm and a walking stick by her side. The
monument honours a fifteenth-century widow, Maud Heath, who
earned for herself some pocket money by selling any eggs and butter
she had to spare at the local market in Chippenham, four and a half
miles away from her home. The path she took each week crossed the
low-lying meadowland beside the river Avon, and it was often dan-
gerously water-logged whenever the heavens opened and the rains
poured down. As she trudged to and fro, Maud Heath had plenty
of time to think about the problem, and when she died, in 1474, she
left behind a proposal and, even more precious, the money to turn
her dream into a reality. With her legacy, a raised causeway was built
from Wick Hill to Chippenham, and on this travellers could walk
dry-shod in all weathers. The bold solution has stood the test of
time, and parts of it are still in use today.[1]

Maud Heath's weekly expedition demonstrates the ties that bind
the private home to the public market place. Housekeeping and
shopping go hand in hand. Self-sufficiency is an ideal to which lip-
service may be paid, but it is rarely attainable in practice. Every cook,

however competent and careful, needs some outside assistance and supplies. In any period, new cooking pots have to be bought, and old ones repaired. The sermons of the fourteenth-century preacher, John of Bromyard, sparkle with tiny vignettes of everyday life, and in one he speaks of the peddlers who look for business in every village, calling out as they go, 'Old pots to mend.'[2] In the Middle Ages, certain staples like salt had to be purchased by anyone who did not happen to work at a salt pan or a salt mine. Others, like firewood, were more readily available but, then as now, those who could afford to do so avoided the drudgery of gathering and chopping their own supply by paying for a delivery of neatly bundled logs, trimmed and ready for instant use in the kitchen. In a sumptuous, early fourteenth-century manuscript, *The Life of St Denis*, we can see just such a supply, waiting to be unloaded from a barge in Paris, and then carried by porters through the streets of the city.[3]

Shopping requires money, and one way to put some in the purse was to follow Maud Heath's example. Householders sold their own expendable stores so they could buy provisions which they were not able to grow or make for themselves. A peasant with a farm animal ready for slaughter did not indulge in reckless plans to feast on meat for days on end. Instead, he sold his prize asset to the butcher and spent the purchase price on the pressing needs of the moment. Whenever his family felt it could afford a meat dish on the dinner table, then a modest joint would be bought from the butcher's stock.[4]

Households large and small thought of surplus stores as income, and sold them to an eager public. Leftovers from the kitchens of great establishments made their way into the kitchens of modest cook-shops and bakeries, and from there into the pies put out for sale on street stalls.[5] Fruits and vegetables could be bought in London from the gardeners of 'Earls, Barons, Bishops and Citizens', who offered

their wares at a certain spot near the gates of St Paul's Churchyard. One day in 1345 they made so much noise as they stood there clamouring for customers that they disrupted the service taking place inside the church.[6] In 1419, the gardener in charge of the vineyards owned by Ely Cathedral could offer for sale something highly prized by serious cooks: thirty gallons of verjuice, the juice of unripe grapes which was used to add tingle and tartness to a thousand recipes.[7] In contrast to such large-scale business ventures, a picture in a 1465 manuscript made in Constance shows two village women humbly crouched on the ground beside a fishmonger's stall and holding out small baskets of herbs for a customer's inspection.[8]

Sometimes the process was reversed, and salesmen made home deliveries to their customers. In the beautiful pages which illustrate the late fourteenth- and early fifteenth-century copies of the health handbook known as *Tacuinum sanitatis*, housewives stand on their doorsteps choosing turnips, or waiting expectantly while the tradesman pours olive oil from a barrel, first into his own measuring-pot and then from that into the jugs they hold out in their hands.[9]

The practice of house-calls was a very old one, and a trace of it can be found in an Anglo-Saxon riddle, recorded with loving care in a late tenth-century manuscript. The riddle, a venerable ancestor of today's Christmas cracker puzzle, posed this problem: 'A creature walked among wise men sitting in crowded assembly. It had one eye and two ears and two feet and twelve hundred heads, back and belly and two hands, arms and shoulders, one neck and two sides – Say what I am called.'[10] The correct answer to this outrageously rigged question is: 'a one-eyed seller of garlic', making his rounds among those 'wise men sitting in crowded assembly'.

The story of Maud Heath pays attention only to her legacy, and says nothing about the purchases she made for herself. In compensation another story, this one told about Grim the fisherman, in the

thirteenth-century *Lay of Havelok the Dane*, shows in rich detail the exuberant shopping spree made possible for him by a successful day's sales. Grim and his sons carry their catch of fish in baskets to every small settlement within reach. When they have some special prize to offer they take it right into the city of Lincoln itself, and tramp through the streets until the baskets are empty and their pockets are full. After these excursions, Grim never goes home 'hand-bare' ('empty-handed'), but loaded with goods, from sensible necessities, like beans and meat, hemp for his fishing-lines and strong ropes for his nets, to special little treats, buns and cakes to make his family beam with satisfaction.[11]

Street Snacks

KITCHEN equipment and the raw materials with which to make a meal were not the only things for sale in a town of any size. It was also possible to buy the meal itself, ready to eat and ready to go. Town life had its dangers and discomforts, but it offered undeniable conveniences as well. In a fifteenth-century tribute to the charms of Oswestry, a town on the border between Wales and England, the Welsh poet Guto'r Glyn conceded that life in the countryside might be good enough for the young, but firmly declared:

> It's an old man's inclination
> to lead his life in the warmth of urban towns,
> He loves the white bread and the beer and the meat.[12]

Snacks bought from a street stall could be very simple, just a small, cold mouthful of nourishment. In one of his poems, William Dunbar mentions curds, milk and tiny shellfish (cockles and whelks), all on sale beside the Market Cross and the Trone, the public weigh-house, in early sixteenth-century Edinburgh.[13]

Such shellfish were very cheap, a godsend to the poor. On a fast day the hungry could get a taste of fish by buying 'a ferthing-worth of moskeles … or so fele cockes' ('a farthing's worth of mussels, or as many cockles').[14]

Fruit was another favourite, easy to find at any site where foot traffic was heavy and the chance of a sale was high. Young girls with their trays of apples or cherries clustered near taverns, ready to tempt likely customers as they passed in and out. The difficulty, as always, was to ensure that the buyer paid the proper price. William Routh, a boy peddler in London, had one really disheartening day of business. He made the mistake of leaving the street, with its eyewitnesses, and stepping in to his prospect's house to close the deal. Once the boy was inside, the customer not only refused to pay the asking price but roughly seized the fruit basket as well, so William trudged forlornly home with no money, no stock, and not even a container for the next day's load.[15]

Apples and mussels are well enough in their way, but they are not very sustaining. Fortunately, when hunger called it was possible to treat oneself to something considerably more substantial. In the poem just mentioned, Dunbar also speaks of 'pudingis' for sale in Edinburgh. These were savoury mixtures of oatmeal, onions and, with luck, a little meat, cooked in a skin, and they could be bought whole or by the slice.

The customers for such ready-made meals, naturally enough, were those who for one reason or another had no kitchen facilities of their own, and so had to find someone else to do their cooking for them. Fast food was not just for the poor but for anyone free for a while from the constricting net of family and social regulation: the student, the traveller, the bachelor on business far from home. For those in cramped, chilly lodgings, cold food was always welcome, but it was the comfort of something hot which was really yearned for.

'Hot' is the key, attention-catching word in the street cries we find in contemporary descriptions of the London scene: 'Cokes and here knaves cryede "hote pyes, hote".'[16]

There was a need for cookshops, and they had long histories in great cities. William Fitz Stephen gave one a glowing review in his *Description of London*, which he wrote some time before 1183: 'There is in London upon the river's bank, amid the wine that is sold from the ships and wine-cellars, a public cookshop. There daily, according to the season, you may find viands, dishes, roast, fried and boiled, fish great and small, the coarser flesh for the poor, the more delicate for the rich, such as venison and birds both big and little.'[17]

As Fitz Stephen makes clear, cookshops welcomed any paying customer, a feature which did not find favour with less indulgent critics. Fast food was always viewed with suspicion by those in authority, its reputation clouded by the undeniable fact that it was eaten not only by the deserving poor but by those on the look-out for a little fun as well as a little snack. It was enjoyed on the wing, at strange times and in strange places, where men and women could meet in dangerously unregulated settings. Fast food and fast women went hand in hand and, in the age-old way, delightful flirtations led to deplorable consequences.

A case in point is that of George Cely, a young bachelor who, as an English wool merchant, had to pay regular business visits to Calais. While far away from home base, he spent many happy hours in a favourite cookshop, where he found both the puddings and Margery, the girl who made them, much to his liking. The end result was not one but two babies for Margery, and a taxing amount of extra expense for George. In January 1482, a friend wrote a discreet note about the second pregnancy to George, who by then was safely back in England: 'Where as we ate the good puddings, the woman of the house that made them, as I understand she is with child.'[18]

François Villon knew all about the dangers and delights of such casual encounters, and listed 'la gente Saulcissiere' ('the charming Sausage-maker') amongst the good-time girls in his own fifteenth-century Paris.[19]

Tavern Treats

TAVERNS, like pudding-shops, were places to go to for food and fun, but it is hard for the reader today to appreciate their attractions because they have to be seen, for the most part, through the eyes of moralists and sermon writers, their sharpest critics. A pall of official disapproval hangs over taverns, and all the other places of rough, rowdy entertainment. Such centres were condemned as rivals to the Church, exposed as the Devil's chapels, deemed to be dens of iniquity where every one of the seven deadly sins lay in wait for the unwary.[20] The emphasis is always on the coarseness of behaviour there, the dangers to the soul, the temptations to wander from the straight and narrow path. Descriptions are dark with disgust. In *Piers Plowman*, Glutton is sick into another man's lap, staggers home, passes out, sleeps through Sunday and misses every church service. When at last he does wake up, his first words do not promise much in the way of repentance: 'Who halt the bolle?' ('Who's got the bowl?')[21]

Because of this hostility, the charm of a tavern was denied. In the ideal world visualized by medieval theorists, it was essential to belong, to one's church, one's community, one's family. Any attempt to escape from society's established conventions was regarded with suspicion. The comfort and the relief of getting away for an hour from the pinch of real life, the rub of real troubles, the pressure to conform, was rarely acknowledged. Only occasionally is the veil of distaste pierced by a voice which affirms the joy of sitting in a snug

corner of a tavern, footloose and fancy-free. One such voice is that of the anonymous twelfth-century writer who is known to us today as the Archpoet. A brilliant, disreputable follower of his patron, the Archbishop of Cologne, he left a handful of witty Latin verses, of which the most famous is his *Confessio*. In this he declares that he prefers the wine he enjoys in a tavern to the watered-down travesty stingily measured out to the Archbishop's household, and prays to die, tankard in hand, at some favourite drinking-hole while, overhead, indulgent angels put in a good word for him as they sing the shameless sinner to his rest:

> Deus sit propitius
> Huic potatori.

(May God have mercy on this toper.)[22]

Despite the barriers of disapproval, it is still possible now and then to catch a glimpse of the kinds of food which were wolfed down with gusto on such premises. Indeed, sometimes it is one of the critics, a sermon writer himself, who opens up a peephole, when he adds a telling detail to his sketch. Master Robert Rypon of Durham reveals that salty snacks were as popular in the fourteenth century as they are today, and for just the same reason. Customers 'more often than not seek food such as salt beef or a salted herring, to excite a thirst for drink'.[23] Tavern keepers were more than happy to oblige. In a play, the *Jeu de Saint Nicolas*, written *c*. 1200 by Jehan Bodel of Arras, the Host tempts passers-by with his bill of fare: warm bread, fresh herring, plenty of wine.[24] Hot spices have much the same effect as salt when it comes to working up a thirst. In *Piers Plowman*, as Glutton settles down for some serious drinking, he asks: 'Hastow … eny hote spyces?', and the ever-obliging Betty the ale-wife has plenty on hand for him to choose from: fennel, peony seeds, pepper and garlic.[25]

Many attempts were made to regulate the tavern-keeper's trade. In Paris, for example, he was not officially permitted to cook on his own premises.[26] The existence of such a law, and its fellows in other cities, may help to explain why provisions which needed no cooking, like salt beef and herrings, held pride of place on the bill of fare. Taverns were allowed, however, to sell items, like bread and pies, which had been cooked already elsewhere. It is possible that customers were also encouraged to bring their own picnic with them, in the hope that more eating would lead to more drinking. Certainly, in a sixteenth-century carol, *The Gossips' Meeting*, when six women gather in their local tavern to spend a holiday hour away from housework and husbands, each brings a fortifying snack:

> Gose or pigge or capons wynge,
> Pastes of pigynes or sum other thyng

(Goose, or pork, or capon's wing, pigeon pies or some other titbit)[27]

However restrictive in theory, the regulation which forbade cooking in the tavern itself was frequently ignored in practice. A favourite appetizer in fifteenth-century France was the 'carbonée', a thin strip of pork sizzled at speed on a charcoal grill, eaten with bread and washed down with wine. The treat was delicious in itself and a guaranteed thirst-raiser. Juicy, crunchy, slightly salty, the strips were only too easy to eat. As they went down, the wine consumption went up, and both customer and host were satisfied.[28]

Travellers' Joy

RATHER more in the way of cooking was expected from an inn than from a tavern by travellers who spent a night under its roof. Hints of what might be on the menu at such an establishment are to be found in two fifteenth-century continuations of Chaucer's

Canterbury Tales. In one, the anonymous *Tale of Beryn*, the party of pilgrims is lodged at an inn in Canterbury. To fill in the time before supper, most of the men wander off to explore the city, but the Wife of Bath and the Prioress are so tired after the journey that they can manage no more than a gentle stroll round the inn's garden, and a restorative cup or two of wine. They find the garden in apple-pie order, neat, trim and packed with herbs, including sage and hyssop, 'for sew and surgery' ('for cooking and for medical use').[29] Careful provision, obviously, had been made for a plentiful supply of herbs to flavour the cooked dishes and the drinks which were on tap for customers. As the narrator remarks, the state of the garden gave new arrivals a most encouraging foretaste of good things to come: 'ffor comers [it was] a sportful sight'.

In John Lydgate's *The Siege of Thebes* (c. 1421), the other poem which hoped to ride to glory on Chaucer's coat-tails, Lydgate himself joins the party of pilgrims as they arrive at Canterbury and stop for the night at one of the leading inns. The proprietor bustles out to take orders for dinner, and tells Lydgate what is on the day's bill of fare:

> And ye shal han mad at youre devis ['you will have, made to order']
> A gret puddyng or a rounde hagys,
> A franchemole, a tansy, or a froyse.[30]

The menu, like so many of its fellows then and now, seems much more varied than it is in fact. Three of the items, the 'puddyng', the 'hagys' and the 'franchemole' belong to the sausage family. They are all savoury mixtures of ingredients, packed into the skin of an animal's stomach and then simmered until cooked. The other two, the 'tansy' and the 'froyse', are also first cousins to each other. They are egg dishes, flavoured in different ways. The tansy is a herb omelette, and the froyse is a pancake filled with chopped meat or fish. Puddings of

any kind were good standbys, because they were cooked in advance and then served on demand, either whole or by the slice. Omelettes and pancakes had to be made to order, but they were very quick and easy to produce at a moment's notice.

Not every hostelry, needless to say, received ringing endorsements from its guests. The French poet Eustache Deschamps (1346–1407), who travelled widely in the service of his King, Charles VI, wrote a blistering indictment of the service he received whenever he had the misfortune to put up for the night as he journeyed through the Low Countries. No matter where he stayed, no matter what he ordered, no matter what the sauce he specified, the dish which at long last emerged from the kitchen and was set before him was always, without exception, smothered in mustard:

> A Brusselles fis demander
> Sauce vert; le clerc me regarde,
> Par un varlet me fist donner
> Tousjours, sans demander, moustarde.

(In Brussels I ordered green sauce; the head waiter gave me a look, then sent a servant to bring, as always, without asking, mustard.)[31]

Bakers

BACK on the street and forced to fend for themselves, those in need of nourishment could turn for help to any one of several different kinds of professional caterers. First and foremost was the baker, who supplied the backbone of a meal, the bread. Most bread was baked commercially, because most private kitchens had no oven. London's orders were filled in the main by bakeries which clustered to the east of the city, at Stratford-le-Bow. The loaves were trundled into town on long carts, and then sold at certain established stands along the principal shopping streets, in Cornhill and Cheapside.[32]

We catch a glimpse of the way bread sales were handled in Paris, in the early fourteenth-century manuscript, *The Life of Saint Denis*, where one little border scene shows a porter making his way across the bridges of the city, with a big basket of loaves strapped to his back.[33]

Bakers were prepared, for a price, to oblige a customer with any kind of bread, from the best to the worst. At the top of the scale were the fine white loaves of Paris, praised by one local connoisseur for the quality of their ingredients. Magic could be made from such materials: 'The wheat and water are so much better than other kinds; for this reason their bread acquires an incredible degree of goodness and delicacy.'[34]

At the other end of the scale was horse bread, a coarse concoction of beans and peas which was fed to horses when hay was scarce. It was a very familiar household staple, so much so indeed that it figured in a mild domestic joke. Thomas Betson was a middle-aged English wool merchant who, like his scapegrace contemporary, George Cely, spent much time on business in Calais. He was engaged to a little girl, Katherine Riche, who was still too young for marriage, and stayed at home in England. Thomas Betson had to wait, with as much patience as he could muster, for two or three years to pass before he could claim his bride. On 1st June 1476, while he was in Calais, he wrote Katherine a letter in which he found just the right way to make her laugh while letting her know of his impatience. His old horse had been left behind with her in England, and he asked Katherine to go to the horse and beg him, very politely, to lend her four of his years, so she could turn into a grown-up overnight. In return, Thomas promised not only to let the horse have four years from his own age, but to give him four horse loaves as a handsome compensation for his kindness: 'I pray you greet well my horse and pray him to give you four of his years to help you withal; and I will

at my coming home give him four of my years and four horse loaves till amend. Tell him that I prayed him so.'[35]

Besides the substantial, sustaining loaves which added bulk to any meal, bakers also provided enchanting temptations, those little indulgences which brighten the darkest hour and lighten even the heaviest workload. They made tarts and flans, cakes and buns. Amongst the street-cries of Paris which were recorded in the late thirteenth century by Guillaume de la Villeneuve are those of vendors peddling several different kinds of cake.[36] It is hard to be sure what any of these treats looked like, but just occasionally there is a tantalizing hint. On a calendar page for August in a French Book of Hours made *c.* 1500,[37] the main scene shows a man separating grain from chaff with a sieve, an appropriate occupation for the month, while the border is filled with small white disks, each with a slight tracery of decoration at its centre. These may represent the end-products of August's harvest: fine tarts made from fine flour.

A plain, everyday cake is easy to carry, and helps to fill the hunger-gap which yawns between one meal and the next. William Worcestre had much business to take care of and many miles to cover, as he travelled to and fro throughout England. In his careful record of expenses for September 1480, he noted down payments for '5 biscuits' and for 'biscuit cakes', which may have kept him going on a hard day's journey.[38]

Such unpretentious comforts formed the bulk of any baker's daily batch, but special cakes for grand occasions were also for sale on the street. One of those street-cries shouted out in thirteenth-century Paris was for 'Gastel à fève orroiz' ('the cake with the king's bean'). This bean cake was eaten on 6th January, the Feast of Epiphany, in cheerful homage to the day's significance. Epiphany celebrates the showing of the baby Jesus to the Magi in Bethlehem. Over the centuries, these mysterious visitors were transformed, in the imagination

of the West, from Wise Men into great kings, who submitted to a higher power when they knelt and paid tribute to the newborn child. Because of the part these rulers played in the story, kingship and Epiphany were linked together in a game. A group of players shared a cake in which a bean had been hidden, and the lucky one in whose slice the bean was found became the king or queen of the party. The game is still today enjoyed in France, where expectant customers study the display in every favourite cake shop window before they make their choice.

In much the same way, when a bean cake is needed in a late fifteenth-century French play, the *Farce Nouvelle de Jeninot*, the household boy-of-all-work is given some money and told to run out and buy one.[39] As so often, there is very little evidence to show what such a cake looked like at the time, but one clue can be found in a mid-fifteenth-century French Book of Hours, the *Hours of Adelaide of Savoy*.[40] There, in one small compartment on the calendar page for January, the players are assembled beside a table, and the game is about to begin. The Master of Ceremonies holds in his arms a cake shaped like a wheel, a round disk, and it is quite large enough to be easily divided into several portions.[41]

Waferers

EVERY kind of cake has its devotees, but in the Middle Ages the wafer was the snack of choice. Sometimes spiced, sometimes savoury, sometimes sweet but always, ideally, crisp, fresh and hot, it was guaranteed to work its magic in flirtation, friendship or solitary self-indulgence. In Chaucer's *Miller's Tale* (l. 3379), one of the opening shots in Absolon's campaign to win the heart of Alison is to send his prey 'wafres, pipyng hoot out of the gleede' ('wafers hot and straight from the charcoal'). Thomas Hoccleve (*c.* 1368–1426), a

bored clerk at the Office of the Privy Seal in London, spent much of his spare time, and far too much of his money, flirting with the girls he found at the Paul's Head Tavern, and treating them to 'wafres thikke'. A far less successful suitor than Absolon, he never got more than a kiss in return, but he kept on trying until his funds ran out.[42]

Everybody loved wafers, and so it was just as well that they could be made and sold at any street corner. The only equipment needed was a charcoal brazier, a bowl of batter, and a pair of wafer-irons. Once those irons had been heated, a spoonful of batter was enclosed between them and then cooked for a minute or two over the hot coals. The most enterprising waferers mounted the tools of their trade on small wheelbarrows, and trundled from one likely spot to another to catch a customer. Whenever there was some great church feast, a saint's day celebration or a royal wedding, all the waferers would converge where the crowd was thickest. The combination of excited throngs and open fires posed obvious problems, and attempts were made to regulate such situations. By law, it was decreed that waferers had to set up their stands at a certain minimum distance from each other, to cut down the danger of flames or sparks jumping from one brazier to the next, and flaring out of control.[43]

Pie Makers

Of all the treats for sale on a city street, the savoury pie was the one which had a special place in the medieval imagination. A good specimen, warm and round, fragrant and fresh from the oven, had undeniable attractions. The pie-men of Paris knew just how to make mouths water when they despatched their boys into the town to sing out the siren song for the day: 'Warm patties, really hot! Warm pastries, scorching hot!' Two such delivery boys step out jauntily through one of the border scenes in *The Life of St Denis*,

with trays of just-baked pies perched on their shoulders.[44] A north Italian fresco, made at the end of the fifteenth century, shows pies being prepared in a large commercial bakery, with an assembly-line of assistants to shape the dough, spoon in the filling, and slide the finished article into the oven.[45] Pie-makers, like waferers, understood the advantage of mobility, and made use of small ovens, mounted on wheels, which could be pulled from one promising location to the next. These may have been designed to keep the cooked pies warm for as long as possible, rather than to do the actual baking. In an illustration on a page of a manuscript copied in Constance in 1465, this kind of oven is being used to deliver a batch of pies to a market stall, where a woman sits ready to sell them to eager passers-by.[46] (See Fig. 19.)

Good pies had much to recommend them; bad ones, on the other hand, could be very nasty indeed, if not positively lethal. Concealment is the essence of a pie, whose contents lie tantalizingly hidden beneath the pastry lid. The mystery has always been part of the pie's appeal, but it led inevitably to suspicion, rumour, accusation and nervous jokes. Did the contents match the label? Did a 'venison' pie brim with venison, or with skinned cat? Were the ingredients as fresh as they were claimed to be, or recycled left-overs rescued from a rubbish dump? A recent modern experiment with a medieval pie recipe has demonstrated that inside a properly sealed pie crust the contents will remain wholesome for ten days or more without refrigeration,[47] but no pastry seal, however cunning, can protect ingredients which are rotten from the start.

Endless attempts to lay down rules of conduct for cooks, and list penalties for infringements, reflect the public concern. Customers shuddered over sensational stories of food poisoning, but most seem to have survived to tell the tale. It may be that the hint of danger added an edge to the enjoyment, as wary suspicion melted

into smiling satisfaction after the first exploratory bite. It is scarcely surprising, however, that there was constant worry about fresh-ness and cleanliness, because the state of food shops and their sur-roundings left much to be desired. The rules drawn up in 1421 to govern the conduct of cooks in the city of Coventry certainly sug-gest that there was room for improvement: 'We command ... that no Cook cast no maner of fylth under hur bordys, ne in the hye stret, ne suffur hit ther to lye, that is to wit, fethurs, here, ne no entrayls of pygges, ne of no other bestes.' ('We forbid all cooks to throw any rubbish under their stalls, or into the high street, or to let it lie there. By rubbish is meant, for example, feathers, hair, the entrails of pigs, or of any other animals.')[48] Such drifts of decom-posing waste will rarely bring much reassurance to an anxious mind.

The physical appearance of those who handled food in busy town establishments seldom inspired full confidence either. In the ideal world depicted in a calendar picture for December in a late fifteenth-century Book of Hours,[49] the butchers are wearing crisp white aprons, but in real life such aprons were somewhat less than pristine. Dirty aprons and dirty hands often go together. A pithy proverb listed by Cotgrave under the word 'Pastissier' ('pie-maker') in his French-English *Dictionarie* (1611) sums up centuries of hard-won commonsense: 'Better no pies than pies made with scabd hands' ('hands covered with blemishes').

Cook Shops

THOSE who handled meat lived under the darkest cloud of suspicion, and there were many robust jokes at their expense. One is told by Jacques de Vitry, a sermon writer of the early thir-teenth century. A regular customer who wants to wheedle a discount

out of his butcher confides that he has bought meat from no other shop for the past seven years. The butcher's only response is to reel back in disbelief: 'You have done this for so long, and you're not dead yet?'[50] Nevertheless, despite all the doubts and hesitations, everybody wanted a taste of meat, and turned to the professionals who could provide it.

Cooks and butchers offered a wide range of prepared foods, in a correspondingly wide range of prices. A 1378 Ordinance of the Cooks and Pastelers (Pie-makers) of London laid down the guidelines for that year. Depending on the plumpness of one's purse, it was possible to choose ten cooked eggs for one penny, or 'Best roast heron' for eighteen pence. A 'best roast capon' cost sixpence; for the same bird baked in a pastry crust the charge was eight pence. There were significant savings if the customer provided the bird: 'For the paste, fire, and trouble upon a capon, one and a half pence.'[51]

Customers who knew their way around the system were rewarded with extra services. In an early fifteenth-century copy of the recipe collection known as the *Viandier* of Taillevent, there is a helpful note: 'Some gourmets take the goose or gosling, when it is roasted, to the goose butchers (in certain quarters of Paris), to be cut up into pieces and slices in such a way that in each piece there is skin, flesh and bone; and they do it very neatly.'[52] What a godsend this must have been, a guarantee that no one at the dinner table could grumble that another guest had been given a better portion.

There was fierce competition for clients, and in the heat of battle collegial courtesies were sometimes shoved aside. In the 1268 Statute of the Cooks' Guild of Paris,[53] there is this reminder: 'Should anyone be in front of a Cook's stall or window in order to bargain or purchase cooked foods, no other Cook shall call to him before he has turned away on his own from the stall or window; no one shall decry another's meat, if it is good.'

Cooks and tavern keepers tried every trick they could think of to reel in their catch. They would clutch the sleeves of passers-by and coax them to stop and try a sample, or improvise a cafe on the street, spread out a tablecloth and urge them to sit down for a bite:

> Cookes to me they tooke good entent ['paid affable attention'],
> and profered me bread with ale and wyne,
> rybbs of befe, both fat and ful fyne.
> A fayre cloth they gan for to sprede.[54]

Only one thing was needed to keep everybody happy: the customer's ability to pay the bill. The verse just quoted ends with a shrug of resignation:

> but, wantyng mony, I myght not speede

(but, with no money, I couldn't take advantage of the offer)

Cross-Currents: The Street and the Household

As we have seen, it is possible to get some idea of what was on offer in the streets of London or of Paris from those cries of hawkers peddling their wares which found a way into the records of the time. The hapless narrator of an anonymous fifteenth-century poem, *London Lackpenny*, is bombarded with temptations as he makes his way through the city:

> 'hot pescodes' ['peas in the pod'], one began to crye;
> 'strabery rype', and 'cherryes in the ryse' ['on the stem'] ...
> ... then comes me one, cryed, 'hot shepes feete'.
> One cryde, 'makerell' ...
> One cryes, 'rybbs of befe, and many a pye!'[55]

In *Les Crieries de Paris*, the late thirteenth-century poem by Guillaume de la Villeneuve, seventy-nine different kinds of food for

sale are mentioned, from fresh fruits and vegetables to cooked pies and rissoles, fried peas and beans.[56]

Most of the hawkers' trade was with customers on the street, but the insistent, endlessly repeated cries caught the ear of ingenious musicians, who wove them into compositions which were designed to please a far more refined and discriminating audience. A thirteenth-century motet has parts for three voices, each singing the praises of the good life which can be enjoyed in Paris. The tenor calls out the city's tempting street cries: 'Fresh strawberries, wild blackberries.'[57] In a part-song first published in 1530, *Voulez ouyr les cris de Paris*, by the composer Clément Janequin, thirty-eight cries, for everything from turnips to tartlets, are included.[58] Compositions like these suggest that street-cries were part of the background music of life for everyone, even for those who might never deign to take advantage of such offers for themselves, and buy a wafer from a windswept stall.

In a somewhat similar way, a cook working in a great establishment might choose at times to model his own creation on that of a street food seller, in the hope that his patrons would acknowledge the allusion with a smile. A fifteenth-century collection of recipes from Naples offers some ingenious suggestions for fast-day feasting. Included amongst these is a way to make a mock Ricotta cheese out of almond milk and fish broth. To add a finishing touch of authenticity, the almond milk confection is to be presented at table in a wicker basket, 'like those carried through the streets by peddlers who shout "Ricotta! Ricotta!".'[59]

These playful cross-references, in music and in presentation, are tiny indications of the truth that the street and the household were not really two sealed and separated worlds. There were in fact surprising links between them, and on occasion the services of professional, public caterers were much in demand by harried householders in need of help.

Outside Assistance

A GRAND household with its own kitchen staff was designed to be self-sufficient, able to provide all the cooked staples and luxuries which its master required. Even in the best-regulated establishments, however, there was always the chance that a need might arise for some occasional service from an outside specialist. The young Henry VIII had a particular fondness for savoury puddings and so, carefully recorded in the Privy Purse expenses, there are payments to 'the wif (woman) that makes the king podinges at hamptoncourte'.[60] Almost certainly, 'the wif' was not a servant attached to the royal household but a freelance pudding-maker whose skills were called for whenever the King felt it was time for another little treat.

Less exalted establishments had to reach out for help when special occasions put too much strain on their resources. In the mid-fifteenth century, two chantry priests kept house together in the Dorset town of Bridport, and for seven years one of them made a meticulous record of their domestic expenses. From one day to the next their cook was able to cope with their routine, modest needs, but in January 1455 they gave a dinner for several local worthies, and the decision was made to brighten the menu with a festive touch or two of unaccustomed luxury. An entry in the accounts reveals a payment of five pence to the town baker, 'William the Baker', for his flour, his labour, and the 'pies made'.[61] This suggests that the raw materials, the actual contents of the pies, were provided by the priests, while the baker supplied the expertise and the equipment. With his own flour he made the pastry shells, filled and sealed each one, and then baked them all in his oven.

Special problems demand special solutions. In the summer of 1267, Sir Roger Leyburn travelled in England and France on diplomatic business for the King. He and his retinue moved from place to

place and, wherever they stayed, his own cooks prepared the meals for the entire company. Only on one occasion was there an urgent need for outside reinforcements. On 1st June Sir Roger came back from France to England and set off straightaway to Canterbury, to welcome a party of French knights with a splendid feast. The guests were important, their number was large, and the timing was tight, so it is scarcely surprising that an order went out to a local town baker for sixty-eight capon pasties, to be delivered ready-made and rushed to the table.[62]

A well-appointed establishment might still turn to a professional baker for help, even when the use of his oven was not required. Something of the way the system worked can be gathered from the treasure-trove of detailed instructions on how to run a household which a prosperous, elderly husband in late fourteenth-century Paris wrote down for his very young bride. The identity of this remarkable man has not yet been incontrovertibly settled, but recent research makes it seem likely that he was familiar with the royal court and had spent some time in the service of the Duke de Berry.[63] For the time being, he is known to his grateful readers today as 'the Ménagier' or, in Eileen Power's translation for English readers, 'the Goodman of Paris'.[64]

Included in the rich selection of recipes which the Goodman chose for his wife is one for 'Norwegian Pasties', and in his notes he explains how a professional cook could help in the making of them. The filling was to be prepared at home and then taken to the pastry-cook, who would make the crust and put the mixture inside. At this stage there were two choices. The cook would be willing either to bake the pasties on his premises or to deliver them, expertly formed but still raw, to the customer. In the latter case, the pasties were to be finished off at home, in a frying pan: 'When the pastry-cook brings them not cooked in the oven, they be fried whole in oil.'[65] Another

way to take advantage of a baker's skill was to hire him to make a house call, and come to cook something, perhaps one of his specialities, in the client's own oven.[66] With the wisdom of experience, the Goodman emphasized that it was best to reach a firm agreement on terms before the work began, and to pay promptly once the job was done. Good relations and good results went hand in hand.[67]

In the normal course of events, a smoothly running household could manage its affairs very well, and needed only a little outside assistance as day followed day throughout the year. Grand occasions, however, called for extraordinary exertions, and it was at such times that professional caterers proved their worth by providing the trained responses and the helping hands.

A Company Dinner

IN 1423, the Brewers of London sat down to plan their annual dinner, and proof of a firm resolve to put on a splendid show is plain to see in the surviving accounts. Every effort was made to ensure success, and much anxious attention to detail went into the organization of the affair. Because they had no resident staff, they turned for help to an army of experienced assistants, hired for the occasion. Having placed an order with a baker to supply one roast goose and two rabbits, they commissioned another cook, Thomas Bourne, to take charge of the rest of the meal. Two turnspit boys were picked also, to be his staff. While this team was busy behind the scenes, the guests at table were to be entertained by 'one minstrel called Percival'. Other key figures were engaged, to cope with the messy aftermath of the party. A laundress was paid to wash the stained tablecloths and napkins, and a porter was found for that even more disagreeable necessity, 'the cariage of donge'. Not only extra help but extra equipment was needed, and fortunately that too could be rented. Listed

among the expenses are payments 'for hirynge of spetes [spits]', and 'for the hirynge of pewter vesselles'.[68]

A London Wedding

W HEN, at long last, the time came for George Cely, the young wool merchant, to stop sowing wild oats and settle down into matrimony, the wedding took place in London, in May 1484. The union between George and Margery Rygon was celebrated with a series of dinners and suppers, given between the 13th and the 22nd of the month.[69] Even in the dry household accounts there can be sensed the excitement of the occasion and the energy expended to ensure success. Those accounts make clear also the kinds of outside service which could be called on for such a special event. The resident cook in the Cely household seems to have been entrusted with the preparation of the meals, but extra helpers were hired for the occasion, to supplement the kitchen crew. A lot of water was needed, both in the dining hall, at the formal hand-washing ceremony for the guests at table, and in the kitchen for the non-stop cooking in progress. Every drop had to be carried in by bucket from some outside source, and so the sum of two shillings and one penny was paid 'unto Steven water-bearer for bearing of water'. Much of the water was used at the clearing-up stages of the meal, for which 'four men that washed dishes' were engaged. Each was paid two pence for his herculean labours.

The cook and his staff had heavy responsibilities, but at least they did not have to make absolutely every item on the menus from scratch: sauces of mustard, vinegar and honey were supplied by an outside caterer. All the trimmings and decorations for the tables were made off the premises and delivered in time for the festivities. Four pence bought assorted 'garlands and bows'. To add a touch

of unaccustomed splendour to the dining hall, a painter was com-
missioned, and the very substantial sum of eighteen pence for the
amount of 'parti-gold' paint he required was duly entered into the
accounts. Entertainment for the guests was provided not by some
minstrel or dancer but by a most unlikely figure, the local poulterer.
In addition to the three dozen rabbits which he supplied for one of
the meat dishes, he sent in three 'quick' (live) ones as well. Some-
one – perhaps George – had had a brain-wave. To release a clutch of
charming little creatures and let them run about amongst the guests
would be a sure-fire way to make everyone laugh at the sheer sur-
prise and fun of the unexpected drama. The poulterer obliged, and
was rewarded with an extra payment of sixpence for his pains.

Funeral Feasts

THE funeral of an important family member was another occa-
sion on which the Celys pulled out all the stops, to demon-
strate their power, prestige and standing in society. When Richard,
the patriarch of the family and George's father, died in January
1482, several commemorative feasts were given in his honour over
a twelve-month period, beginning with the funeral and ending with
its anniversary, the 'year's mind'. Much outside help was called for, to
stage an appropriately grand tribute to his memory. For the funeral
feast itself, not only were one cook and two turnspit-boys engaged
for twelve pence, but an additional sixteen pence was paid to Thomas
Lyn, the hired butler. For the feast which officially closed the mourn-
ing period, the very considerable sum of thirteen shillings and four
pence was earned by 'Wylchyr cook for his labour'. Wylchyr must
have given satisfaction, because (with his name now spelt Wylshyre
in the records) he was chosen to cook for yet another funeral feast,
when Richard's widow, Agnes, died one year later.

A family friend, William Maryon, was put in charge of all the catering on that occasion, and he too was paid for his services. He earned every penny, because he bore heavy burdens. He had to calculate the quantities needed, and order the provisions from various caterers: wild fowl from Collett the poulterer, unspecified 'victual' from Croke the butcher, spices from William Dygon the spicer, and so on. The dinner set before the invited company had to be as lavish as funds would permit, and it was also highly desirable that its presentation should be eye-catching. Guests were expected to take note of table settings and displays of glittering plate with nods of approval and, if possible, a twinge or two of envy, so it comes as no surprise to discover that sixteen extra sets of pewter dishes were rented for the funeral feast of Agnes Cely.

More details of the personnel and the equipment which had to be hired for a special occasion can be found in the notes of expenses incurred for a funeral in another merchant family, the Stonors, when Thomas Stonor died in 1474. A harried memorandum lists some of the urgently needed essentials: 'Item, cooks. Item, butlers ... Item, a porter. Item, other servants to serve. Item, cups and bowls and pots. Item, spits, cauldrons, rakes and other necessaries for cooks. Item, wood and coals.'[70]

The Paris Connection

THE picture which emerges from these English household accounts can be enriched with details drawn from the helpful notes which the Goodman of Paris assembled for his wife, to give her some idea of how to plan a really important social occasion.[71] He took as his examples a handful of feasts which had been given recently in Paris, and led her step by step through the preparations

for such affairs, to reveal the stage management which underpinned the splendid show.

He makes it clear that the host with deep pockets and the right connections could hire just about anything needed for a feast in the city. Indeed, it was even possible to hire the site itself, and make use of a grander house than one's own by renting someone else's for the event, perhaps the town house of an important figure who happened to be away at the right time. For one of the feasts mentioned by the Goodman, the Paris residence of the bishop of Beauvais was rented, and an extra payment bought the use of the trestle tables in its dining hall as well.

A cook, complete with his own crew of assistants, could be engaged for a certain sum, from which the cook was also expected to pay the men who would do the heavy work and act as porters or water-carriers, as well as the security guards needed to discourage gate-crashers: 'Item, a big and strong *sergent* to guard the portals.' Not only kitchen staff but also a hundred and one extra pieces of equipment had to be hired for a big event. A senior, responsible officer, a member of the permanent household staff, was told to 'go bargain for the kitchen things', which on one occasion included 'a mortar and a pestle, six large cloths for the kitchen, three large earthenware pots for wine, a large earthenware pot for pottage, four wooden basins and spoons, an iron pan, four large pails with handles, two trivets and an iron spoon'. For another party, the kitchen needed 'two large pails, two washing tubs and two brooms'. The same household officer was expected to make sure that the tiny, bewilderingly varied essentials for success were gathered in and set in place, ready for use when the time came: 'greenery, violets, chaplets, milk, cheese, eggs, logs, coal, salt, vats, and washing tubs both for the dining hall and the butteries, verjuice, vinegar, sorrel, sage, parsley, fresh garlic, two brooms, a shovel and other small things'.

Another experienced and (even more important) totally reliable household officer was delegated to go shopping with the cook, to buy the major items for the feast from 'the butcher, the poulterer, the spicer'. After the purchases had been made, it was his job to hire porters to carry home the provisions, and then to see the bundles safely stored under lock and key until they were needed. At the end of the meal, he was expected to make sure that all the leftovers were carefully accounted for and did not vanish into thin air, to be enjoyed by those who had no claim to them.

Delegation, of course, had its dangers. Very cosy pacts for mutual benefit could be made between an unscrupulous household officer and the hired cook as they set off on their shopping expedition and then came back with padded bills for an inattentive or inexperienced master. The Goodman makes it very clear that he does not expect his wife to shop or cook herself but, instead, to acquire the knowledge which will ensure that she is able to direct her servants wisely, and be aware of just how well they are carrying out her orders: 'It is meet that I tell you how you may comport yourself therein, what help and what folk you shall take and how you shall set them to work, for in these affairs I would that you should have only the ordering thereof, and the supervision and the care of setting others to perform them at your husband's cost.'

Christine de Pisan, writing in the early fifteenth century, gives a telling account of what can go wrong in a household where there is a careless mistress and a servant who knows just how to take advantage of the situation: 'There are some dishonest chambermaids who are given great responsibility ... They get their position of buying the food and going to the butcher's ... and claim that the thing costs more than it really does and then keep the change ... They put on one side a little titbit, have a pie made and baked, charging it up to their master, and then ... a delightful little banquet is spread in the

kitchen ... The other housemaids in the street ... turn up, and God knows how they plunder the place.'[72]

Officers and waiters for the feast itself could also be hired. Experience was essential for success on such occasions, for the duties were many and skilled performance was prized. The main job was to ensure that the event went smoothly from start to finish, with guests conducted to their places, wine served, dishes presented and dishes removed, all in the proper order and the approved fashion. Awkward situations had to be handled with diplomacy. Even a most distinguished guest might feel the urge to pocket a handsome piece of tableware, so the servers were instructed to keep a sharp but discreet eye on the cutlery: 'They shall give out spoons and collect them again.' At the end of each course, 'they shall take away, throw the remnants into baskets and the sauces and broths into the buckets and pails'. The responsibility for making sure that those baskets and buckets were in position was given to the 'two knife-bearers', whose main task was to cut and trim slices of bread for use as trencher-plates and salt-cellars, and then place them in position on the tables.

Beside the extra help and equipment which could be brought in for a special event, it was also possible to order many ready-made items for the feast itself. Greenery and flowers might be supplied by: 'a woman chaplet-maker, who shall deliver garlands on the wedding-eve and on the wedding day'. Bread of any quality, to fill any need, could be carefully specified and then ordered from an outside source: 'From the baker, ten dozen flat white loaves, baked the day before ... Trencher bread, three dozens, half a foot wide and four inches high, baked four days before, and let it be brown.'

Bread provided the foundation on which any meal, even the most modest, was formed. Wafers and tiny, candied confections were the extras, the irresistible indulgences which helped to transform plain dinner into memorable feast. Such little luxuries did not have to

be laboriously made at home: 'From the wafer maker, a dozen and a half of ready-made cheese wafers … Item, a dozen and a half of *gros batons*, to wit flour kneaded with eggs, and ginger powder beaten in with it, and made in the shape and size of a chitterling [small sausage], and then set between two irons on the fire.' 'From the spicer, spices for the chamber, to wit candied orange peel, 1 lb. … Citron, 1 lb. … Red anise, 1 lb. … Rose sugar, 1 lb. … White comfits, 3 lbs.'

Sauces to add flavour and colour to a savoury dish were essential features of any feast worthy of the name, and these too could be bought from a specialist. That professional was prepared, for a price, to make the sauce from scratch, but fastidious hosts often preferred to provide him with the raw materials. The Goodman in his notes calls for 'sorrel to make verjuice for the chickens', and then places his order: 'From the sauce-maker … a quart of sorrel verjuice.' Sauces, like pies, might contain many hidden hazards, and it was best to be wary. The problem did not go away with time. At the very end of the sixteenth century, Sir Hugh Plat offered his readers a recipe for home-made mustard as a protection, 'because our mustard which we buy from the chandlers at this day, is many times made up with vile and filthy vinegar, such as our stomachs would abhorre, if we should see it before the mixing thereof with the seeds'.[73]

Fine ingredients for the cook to work with and ready-made additions contributed by outside caterers added up to an alarming bill. It is no wonder that any small economy was seized on with alacrity. Large candles for torches were supplied by the wax chandler for a certain set price. After the feast, it was the sensible custom to collect all the partly used candles and carry them back to the chandler. He was delighted to take these bits and pieces, because they could be melted down and re-formed into brand-new, full-size candles, so he was willing in return to knock a little off the original

price: 'From the wax chandler were bought torches and flambeaux at 3s. the lb. … and at 2s. and 6d. for the returned ends.'

Much can be discovered about the organization of a feast, but many puzzles remain. Did the resident cook feel resentment, or relief, when the freelance chef came bustling in to take charge? How did the regular household staff react when the hired help arrived? How was all the extra rented equipment squeezed into an already crowded kitchen space? The answers are lost, veiled by the silence of the records and the passage of time. Fascinated but frustrated, we are left to smile over imagined possibilities for chaos and comedy, and to marvel that, somehow, the system worked, and the hastily assembled stage-hands really did put on a show.

No matter how much aid and comfort were supplied on special occasions, there was still an enormous amount of work to be done on every other day of the year by the resident cook in any prosperous establishment. What was expected from him and his staff, and what were the tools and techniques with which they did their best to satisfy those expectations, will be considered in another chapter.

✦ ✦
✦

4

The Comforts of Home

It snewed in his hous of mete and drynke.

Chaucer, *General Prologue*, l. 345

The Model Modified

As we look back today through the clouded centuries, our imagination is fired by visions of the medieval feast as a staged performance, choreographed by ceremonial. There is a crackle of excitement in the air, an enjoyable tension between the rival claims of display and decorum. The event takes place in the great hall, the heart of the establishment, and is an experience shared to some degree by every member of the household.

To judge from the relish with which such occasions are described in the romances, this image glowed just as brightly in the medieval mind. The expansive charm of romance, however, is a refuge from the constrictions of reality, and the ideal of the properly conducted feast was inevitably modified by circumstance for those whose households could never hope to match the resources of a powerful lord, let alone those of a royal sovereign. Just as the admired model of the great hall itself had to be squeezed by builders into many different house plans, determined by many different ground-sites, in order to satisfy the ambitions and suit the purses of their clients,[1] so the model of the great feast was shaped by the limitations of life as lived below the topmost rungs of the social ladder.

In the organization of any grand establishment there was a certain military emphasis on clear lines of command and division of labour.

The master cook called on the services of expert craftsmen, from sauce-maker to waferer, each with a special skill and each expected to focus on the particular contribution he had been trained to supply. In a more modest household there were no such sharp demarcation lines. As we have seen in Chapter 3, ready-made sauces, and indeed whole dishes, could be ordered from outside caterers for important occasions, but in the day-to-day running of the kitchen there was less specialization and more sharing of the work to be done between helpers of varying degrees of experience and energy, drawn from an age-range which might stretch from a small boy chopping cabbages on his first job to that blind, paralysed old woman who was tucked into a warm corner of an Italian merchant's kitchen, and tolerated there 'for the love of God'.[2]

Principle and Practice

IN principle, there was an unbridgeable gap between the master and mistress of any household and their servants. In practice, the ingrained idea of hierarchy was somewhat modified by the relationships which were formed in a modest establishment. Limited space in a house leads inevitably to intimacy, to more informal contacts between the inhabitants. In face-to-face encounters, character often outweighed social standing, and medieval servants showed themselves to be just as hard to handle as those in later periods. To have any hope of victory in the battle of wits, the householder had to know the enemy, be alert to every trick that might be tried, and counter every ploy. Advice familiar still today was already being offered in the Middle Ages. Hired helpers, brought in to do a special job, are: 'commonly tiresome, rough and prone to answer back, arrogant, haughty (save on pay day), and ready to break into insults and reproaches if you do not pay them what they ask when the work

is done'. Unforeseen extras found their way into the final reckoning: 'Sir, there was more to do than I thought.' The remedy is to 'always bargain with them before they set hand to work, that there may be no dispute afterwards'.³ A careless mistress who does not take the trouble to keep abreast of current prices will find that the trusted maid sent out to shop in the market is padding every bill, and pocketing provisions for herself. When challenged to explain why the charges are so high and the cupboards at home are so bare, the culprit will pertly reply that it is her masters' fault, because they give so many dinner parties.⁴

Even when not actually dishonest, servants could be aggravatingly reluctant to follow orders. In a letter written on Christmas Eve 1459, Margaret Paston complains to her husband that their new steward absolutely refuses to follow the established Paston custom, and present a daily record of the quantities of bread and ale consumed in the household, on the grounds that he has always been used to draw up a weekly one, and sees no good reason to master a new method.⁵ There was another battle of wills, this time between Francesco di Marco Datini, an Italian merchant in late fourteenth-century Prato and Florence, and his cook, who felt very badly done by when there were unexpected guests. These had the temerity to make matters worse by outstaying their welcome: 'I brought home to dinner the Mayor and Matteo d'Antonio. She had no more to do, for the steak and the fish were already cooked. But because those two ate with me today, and because some fish was left over, and she has also got to cook two bowls of beans, she complains she has too much to do.'⁶

Such tiny snapshots give a sense of the face to face encounters, the flare-up of tempers, the daily jockeying for advantage in these kitchen skirmishes. On the other hand, enforced familiarity led to many acts of human kindness and concern. Servants were remembered quite often in their masters' wills. In 1451, Sir Thomas

Cumberworth left a pair of gloves to his kitchen boy.[7] The Goodman of Paris impressed on his wife the need to pay personal attention to servants when they were sick: 'If one of your servants fall ill, do you lay all common concerns aside, and do you yourself take thought for him full lovingly and kindly, and visit him and think of him or her very carefully, seeking to bring about his cure.'[8] Francesco di Marco Datini himself was very partial to guinea-fowl, and a firm believer in their medicinal value for everybody else as well. A benevolent bully, he dispatched six of the birds to a sick servant, with the brisk command: 'Look to it that you eat them, for you could eat naught better, or more wholesome, and I will go on purveying them for you.'[9]

Distraction and Disruption

A GREAT establishment with its carefully organized team of trained specialists was expected to run smoothly from day's beginning to day's end, rarely thrown off course by any disturbance. A modest household was less insulated from the jolts and jars of unforeseen calamities, and felt their shock more sharply. It is not likely that dinner was served right on time on the day when a little boy bled to death after cutting himself with a knife in the Prior of Newnham's kitchen,[10] let alone on that October Tuesday in 1465, when the Pastons' cook was forcibly abducted by the Duke of Suffolk's men.[11]

Routine could be rocked by masters as well as by their servants. One summer day in 1453, Sir John Hevingham was inconsiderate enough to drop dead in his own garden as he sat there, 'never merryer', waiting to be called in to the dinner table.[12] Thomas Betson, a wool merchant on a business trip to Calais, was so enjoying himself as he wrote to a very special correspondent on 1st June 1476, that he could not bring himself to break off, even when he heard the clock strike

nine and his hungry companions shouting through the door: 'Come down, come down to dinner at once!'[13]

The hiring of extra help for big occasions must at times have proved more of a hindrance than a help. We can only guess at the throb of tension in the air as the home team watched the outside professionals sweep in and over-run its base, but it is easy to imagine that the ripple-effect of the invasion might be felt throughout the house. One friend of Francesco, the merchant, wrote that he would not be coming to visit until the current festivities were over: 'for when you have guests, I well know what a turmoil you are in'.[14]

The Master

As these words suggest, a master with the right temperament could choose, if he felt so inclined, to play an active part on the domestic stage. To take an interest in kitchen matters was not considered to be beneath his dignity, a subject unworthy of alert attention. Much of our own understanding today of medieval cookery comes, indeed, from the remarkably knowledgeable comments recorded at the time by one or two heads of household.

There were several reasons why such a master found it well worth his while to take note of the food served at his own table. Dinner was an important card to play in a family's dealings with the outside world. Meals were used as milestones to mark important stages in both public and private life, to seal a pact, celebrate a marriage alliance, signify membership in some professional association. Every detail of such momentous occasions had to proclaim, to sharp-eyed, sometimes sceptical observers, the refinement and resources of their hosts. Fine linen, handsome dishes, gleaming goblets, all made their contributions to the scene, but it was the food which had the leading part to play, What was served, and how it was served, were matters of

moment, and it was the wise man who paid attention to the details. Francesco shows his own hands-on approach to housekeeping in the instructions he wrote to Margherita, his wife, on how to entertain an important visitor at a time when Francesco himself had to be away from home. While Margherita and her maids whirled through the house, cleaning it from top to toe, he planned to help with the dinner preparations by sending to her reinforcements, a man with a mule-load of extra supplies: special sweets, ten herrings and two large saucepans.[15] Quite how this odd assortment was to be folded into the dinner plan will always pose a puzzle for the uninitiated, but doubtless a well-trained wife after many years of marriage would know just how to crack her husband's code.

The men of any household were far more likely than its women to spend time away from home. This gave them another reason to become knowledgeable about kitchen matters, because they were the ones entrusted with the family shopping-list and expected to look out for special provisions whenever they visited a sizeable town or a major market. When George Cely, the young wool merchant, came home from Calais for Christmas in 1481, he brought with him the green, preserved stem-ginger and the saffron which his mother had asked him to buy. On an earlier occasion, in 1478, it was for a colleague that he carried back to England six sugar loaves and twelve pounds of currants.[16]

Not only does food have an important part to play in the serious business of life; it is also one of life's special pleasures. In the romance *Sir Gawain and the Green Knight*, a single line sums up the misery of its hero as he makes his way in bitter winter weather through a strange, hostile landscape: 'Ther he fonde noght hym byfore the fare that he lyked.'[17] It is not hard to grasp why any man with some authority in his world might take steps to make sure that at his own table, if nowhere else, he would find the food that

he liked best. Francesco Datini had very firm views on the matter. As he was about to return home to Prato from Florence, he sent on ahead instructions for the dinner he expected to find on his arrival: 'A good broth with fat cheese of one kind or another to eat therein … eggs, fish … and many good figs and peaches and nuts … and look to it that the table be well laid and the room well cleaned.'[18]

The head of a household thus had many incentives, ranging from public ambition to private indulgence, to pay attention to food, not merely to know what he liked, but to know where to find it, how to choose it, how to cook it. When Francesco wanted his servant to buy a piece of veal, he issued detailed advice on how to go about the business: 'Purvey me a good piece of veal like the one we had on Sunday … and bid Belozzo … to go where there are most people and say: "Give me some fine veal for that gentleman from Prato", and they will give you some that is good. And bid Margherita to put it on the fire in the saucepan wherein I cooked it last time, and take off the scum.'[19] In this closing sentence there is even a hint that Francesco was not above turning his hand to a little cooking when he felt in the mood to do so.

In the invaluable guide which he wrote for his very young bride, the elderly Goodman of Paris gathered together the rich harvest he had reaped from a lifetime's experience. Like Francesco, he knew what he was talking about, and showed the same practical grasp of housekeeping and its problems. He could give his wife clear, confident instructions on exactly where to buy supplies in the city, and occasional warnings about sharp practice in the street trade. Nothing must be taken for granted. When buying cow's milk, for example: 'Say to the woman who shall sell it to you that she give it not to you if she have put water therein, for often they add to their milk and it is not fresh if there be water in it, it will turn.'[20]

The Mistress

THE part played by the mistress of the house in the ordering and preparation of the daily meals is harder to gauge. We are never lucky enough to catch an echo of her voice, because her own views were not set down on paper. The guidelines she was urged to follow are clear enough, but any personal annotations have been taken with her to the grave. From the general advice which poured down on daughters and young brides, it can be gathered that she was expected to be seen by her household as a figure of authority. The Goodman says: 'I leave you the rule', to hire and fire the servants, but adds an endearing, and characteristically sensible, suggestion: 'Nathless you should privily speak with me about it and act according to my advice, because you are too young and might be deceived by your own people.'[21] The badge of her authority was the bunch of keys with which she could lock and unlock the rooms and boxes where the most precious provisions were stored. Such keys were taken away from Margery Kempe when, as a young wife, she had a nervous breakdown and so lost control of her own household; they were the first things she begged for as she got better.[22] The mistress not only was in charge of what was already in store, but took an active part as well in the obtaining of new supplies. The men of the family may have done most of the actual shopping, but it was the mistress who told them what to buy. Margaret Paston, for example, wrote to her husband some time in 1448, and asked him: 'to don bye for me i. li. of almandys and i. li. of sugyre'.[23]

The role she was expected to play in the running of the household was that of manager rather than executive. As the Goodman puts it: 'In these affairs I would that you should have only the ordering thereof, and the supervision and the care of setting others to perform

them at your husband's cost.'[24] In order to play that part well, she had to know what she was talking about when she asked for something to be done. Knowledge was the key to success: 'The wise lady or housewife ought to be very familiar with everything pertaining to the preparation of food so that she may know how best to organize it and give orders to her serving-men or women; in this way she may always be able to keep her husband contented.'[25] In principle, she was supposed to keep a proper distance between herself and her servants, but in real life she had to be prepared to roll up her sleeves and lend a hand when circumstances called for crisis control. Her contribution would then be of value in itself, and an encouragement to her team:

> And if thi nede be greet and thi tyme streite [limited]
> Than go thi silf therto and worche ...
> Thanne wille thei alle do the bettir that aboute thee stande.
> The work is the sonner do that hath many handis.[26]

How much actual, hands-on cooking was ever done by the mistress is not clear from the record, but there were one or two threads, besides that of occasional necessity, which might have led her to make the attempt from time to time. Certainly it was assumed that she would know how to make up medicines and cordials for her household. Margery Paston's husband wrote home sometime in the early 1490s, urging her to send her own special ointment to soothe the aching knee of an old friend.[27] There are strong family ties between the making of medicines and the cooking of food. The same kinds of equipment (from pestles to sieves), and techniques (from pounding to straining) are used for both, and the fact that indeed the two activities were thought of as closely related to one another is suggested by the way kitchen recipes and medical ones are copied down on the same page of a manuscript, with instructions

on how 'to burst a boil' side by side with elaborate advice on how 'to stew herring'.[28]

While many may have felt it inappropriate and socially demeaning to do more than decide what needed to be done and delegate its execution, it seems likely that some were drawn by temperament to try out a recipe or two. It would have been but a small step from pounding ingredients for an ointment to pounding herbs for an omelette. As a spur to such enterprise there was the time-tested truth that a contented husband is an indulgent husband, and that nothing is more guaranteed to make him smile than a favourite treat supplied by loving hands. The Goodman of Paris savours every detail as he describes the ways with which the cares of a hard-working husband can be smoothed away when he comes home: 'to be unshod before a good fire, to have his feet washed and fresh shoes and hose, to be given good food and drink, to be well served and well looked after'.[29] One of Francesco's friends glows with affection as he confides that his wife spoils him by preparing: 'some roasted chestnuts every day' before he sets off for work. This is only one move in a delightful game they play with each other, for: 'she pampers me as I do her'.[30]

Despite the likelihood that the mistress of any but the grandest establishment played some part in the actual cooking from time to time, it is exasperatingly hard to find traces of such activity in the records. It is a rare concession when the veil of silence is lifted, and the reader is permitted a glimpse of the lady of the house at work. In one of the stories which in the fourteenth century the Knight of La Tour Landry told his daughters, an indulgent uncle comes home from his travels with splendid new dresses for his two favourite nieces. One niece miscalculates badly, and does not emerge to greet him until she has tidied herself and ensured that she is looking her best. The other one makes a far better strategic decision. When her uncle walks in, she is busy kneading dough, but breaks off and rushes

to hug him straightaway, even though her arms are covered in flour and her hands are sticky. It is only when she sees that her impulsive embrace has powdered her uncle with flour as well that she pulls up short, remembers decorum, apologizes for appearing: 'in so symple a wyse before you', and begs: 'plese you to foryeve it me'. Needless to say, the uncle is disarmed, the loving niece is rewarded with both gowns, and the vain one is left to learn her lesson the hard way.[31] For the present study, there is one precious nugget in the telling of the tale. It is said that the good niece was kneading dough 'for her playser and disporte'. She was really enjoying herself.

The Balancing Act

THE conspicuous hospitality which any household was expected to offer on important occasions had to be underpinned by careful economies in the day to day diet. The contrast between public and private style could be striking. When a friend of Francesco Datini wrote to thank him for the lavish week of pampering which his wife and daughter had enjoyed as Francesco's guests, he ruefully admitted that it would be hard for them to come down to earth. He would have to: 'bring them back to the little cooking-pot ... for they have spent eight days as at a wedding banquet'.[32]

Frugality was always praised as one of the principal virtues. It was an ideal to be aimed for by people in every walk of life. Even anchorites, however ascetic, might still find themselves guilty of carelessness, and so were urged to confess each week 'all common sins', which included: 'dropping crumbs and spilling ale, letting things become mouldy or rusty or rotten ... not taking care of the things you use'.[33] Every housewife was expected to keep a sharp eye out for any hint of slackness: 'She should understand that nothing must be wasted, and she should expect all her household to be frugal ...

always watchful, she must ask for everything to be accounted for.'[34] The practice of this much-valued virtue led to useful economies but, even more important, it also provided a discipline which imposed order, decency and decorum in the house. The fourteenth-century preacher, San Bernardino of Siena, painted a grim picture of the domestic misery for a husband cursed with a feckless wife: 'If he is rich and has some wheat, the sparrows eat it, and mice. If he has some oil … it is spilled … And in the room in which he eats, the floor is covered with melon rind and bones and salad leaves … Know you how he lives? Like a brute beast.'[35]

Frugality was not merely a virtue; it was a necessity. Any householder might all too quickly discover the disagreeable consequences of improvidence or over-indulgence. It was dangerous to fritter away resources, for unchecked extravagance led to empty cupboards which, in short order, led to empty stomachs. A fourteenth-century poet sums up the advantages of moderation in one crisp line: 'Better were meals many than a merry night.'[36] Stores, once spoilt or squandered, could not always be replaced, and certainly not at a moment's notice. To his detailed description of the dishes served at a wedding feast in Paris, the Goodman adds a terse note: '*Item*, cherries, none, because none were to be had.'[37] The household hints which he gathers together for his young bride include several which show how to make do by improving inferior ingredients when nothing better is at hand. Verjuice, pressed from unripe grapes, is too sharp when it is very new, and too bland when it is very old. The solution proposed is not to throw both out in despair, but to mix them together and so achieve an acceptable balance: '*Note* that in July the old verjuice is very weak and the new is too crude; wherefore in the vintage season, verjuice half old and half new mixed is the best.'[38]

Several strategies could be tried in the practice of frugality. Any or all might help to turn the household accounts from red to black.

Some judicious economies were possible even in a display of public hospitality. The invaluable principle of hierarchy could be invoked, to shave something from the cost by offering one set of dishes to the important guests and another to their inferiors. This was an accepted convention, guaranteed to raise no eyebrows and provoke no titters. After the funeral service in 1474 for Thomas Stonor, a wool merchant, his family provided bread and cheese for 'poor men', while for 'priests and gentlemen' there were lamb and veal kidneys in broth, roasted mutton and chickens.[39]

Within the household, servants were to be fed amply, but not luxuriously. The Goodman, as always, offers sensible suggestions: 'Give them to eat one kind of meat only, but good plenty thereof, and not several varieties, nor dainties and delicacies; and order them one drink nourishing but not intoxicating, be it wine or something else, and not several kinds.'[40] When the master was actually away, the household was battened down in full economy mode. While Ralph Shrewsbury, bishop of Bath and Wells, was in residence, such luxuries as fresh beef, veal and game appeared on the table, but when he was away during the month of November 1337, the servants lived on bread, ale, bacon and mutton, with a heavy emphasis on the bread and the ale.[41]

When all else failed, master and mistress had to practise economy on themselves, in private, far from prying eyes.[42] The best way to make significant economies for oneself was to cut back on poultry, game and fine fresh fish, those expensive, desirable delights which featured in everybody's dreams of a great meal, and blunt the edge of appetite with such substantial, disheartening, all too familiar fillers as dried peas and beans. However carefully prepared, and even when enriched with plenty of bacon or butter, these were rarely greeted with any obvious enthusiasm, and sometimes with downright dislike. A Dutch story tells of the master builder of Sint-Janskathedraal,

in 's-Hertogenbosch, who was so outraged by the pot of peas his frugal wife had made for him that he swept it off the table and down on to the floor. To shame him for ever for this spurt of sinful pride, the little drama was carved in stone for all to see, on the north side of his very own cathedral.[43]

Addition and Subtraction

Luckily for the cook, the characteristic structure of the medieval dinner left ample scope for addition, subtraction, substitution and last-minute improvisation. Any course offered a selection of individual dishes, from which the diner could choose. Each stood alone, sufficient in itself; it was not an integral part of a co-ordinated scheme. Its presence may have been welcome, but its absence did not wreck a master plan. A specimen menu for a 'feast for a franklin' was noted down by John Russell in his mid-fifteenth-century *Boke of Nurture*.[44] The dishes offered in one course ranged from 'brawn with mustard' and 'bacon with peas' to beef stew, boiled chicken and roast goose. No dish was irreplaceable; none needed another as its foil. If for any reason one could not be prepared exactly to plan on the day, then with luck something else might be found to slip into its place. The experienced cook knew how to improvise when an important ingredient was not at hand. The Goodman gives a recipe for young capon in a sauce made from 'new and black grapes', and he adds a helpful note: 'If you want to make this sauce after St John's Day [24th June] and before that there be any grapes, you must make it of cherries … After that no more grapes are to be had, in November, the [sauce] is made of wild sloes.'[45]

Cooks had to brace for surprises, and prepare to be flexible, because unexpected gifts of food were often brought by a visitor or sent over by a neighbour. One day in the first years of the fifteenth

century, a pike 'three feet long' was presented to Robert de Stodhowe, to congratulate him on the birth of a son,[46] and duly incorporated into the celebration feast. Such welcome, if at times disconcerting, additions might be of any size, and certainly did not have to be large enough to feed the entire company. They were intended as compliments to the master, and he had first choice. Once again, the invaluable principle of hierarchy laid down the ground rule of practice.

Variety, an important feature of any festive meal, poses a puzzle. With limited space and a limited number of servants to call on, how was such a dinner produced? The answer may lie in the fact that many dishes could be prepared in the days leading up to the great occasion. To take the specimen menu for that 'feast for a franklin' as an example, the brawn with mustard and the boiled chickens would be equally acceptable whether hot or cold.

Provisioning

A GIFT by its nature is a grace-note, an unexpected, gratefully received addition to the stockpile. Regular, planned supplies flowed into the kitchen from many different sources. Crops might be grown and livestock raised on the householder's own land. Freshwater fish could be bred in a private pond, carefully maintained on the property. At the end of the fifteenth century, Humphrey Newton of Newton in Cheshire kept a record in his notebook of the sums of money he spent on the upkeep of such ponds, for the pleasure of enjoying the luxury of fresh fish for his own use.[47] A dove-cote in the garden, which provided both meat and manure, was a much-prized asset, listed in wills as a valuable legacy. When he died in 1518, Thomas Paycocke, a wealthy cloth merchant in Coggeshall, Essex, left to Ann, his young wife, not only the family house but also: 'my dof house with the garden yt stoundeth in'.[48]

Self-sufficiency has many advantages, but it is a hard taskmaster, demanding constant effort. Anyone in a position to do so was more than happy to delegate the work and buy supplies and services from someone else. Provisions might be bought in bulk, or purchased piece-meal to fill a special need. The housekeeping accounts of the two chantry priests of Bridport, encountered in Chapter 3, show that they used both methods. They ordered their year's supply of honey each July, but bought vinegar, saffron and mustard only rarely, and always in very small amounts.[49] Everybody needed a large stock of dried, smoked, or salted fish for the six-week Lenten season, and the steady, reliable orders brought prosperity to many seaside towns. King's Lynn in Norfolk owed a great deal to the herring, and in silent acknowledgement of the debt one of the bench-ends carved in the fifteenth century for St Nicholas's Chapel in the town shows three kippered, split herrings lined up below a handsome fishing boat.[50]

Fish for Lent and, indeed, for all the many other fast days in the year, was a non-negotiable necessity. Bread and ale were two other year-round essentials. Bread could be baked, and ale brewed, at home, if that home had the space and the equipment to make this possible, but it was quite customary to buy both as needed from an outside source. Pleasant little seasonal indulgences were bought from day to day by those in a position to do so, often in the small amounts needed to brighten one particular meal, or make one special dish. When the young wool merchant George Cely and his wife were living in London, in November 1486, their steward bought for them some pears and a little honey. Perhaps the plan was to poach the two together. On another day, he bought butter and parsnips. Once again, it is easy to imagine that a dish of buttered parsnips duly made its appearance soon afterwards on their dinner table.[51]

Daily, or frequent, purchase of provisions had two advantages. The small quantities involved did not need a large storage space, and the problem of keeping ingredients in good condition until required became far less pressing. Few households had the room, or the number of containers, needed to cope with large amounts for any length of time. Space for kitchen equipment was also in short supply. Reports of the preparations for grand meals on important occasions often contain notes on the extra pots and pans which have to be rented or borrowed for the day. This strongly suggests that the household's resources have been strained to their limit, and cannot rise to the challenge on their own. For the funeral of Thomas Stonor in 1474, the call went out for some very basic tools of the trade: 'Item, spits, cauldrons, rakes and other necessaries for cooks.'[52] For a wedding feast in late fourteenth-century Paris, the Goodman jots down a detailed list: 'there be needed two large copper pots ... two boilers, four strainers, a mortar and a pestle, six large cloths for the kitchen, three large earthenware pots for pottage, four wooden basins and spoons, an iron pan, four large pails with handles, two trivets and an iron spoon'.[53]

Kitchen Comforts

COOKS and their rag-tag crew of helpers faced strenuous days. Not only did they have to produce the meals, they also had to prepare the ingredients in all those messy ways which rarely have to be faced by their counterparts today, from plucking feathers to emptying entrails. In a household ruled by a reasonably benevolent master, certain permitted indulgences softened the rigours of the working hours. The Goodman of Paris did not encourage idleness, but recognized the need for breaks to ease the daily pressure. He knew how to control his servants without appearing to coerce them:

'And do you bid them to eat well and drink well and deeply, for it is reasonable that they should eat at a stretch, without sitting too long over their food and without lingering over their meat, or staying with their elbows on the table.'[54]

Many kitchen jobs can be done while sitting down. Here and there in the pictorial record it is possible to find someone taking the weight off the feet while busy with the task at hand. One picture in a beautiful manuscript copy of Virgil's poems, made in Ferrara in 1458,[55] shows a black maid seated on a high-backed chair as she stirs the contents of a cooking-pot suspended over the fire.[56] Close by, a young man sits astride a trestle-table, pounding something in a mortar with his pestle. In the cycle of images devised to illustrate the luxurious copies of the health handbook, *Tacuinum sanitatis*, made in northern Italy in the late fourteenth century, other pictures offer glimpses of leisurely assembly-line co-operation. Legs of lamb are trimmed by one woman at a table, while another sits on a stool by the fire to cook them. Tripe is scraped by one maid, and cooked by another. At the end of the day, young and old sit and talk around the kitchen fire, while hams hang high in the chimney to cure.[57]

The companionship hinted at in such scenes does not invariably sweeten tempers. There is a distinct edge of sarcasm to that collective term recorded in a fifteenth-century recipe book: 'a temperance of cooks'.[58] Even so, in a shared workplace, whenever a running battle is not being fought between two clashing personalities, the chance of a little gossip, a touch of flirtation, a muttered grumble or a whispered joke, can do a lot to lighten loads and ease tensions.

Wood and Water

MOMENTS to breathe and pauses to relax are enjoyed in any job, and must have been specially savoured by those who had to do the heaviest work, the haulage of wood and water. Day-by-day cooking, however basic, demands a never-ending supply of both. Kitchen surfaces and floors also have to be washed from time to time, as the Goodman was careful to remind his wife: 'Bid master Jehan the Dispenser to order Richart of the kitchen to air, wash and clean and do all things that appertain to the kitchen.'[59] The basic tasks of chopping wood, drawing water and carrying the bundles and buckets from source to workplace were usually allotted to the humblest, heartiest members of the kitchen crew, young men like Arcite in Chaucer's *Knight's Tale* (ll. 1422–3):

> Wel koude he hewen wode, and water bere,
> For he was yong and myghty.

For really heavy loads, horse-power could provide a welcome supplement:

> In Wyntir seson …
> The hors is nedeful wode and stuffe to carie.[60]

Those not so well equipped by nature soon found out that these were jobs to be avoided whenever possible. Even the indefatigably self-mortifying Margery Kempe implied that, after agreeing to help an old woman for six weeks by collecting and carrying her firewood and water, the effort had put a distinct strain both on shoulders and good intentions.[61]

Maintenance of a sure, sustained supply of fuel and water was demanding work, and any way to lighten the labour was welcomed. Those lucky enough to live in town had the chance to enjoy some

big-city conveniences. Hints of home-delivery services can be found in the borders of a 1317 French manuscript, *The Life of St Denis*,[62] where porters unload sacks of charcoal from barges tied to one of the bridges of Paris, and a water-carrier with two buckets makes his way through the streets of the city.[63]

One bucket of water delivered to a customer's door was surely better than nothing, but scarcely enough to satisfy the domestic demands of a single day. The only way to guarantee sufficiency without backbreaking effort was to build a conduit through which a stream of water could flow to a public tap in a district or, as the height of luxury, to one particular house. Such construction was rare, because it required expert skill and considerable capital. William Worcestre singled out such a special feature for comment when he jotted down notes about the life's work of Thomas Beckington, a weaver's son who rose to become bishop of Bath and Wells. Under the year 1480, Worcestre recorded that Beckington made extensive improvements to the Bishop's Hall, including: 'a very large kitchen, with conduits of water to the kitchen'.[64]

The making of a reliable fire required judgement seasoned with experience. Different kinds of fuel were used at each stage of the process: dry twigs and stalks to start the first quick blaze, faggots and chippings to build the heat, and large logs to sustain it. Once started, the fire had to be managed with attentive care, to ensure that it neither died down completely while still needed during the day, nor burst dangerously back to life during the night. At bedtime, rounded metal covers, 'curfews', were placed over the embers, both as a protection against this hazard and as a way to retain their heat until morning when, with a handful of new kindling, they could be coaxed back into life. In the Goodman's household, the last act of the work day was always an inspection tour to check: 'that the fires on the hearths be everywhere covered'.[65]

The fuel supply was so essential that it comes as no surprise to find that the chopping and gathering of firewood were sometimes chosen in cycles of calendar illustrations as signature activities for the winter months. The picture for January in a French Book of Hours, made *c.* 1500,[66] shows a huge stack of cut wood neatly piled in a courtyard, and a servant walking into the house with a log for the fire on his shoulder. In a February scene, made for a Flemish Book of Hours of the same period,[67] firewood is being carted home on an overloaded wheelbarrow, steered by one man and hauled on a rope by another.[68]

Always, at the back of every mind, was a nagging worry about the size of the stockpile, and the prudent did their best to think of ways to add to it. In his account book for 1480, a wealthy Norfolk knight, Sir Roger Townshend, recorded his decision that some broken old hurdles out in his fields must be chopped up and brought indoors as firewood.[69] When such additions cannot be made, special care is called for to husband resources. In many medieval recipes, the cook is directed to simmer a piece of meat for a while, and then at a certain point to lift it out of the liquid and finish the cooking by a different method: 'Boil it in water until it is half cooked and then fry it in bacon lard.'[70] Simmering requires less fuel than does cooking over high heat, and it may be that economy was the driving force behind the development of this two-pronged approach. Simmering offers another advantage: several items, each carefully wrapped in cloth or sealed in a jar, can be cooked together in the same large cauldron,[71] a saving both in time and fuel.

It was quite usual to make arrangements to buy, or cut from one's own woods, a large quantity of fuel at any one time. The two chantry priests at Bridport, for example, bought three cart-loads of ash and two of oak, a year's supply for their household, in 1454.[72] Even so, it is clear that special events often called for special, supplementary

reinforcements. When George Cely gave a small dinner-party in Calais, in March 1482, amongst the orders which went out for fish, candles and beer was one for: 'two loads of wood'. For Thomas Stonor's funeral in 1474, the long list of extras which had to be gathered in by the harassed organizer ends with: 'Item, wood and coals.'[73]

The fuel supply, in short, was a never-ending worry. It is no wonder that extravagant Wastoure, in the mid-fourteenth-century poem, *Wynnere and Wastoure*, argues for a short and merry life, on the grounds that the longer a man lives, the more timber he must use up, 'to warm his heels', and so he will find himself forced to search for trees to cut down, fifteen miles further afield than ever his father before him had to go.[74]

Tools

THE basic techniques of cookery have not changed significantly over time. Medieval and modern cooks alike will fry or simmer, grill or roast, baste or lard, as the recipe of the moment requires. The function and design of the standard pieces of equipment have also remained much the same. The slotted spoon, the ladle, the spit and the saucepan all have their place in the household inventories of any century. Even the prized weapon in the medieval arsenal, that heat-seeking missile, 'Gib Hunter, our jolie cat', scourge of town and country mouse alike, still has his pampered counterpart in many kitchens of the present day.

The hundred and one ingenious inventions and devices which make life easier for the cook in our own time had their place in a well-stocked medieval cupboard. Graters and sieves, scissors and trivets, strainers and tongs, were all known, and used by those fortunate enough to possess them. Provisions were stored in

stone jars and wooden barrels, hung up in nets, carried in baskets. They were packed into bags, locked into chests, placed in boxes whose slotted sides allowed air to circulate and keep the contents fresh.

By its nature, kitchen work is messy. There is no getting around this fact of life in any period, and so across the years the same call rings out for buckets and brooms to cope with the never-ending chores. In any well-run establishment, cups and plates have to be cleaned after every meal. Medieval ones were first washed and then wiped dry with towels, which grew ever more blotched and stained through heavy use. In one cautionary tale, an undutiful wife who had refused to sit down to dinner with her husband was brought to her senses when forced to eat her meal at a table spread not with a fine white cloth but with: 'the kichin clothe that his [the husband's] disshes were wiped with'.[75]

One piece of medieval equipment which is not so easily matched by an equivalent today is the small, improvised oven. Full-size ovens were not standard features, even in the kitchens of moderately prosperous households, and there was a need to contrive a simple substitute. Ingredients were placed inside a miniature, makeshift model which had been assembled by putting a domed lid over a stone or metal plate. This covered dish was then set to bake in the hot ashes of the fire. The Goodman of Paris offers a recipe for mushrooms cooked in this way: 'Put them between two dishes on the coals and then add a little salt, cheese and spice powder.'[76] An ingenious variation was to transform an actual pie into an oven, by treating the pastry case and its crust as the container. Once the pie had been baked the pastry, like an eggshell, had served its purpose and could be set aside, The top crust was sliced off, and then the contents were spooned out, cut into bite-sized pieces and served on a separate dish.[77]

The essential form and function of most pieces in the battery of kitchen equipment familiar to us today had been well established by the medieval period. What is striking is the contrast between the abundance of the present and the scarcity in the past. In the Middle Ages, a valued piece was patched, mended, and then repaired yet again, to keep it going for as long as possible. An extreme example of this frugal economy is a soapstone cooking pot, excavated in Liguria, which has been put together from pieces of at least three other pots, all sewn into place with copper wire.[78]

An important item was made to last, and became a familiar, friendly presence in the kitchen as the years went by. A motto inscribed on a large cauldron in Warwick castle assures the cook: 'I give the meat good savour.'[79] Favourite pieces were treasured, and then handed down in wills to the next generation. In 1434 Roger Elmesley, a wax-chandler's servant in London, bequeathed a prized possession to his little godson, an iron rack: 'for to rost on his eyren [on which to roast his eggs]'.[80] Cooking equipment has even at times been buried with its owner in the grave. At Peel castle on the Isle of Man, a roasting spit, a feathered goose-wing and some seed-bearing plants were placed beside the body of a high-ranking woman in a Viking-age grave.[81] The reason why these objects were chosen is not yet completely understood, but their very presence is a sure sign that they were valued, and that possession conferred prestige.

Such pride of ownership may have stemmed in part from the fact that most householders did not possess a great deal of kitchen equipment, and made do from day to day with the bare essentials. As noted already, extra pieces had to be hired or borrowed for important occasions. Although special pieces did indeed give satisfaction to their owners, they never had the same value as fine table linen or handsome cups and serving platters. Those were showpieces, designed to represent the family in the theatre of public opinion.

The proper place for kitchenware was behind the scenes, out of sight and out of mind.

Tools were in constant use, easily broken or mislaid, and not usually regarded as important enough to be meticulously recorded in the household accounts. Chance discoveries of stray details help to bring the medieval kitchen scene to life. Often an archaeological dig will uncover fragments of assorted cooking pots; occasionally there is a more unusual find, like a small, personal whetstone for sharpening knives, pierced with a hole so that it could be hung from its owner's belt.[82] Sometimes the existence of a kitchen tool is revealed by a stray reference in the paper record. The customs accounts of the port of King's Lynn for 1503–4 note the flow of household goods pouring into England from the Low Countries, and amongst the lutes, game counters, feather beds and copper kettles are 'pepper grinders'.[83] An inventory of 1295 drawn up for the Abbey of Coggeshall in Essex lists: 'In the room at the end of the Guest-Room: Hurdles for storing apples'.[84] In February 1406, Sir Hugh Luttrell paid a smith, John Corbet, for making thirty-six hooks for the kitchen, on which sides of bacon were to be hung up in the fireplace to cure.[85]

Experience

Like any music score, a recipe on the page needs an interpreter to touch it into life. We owe a great debt today to men like the Goodman of Paris and Francesco Datini, the merchant of Prato and Florence, those knowledgeable masters of their households who had a vested interest in making sure that the food set before them was cooked just the way they liked it, and had learnt by trial and error how to achieve the desired results. Through their little asides and annotations we are offered glimpses of the medieval cook in action, improvising, solving problems, saving the day.

Both firmly believed in the importance of taking trouble, of treating even the simplest procedure with respect. Every detail mattered. Francesco was very fond of the chickpeas he grew on his own land, and wrote down instructions on how to cook them properly. First they had to be soaked overnight, and then: 'they should be boiled in a little water and often stirred, that they cling not to each other as they swell'.[86] The Goodman was a fellow believer in the importance of attentive stirring in the treatment of the whole dried pea and bean family: 'Before your pottage burns and in order that it burn not, stir it often in the bottom of the pot, and turn your spoon often in the bottom so that the pottage may not take hold there.'[87] All this attention to detail in the handling of very humble ingredients is in sharp contrast to the decidedly unhelpful silence on the cooking of: 'peas, split beans, mashed beans, sieved beans or beans in their shell', maintained by Taillevent, the great chef at the royal court of France for many years in the fourteenth century. He considered such mundane matters to be quite beneath the notice of any self-respecting professional.[88]

The Goodman was well able to afford expensive ingredients, but wise enough to frown on extravagance. As a born teacher, he took care not simply to forbid waste but to show how to avoid it. When a recipe called for both precious spices and everyday breadcrumbs, he laid down the best order in which to prepare them. First the spices were to be pounded in a mortar, and set aside in a dish. Then the bread had to be put into the same mortar so that, as it was broken down with the pestle, the crumbs would pick up any traces of spice which might be clinging still to the sides of the bowl. In this way, he explained: 'naught is lost that would be if 'twere done otherwise'.[89]

Experienced cooks know that recipes are not carved in stone but made to be played with, patted into shape as circumstance demands

or taste decrees. When an important ingredient is not at hand, an acceptable alternative can usually be found to take its place. The anonymous compiler of a fifteenth-century cookery book recommends a little wine or vinegar to brighten up a mutton stew. If neither is available, he adds, then a mixture of ale, mustard and verjuice will produce much the same effect.[90] Just as substitution can save the day, so judicious addition will tailor a recipe to please an individual palate. Every now and then, the Goodman annotates a favourite recipe with his own suggestions for improvement. After listing vinegar and rosewater as the proper ingredients of a summer sauce for a roast capon, he adds an afterthought: '*Item*, orange juice is good thereto.'[91]

Cooking takes time and trouble. Attention must be paid at every stage if disaster is to be averted. Certain pitfalls are common to every century, and so are the ways to avoid them. To prevent the filling in an open tart from bubbling over while the tart is baking in the oven, it is always best to build up the pastry sides high enough to hold in the mixture even as it rises. The nameless author of the cookery book recommends that for safety's sake they must be more than an inch in height. To make sure that an earthenware pot does not crack as it is moved from one extreme of temperature to another when it is taken off a hot fire, he says that it must never be set down straightaway on a cold floor.[92] In another version of the same recipe, a second writer includes the helpful suggestion that, as an added precaution, the pot should be left to cool down gradually on an insulating layer of straw.[93] When making a jelly, it is emphasized that care must be taken to keep the liquid warm while its flavour is being fine-tuned, because otherwise it will start to set too soon.[94] Francesco Datini was aware of that other flaw in a jelly's nature, its tendency to fall apart when the temperature rises. He wanted very much to offer a pork jelly to some important guests, and it is possible to sense

that he was allowing hope to over-ride caution when he wrote to his wife: 'If it be well made and stiff it will travel well, for the weather is not hot.'[95]

A perennial problem, which always needs an answer in a hurry, is that posed by the arrival of an unexpected guest. What can be served when there is no time for elaborate preparations, and no special ingredients are conveniently at hand? In his 'Quick Sauce for a Capon', the Goodman pulls out of his bag of tricks an engagingly simple solution, guaranteed to please in any century. Add an onion to a very basic recipe and relax: 'Have some fair clean water and set it in the dripping pan below the capon while it roasteth, and sprinkle the capon with it continually, then bray a sprig of garlic and moisten it with the water and boil; then serve forth.'[96]

The Goodman enjoyed his food, and appreciated quality. He liked variety, and looked forward to eating his favourites at the right time of year: 'Fresh shad cometh into season in March'; mushrooms 'be found at the end of May and June'.[97] He was fastidious, and understood the importance of presentation. Even the simplest dish had to please the eye as well as the palate. When suggesting a recipe which called for bacon to be cooked with dried peas, in order to enrich their flavour, he was careful to point out that, once the mixture was ready, the strips of bacon must be lifted out, rinsed in broth, and then arranged once more on the dish just before it was carried to table, so that they: 'be not covered with bits of the peas'. He was also very particular about the appearance of the bacon itself: 'bacon which is fair and white is much better to be served up than that which is yellow, for however good be the yellow, it is too much condemned and discourages one to look upon it'.[98]

Limitations

E VERY one of these hints and suggestions demonstrates an appreciation of good food, grounded in an understanding of just what it takes to make a diner smile, from the first handling of the raw ingredients to the last flourishes for the finished dish. A telling sign of experience in these knowledgeable male householders is their grasp of reality. They know the limitations of their world. When Francesco Datini proposed that pork jelly for his special guests, he was well aware that success depended on the weather conditions for the red-letter day. He was resigned, if reluctant, to accept a substitute: 'If you would lever do without the jelly, we will eat roast pork and salad. But since they [the guests] have never been here ere now, I would do them honour.'[99]

It is obvious that the Goodman had eaten very well in many grand establishments, but he knew enough to be quite down to earth in his assessment of what could or could not be achieved by his own kitchen staff.[100]

Limitations in scale and staff modified not merely the menu but also the actual presentation of the meal in a modestly prosperous household. The model for emulation was always the ceremonial ritual of a feast at court, with its elaborate and highly skilled carving and saucing at the table, its last-minute touches of decoration added to a dish, its stately choreography of service. Neither such skills nor such resources were at hand in an establishment which stood somewhat lower on the social scale. Master, mistress, and assembled company did indeed sit at table, and they were waited on, but both presentation and service were distinctly simplified. Some impression of the everyday routine to be expected may be gathered from the well-known border scenes in the early fourteenth-century *Luttrell Psalter*[101] which show Sir Geoffrey Luttrell seated at dinner on one

page, and his cooks preparing to serve the meal on the other. No carving is in progress at table. Instead, the kitchen hums with activity, prosaic, purposeful, and entirely without ceremonial embroidery. The cook with his cleaver chops meat into portions, which are then put on plates and carried by servants in to the hall, while another member of the crew is busy, pouring wine into individual cups, at a table which stands inside the kitchen quarters (see Fig. 16). Only Sir Geoffrey himself has been served at the dining table with a great cup, the token of his authority. This has been presented by his steward who, as a mark of respect, has knelt on one knee to do so. The meal itself is conducted with a decent respect for the conventions, but no high drama.[102]

The Comforts of Home

D INNER at home could never be more than a faint, distorted shadow of dinner at court, but it had its own distinct advantages. Ceremony has many drawbacks, and unbuttoned ease has many charms. In one of his *Ballades*, Eustache Deschamps (1346–1407) warns his readers to keep well away from court during the bitter winter months, when the fuel ration is so meagre and so grudgingly doled out that the great hall is never warm enough. To add insult to injury, only the most senior in the company are permitted to wear their cloaks indoors; servants and squires have to shiver in smart liveries and smile.[103] A courtesy book of the fifteenth century indicates that, in England at least, the heating season opened and closed on fixed dates in the calendar. The job of the 'fuel groom' was to bring in wood for the hall fires from All Hallows Day (1st November) to Candlemas (2nd February). Official rules and regulations being what they are in any period, it is to be suspected that it was never deemed feasible to stretch the

scheme to cover 31st October or 3rd February, however bleak the weather.[104]

Medieval people had a strong sense of their place in the community, caught as they were in a web of connections, in family and public life, which both controlled and defined them. The idea of personal privacy was not so fully developed as it is today, nor was the need for it so sharply felt but, nevertheless, they were by no means unaware of its appeal. As the centuries wore on, there was a slow, steady movement by the master and the inner circle of his household towards dining in more intimate quarters, away from the great hall itself except on the most important occasions. Even so, though withdrawn from public view, the master was never truly on his own. He was still a public figure, the focus of attention, with a key role to play in an elaborate ritual. Dinner was brought to him with a ceremonial formality in which every gesture proclaimed his importance and acknowledged his authority.[105] This straitjacket of service was as constricting as it was splendid, and it is no wonder that on the rare occasions in medieval romance when the hero is allowed to relax by himself for a while before joining the company at large, a glow of appreciation warms the lines. Once Gawain has made his painful winter journey to Bercilak's castle, he is welcomed in the most heartening way, swept into a private room, set down beside a roaring fire and served with a delicious supper. For the moment, worries slip away. Gawain stretches out his hands to the blaze and begins to feel better: 'thenne his cher mended'.[106]

Such moments of happy self-indulgence could always be found most easily in a modest setting, far from the constraints of the court. The pleasures are caught in the calendar picture for January in a Flemish Book of Hours, made *c.* 1500,[107] which shows a table laid for a meal, drawn up beside a crackling fire, with husband, wife, small child and bright-eyed dog all seated around it, alert and expectant,

as a promising pie is carried into view.[108] In informal interludes, the members of the party might even try their hands at a little cooking on their own. There are hints of such self-service in the teasing asides about his friends with which Bartolomeo Sacchi the Italian humanist, known to intimates and readers alike as Platina, embellishes two recipes in his *De honesta voluptate et valetudine* (1460). The first is a way to roast eggs in the fire: 'Thrust whole eggs into burning coals, and when they are cooked and removed, cover with parsley and vinegar. My friend Pomponius does not do this because, when he recklessly loses a couple of eggs, he would not have the means to buy others, because of his poverty.' In the second, even simpler set of instructions, Platina explains how to fry eggs, and then ends with this postscript: 'While he is eagerly preparing these, Callimachus makes us laugh, as he clings spellbound to the pan.'[109]

Fun with friends around the fire is one of the incidental pleasures of the domestic scene. To be able to slip off the public mask, lay aside the cares of the outside world and relax over a good meal, cooked to one's liking, these are the true, very considerable comforts of home. Another calendar picture, this one for February, captures their charm. It appears in a French Book of Hours, produced *c.* 1500,[110] and presents the master of the house with his back to the fire, luxuriating in that special moment before he will settle down to dinner on his own at the small table, laid just for him, which has been drawn up close to the blaze.[111] As a thirteenth-century poet, Colin Muset, puts it in one of his *Chansons*, when he comes home with money in his purse, to a warm welcome from his wife and a meal of two capons in a garlic sauce, he feels he is truly master of his own private domain, and happier than he can ever put into words:

> Lors sui de mon ostel sire
> A moult grant joie sans ire
> Plus que nuls ne porroit dire.[112]

5

The Staging of a Feast

And note, my master, that if your cook is not sharp enough, he will never prepare anything good, no matter how good it is to begin with.

Maestro Martino

Backstage

A STAGE-STRUCK enthusiast, permitted to peep behind the scenes, sees many surface details, a coil of ropes, a rack of costumes, a pile of props but, as an outsider, can never hope to grasp the purpose of the random placements, or spot the underlying pattern which gives coherence to the clutter. For much the same reason, those thumbnail sketches of the medieval cook at work which were discussed in Chapter 1 capture the heat, the smoke, the sizzle of meat in pan, the thud of pestle in mortar, the bellowed, bad-tempered commands, but leave the reader at the end no wiser as to how out of such high-pressure confusion any meal, let alone a courtly feast, could be assembled and brought, approximately on time, to table. Written by the uninitiated, they show only the hot kitchen, not the cool head needed to plan a menu and mount a production.

Deference and Diplomacy

THE cook at court was not an artist attentive to his Muse but a servant attendant on his master. Working not alone, as a solo performer, but in concert with many others he was just one, very important, cog in a complicated social machine. It was necessary for

him to deal, on a daily basis, with household officers of a far higher rank than his own, and to defer to their decisions on financial or dietary constraints. The cook was the one held responsible for the success or failure of a meal, but he was not a free agent. Enmeshed in a system, he had to find ways to make that system work to his advantage and help him realize his grand design.

In the planning of any menu, he was expected to take into account not simply the season of the year and the availability of ingredients but also the rules of the Church and its calendar of feasts and fasts, days on which meat was permitted, and days when substitutes had to be found. No matter what the occasion, he always had to bear in mind the personal likes and dislikes of his master, and be braced to cope at a moment's notice with the whims of a guest too important to be over-ruled.

Flexibility was the key to success. No menu plan was set in stone, for the cook's suggested choices could be modified or brushed aside by his superiors. Ways might be found to circumvent their commands; open defiance was out of the question. The successful cook was a diplomat, able to get his own way without ever seeming to forget his station, his place in the pecking order of the household.

Senior officers were not the only people with whom it was advisable for the cook to be on good terms. It was just as important to have a smooth working relationship with his colleagues, those fellow experts who made their own special contributions to the meal. Eustache Deschamps (1346–1407) wrote a play, *Dit des Quatre Offices de l'Ostel du Roy*, on the rivalry between the four great food offices in the royal household: Cookery, Buttery, Pantry and Saucery. Their representatives, hot blooded and bad tempered competitors throughout the action, grudgingly shake hands and make up in the final scene. They have been forced to acknowledge that they need each other. Without collaboration, the show cannot go on.[1]

Organization

PROVISIONS are the nuts and bolts of any meal, but they do not appear by magic at a moment's notice. After planning a menu, the cook's job was to list the ingredients, estimate the amounts required and set in motion the complicated process of gathering them in, on time and in good condition. In the simplified world of story, the cook does the shopping himself. The Earl of Cornwall's cook is first introduced in the thirteenth-century English romance, *Havelok*, not in a smoky kitchen, stirring a stewpot, but down on the quayside in Lincoln, choosing the best fish from the catch of the day.[2] In the real world of the great household, the cook had others to do this for him, but his was the mind which made the calculations and caused the orders to be issued. Organization, indeed, was one of the most important skills which had to be mastered.

It was hard enough to make the arrangements for some run-of-the-mill occasion, but the planning for a major event posed special problems. The scale was vast and the stakes were high. To read the account of the provisions which streamed in to London for the great feast held by Edward I on Whitsunday, 22nd May 1306, the four hundred oxen, the thousand hens, the two thousand eggs and the hundred other items, all in comparably ample quantities,[3] is to realize the need for an ability to see both the big picture and the small details if order was ever to be coaxed out of incipient confusion.

Master Chiquart

WITH a rare stroke of good fortune, one cook's notes on his own approach to such logistical problems have been preserved in *Du fait de cuisine*,[4] the book which he dictated for his master's pleasure. Chiquart Amiczo served Duke Amadeus of Savoy

for well over twenty years, from the start of the fifteenth century, and in 1420 the Duke ordered him to set down a permanent record of his professional experience. For some time before this it had been permissible in sophisticated court circles to show a mild interest in the way everyday jobs were carried out. In 1379, for example, Charles V of France had commissioned a short book on the training and duties of a shepherd, written not by some desk-bound scholar, but by Jean de Brie, an actual, working practitioner of the craft.[5] This fashion may have played some part in the Duke's decision, but the fact that he chose to ask his cook to turn author suggests that he had come to value Chiquart's achievements and to feel at least a stirring of curiosity about the art of cookery and the mysterious skills which created the dishes he enjoyed at his own table.

By 1420, when Chiquart was asked to collect his ideas, long years of experience had taught him the value of forethought and the virtues of informed prudence, planning and preparation. In his calculations of the time required and the quantities needed for any undertaking, he never cuts too close to the bone but makes generous allowance for unexpected setbacks and changes of plan. The prized feature of any feast was not the farm-raised meat but the game and birds which had to be hunted in the wild. These were elusive prey, and in order to guarantee that a sufficient supply could be gathered in to grace a particular occasion, plenty of huntsmen and plenty of time were essential: 'And your purveyors of game should be able, diligent, and foresighted enough to have forty horses to get to various places for deer, hare, rabbits, partridge, pheasants, small birds (whatever they can find of these, without number), whatever sort of game they can get. They should set about this two months or six weeks before the feast, and all of them should bring or send whatever they have been able to get at least three or four days before the feast so that this game can be hung and properly prepared in each case.'[6]

For game, precise numbers were of little use; co-operation from the hunted could not be guaranteed. It was easier to be specific in the order sent to the butcher, but it was always wise to ask for more than the menu required: 'so that, should it happen that the feast lasts longer than is intended, all that is needed will be immediately available'.[7]

Time was of the essence in the actual cooking of a meal: any preparations which could be carried out beforehand would make life a little easier for the kitchen staff, and were to be encouraged. Chiquart recommended that all spices should be ground, and each kind stored separately in a 'good big leather bag', so that when the cook needed, say, nutmeg for a sauce, he had just what he wanted, ready made and ready to hand.[8]

Raw ingredients need heat if they are to be transformed and brought to table as delicious dishes. The catastrophe of a kitchen fire which refused to burn brightly or, even worse, to stay alight long enough to finish its job, was a nightmare to be avoided at all costs. Plans for the fuel supply were quite as vital in the scheme of things as those for the food itself. Chiquart emphasized that arrangements to collect 'cartloads' of wood must be made well ahead of time, and that it was important to inspect the loads and make sure that only 'good, dry' faggots and logs had been selected. As an added safe-guard, it was prudent to find out beforehand where extra supplies of fuel could be found in a hurry: 'You should always know where to get more, so as not to run out.'[9]

However Stygian the gloom of a kitchen in medieval stereotype, in real life it is hard to cook competently when visibility is close to zero. Chiquart underlined the need for candles whenever work had to be done at night or on dark winter days: 'If it should happen that the feast is held in winter, each night for cooking you will need sixty torches, twenty pounds of tallow candles, and sixty pounds of suet

tapers to inspect the butchery, the pastry kitchen, the fish kitchen and all of the activities of the kitchen.'[10]

He understood very well that the work of cooking and of cleaning up was carried out most efficiently with the help of the right equipment, in the right quantities. He ran a tight ship. No detail was too small to escape his eye, no job too humble to be beneath his notice. Besides the 'twenty large frying pans', the 'twenty-five holed spoons' and the 'sixty two-handled pots' which he put on his list of essentials, there had to be as well: 'a half-dozen rasps to clean the work-tables and the chopping-blocks', and 'a hundred baskets for carrying meat to the pots … to carry coal for the roasts … and to carry and to gather the dishes'.[11]

Chiquart paid just as close attention to the conduct of the feast itself, once it was in progress, as to the preparations beforehand. To serve many dishes to many diners in smooth and steady sequence was a challenge. His helpful suggestion was to double the number of serving platters required, so that the second service could follow the first without interruption: 'You must have a great supply of dishes, of gold, silver, pewter and wood … in such quantity that when you have presented the first serving you will have enough for the second serving and still some left over, and in the meantime you can wash and clean the dishes in that first serving.'[12]

Crisis Control

THE ability to foresee and forestall problems was an essential part of a cook's equipment, but it was not enough by itself. Flexibility was just as important. To plan a menu and marshal its materials into place at the right time was taxing even in a settled context. Unfortunately for the cook, the circumstances with which he had to cope rarely stayed constant for long, in one comfortable,

familiar groove. An ability to improvise often had to be called on to save the day. The cook was responsible for producing a feast on a certain date, for a certain occasion, but had no control over last minute changes of plan, made by superiors who had little or no interest in how he solved any particular problem, only a firm insistence that solutions must be found, and found on time.

It has been shown already that Chiquart always took care to make allowances for sudden emergencies. At the back of his mind was the ever-present fear that, for one reason or another, supplies might run out. His estimates were always generous, to ensure that there would be enough to meet any extra demand. As an added precaution, he insists that steps must be taken to find out beforehand where to turn for help in a crisis. Having ordered a certain quantity of flour to be provided for the staff in the pastry kitchen, he notes: 'And they should be sure of being able to get more if the feast should last longer.'[13]

Even with the best will in the world, it was not always possible to gather in enough of any special delicacy to satisfy demand. When that was the case, judicious substitution was called on to smooth away the crisis: 'There should be an ample provision of two hundred cockerels and young poultry ready for serving in case the partridge runs out.'[14]

Important guests posed many problems. Not only could late arrivals upset careful calculations of the number of mouths to be fed, but also they might airily reveal their preferences in diet at the very last moment. The cook must never be caught empty-handed, so it was prudent to be prepared: 'Since there may be very high, mighty, noble, venerable and honoured lords and ladies who will not eat meat, it is necessary to have similar amounts of sea-fish and fresh-water fish, both fresh and salted, and these in as varied preparations as can be.'[15]

Another crisis waiting to happen was the entry on the scene of one or two invalids, each with a diet plan and a personal doctor in tow. Long experience taught Chiquart to brace for the worst. As he remarked, he had learnt to expect that, in any large assembly: 'it would be surprising if there were no sickly or delicate individuals, or none who were affected with infirmities or illness'. Helpfully, he included in his notes advice on: 'how to make and prepare some dishes which are good and refreshing for the sick'.[16]

Difficult guests and their demands might be tiresome but they were manageable. A more serious challenge was presented by the fact that royal courts and noble households did not always stay put in one place. In the course of any normal year the master and at least the core of his retinue might make a progress to several of his properties or even, on occasion, take up temporary residence at a place determined by the politics of the moment. The cook's convenience was not consulted when such decisions were made. He was given his marching orders and expected to put his best foot forward. A trusted lieutenant was deputed to see that those members of the household who were left behind would continue to be fed, while the master cook travelled with an advance party to inspect the chosen site and make sure that sufficient supplies of such essentials as fuel and water were at hand: 'The Household Steward, the Kitchen Squires and the Chief Cook should meet to locate, inspect and organize good, adequate places to carry out the kitchen activities.'[17] When existing local facilities were not up to the demands of the special event, a temporary kitchen had to be built in a hurry. This could prove to be more of a hindrance than a help to a harassed cook. For Edward I's coronation feast in 1273, a wooden kitchen was erected, but inconveniently burst into flames and burnt to the ground.[18]

When the cook drew up his plan of campaign for a series of elaborate feasts in unfamiliar locations, it was imperative for him

to ensure that there would be adequate supplies not just of food, fuel and so on, but of experienced kitchen staff as well. If necessary, cooks already at work in the district had to be rounded up as extra help. Chiquart sounds uncharacteristically vague in his instructions at this point: 'Send someone to look for some [cooks] in places where they can be found, so that the feast can be done in a grand and honourable fashion.'[19] The picture his words paint is of a Help Wanted poster, pinned on every tree and tavern door for miles around, but it is far more likely that the cooks were 'borrowed' for the occasion from suitable households in the neighbourhood. That is what happened when, to help with the wedding festivities for his daughter in August 1417, Robert Waterton of Methley hired three local cooks, one from Lord Scrope of Masham, another from the Prior of Nostell, and a town cook from Wakefield.[20]

Economy and Discipline

T HE ideal feast was imagined as an embodiment of good fellowship. In the seventeenth century, Robert Herrick caught the image's timeless appeal in his *Panegerick to Sir Lewis Pemberton*:

> … all who at thy table seated are,
> Find equall freedom, equall fare.

Generous hospitality was the keynote. In *Sir Gawain and the Green Knight*, each happy pair of diners at King Arthur's Christmas feast found on the table before them a choice of twelve dishes, washed down with 'Good ber and bryght wyn'.[21]

Reality, needless to say, did not measure up exactly to the ideal; its image did not always shine so brightly nor glow so warmly in the heart. It was only too obvious that what was served at high table and shared with favoured guests was decidedly different, in both

quality and quantity, from what was placed before the rank and file. Fortunately, the principle of hierarchy was so engrained in medieval minds that acceptance held resentment in check. In the fourteenth-century debate poem, *Wynnere and Wastoure*, Winner bitterly remarks that the only bird ever offered to him in hall is one of the hens last seen scratching in the back yard, while he watches with envy as an endless procession of huntsmen's trophies makes its stately way to high table: 'basted birds broach'd on a spit ... Woodcocks and woodpeckers, full warm and hot.'[22] Even so, these were resigned grumbles. This was the way things were, and always had been. The dream, for everybody, was not to level the playing field but to climb the ladder and enjoy the rewards of a perch on a higher rung.

Great feasts cost money. The cook, in consequence, was expected to put on a splendid show while at the same time to trim expenses wherever a corner could be cut. As Winner's envious outburst reveals, there was never any question of the whole company sharing the whole menu. The most luxurious dishes were reserved for the most important people present. Even for those in the charmed circle of privilege there were careful gradations in the actual amounts offered to each person. Rank had its own distinct advantages, as Chiquart demonstrates in his notes on a partridge recipe: 'Take all the roast partridge you have to the dressing table and the Household Stewards will come to decide how many of them are to be put on each dish to serve kings, dukes, counts – for example, six partridges on one dish, five on another, four on another, and three on another.'[23] At the court of Edward IV in England, crisp sweet wafers were served every day to the king, the most senior members of his household and the most important visitors. Only at Christmas, Easter and Whitsun, the principal feasts of the year, was the rule relaxed, and: 'other lower officers more generall' allowed to share the privilege of enjoying those delectable little confections.[24]

Behind the scenes the cook, and all the other senior officers in the kitchen quarters, had to keep a sharp eye out for ways to save, recycle and cut down on waste of every kind. No detail was too small to escape the notice of those who laid down the rules for Edward IV's household. It was the custom to trim away the crust from the slices of bread which were set before the king at table. Because the servant who did the job was allowed to keep the trimmings as part of his wages, it was decreed that he must be watched, to make sure that he did not cut off with the crusts too much of the precious crumb itself. In the same book of regulations there were also strict instructions that, once it had become no longer possible for even the most robust and resourceful laundress to scrub out the tell-tale mementos of a hundred fine feasts, the sullied tablecloths were not to be thrown aside but cut up and passed down to the scullery and the pitcher house: 'to wipe and kepe cuppis clene'.[25]

The by-products of all the joints of meat in the kitchen could also be put to good use. As noted already, candles had to be used whenever the cooking crew was forced to work at night. For this purpose Chiquart recommended candles made not from fine beeswax but from suet and tallow. It would be an unnecessary extravagance to buy these from an outside supplier, because they could be made more cheaply on the premises, with fat stripped from carcasses and rendered down. Indeed, rather than spending money on such useful, humble products, a noble household often made a little extra income for itself by selling its surplus to eager local customers.[26]

Well-scrubbed surfaces and well-swept floors added their own contribution to economy, because they helped to cut the amount of food lost to spoilage. In Edward IV's bakehouse, records were kept of supplies made unusable by careless handling and dirty conditions: 'wasting of floure, some etyn by byrdes, some wasshen by waters, … some brede all to brokyn and etyn with rattes or suche other

causes'.[27] Chiquart himself was insistent that attention must be paid to hygiene, and reminders crop up again and again in his recipes: 'take a good earthenware pot, very clean', 'chop with a small, clean knife', 'crush in a mortar that has no garlic odour', 'remove them to a nice clean surface'.[28] Regrettably, not every cook felt the need to rise to this level. Slovenliness could have expensive consequences, like those revealed in a report on conditions in the royal kitchen during the reign of Henry III. In June 1260, payment had to be made for the building of: 'a certain conduit through which the refuse of the king's kitchens at Westminster flows into the Thames; which conduit the king ordered to be made on account of the stink of the dirty water which was carried through his halls, which was wont to affect the health of the people frequenting the same halls'.[29]

The Making of a Master

THE senior cook in a royal or noble household was, quite clearly, a man of many parts. The training which produced such a paragon remains today, however, something of a mystery, for there is frustratingly little to be found in the record. One reason why Chiquart's remarks are precious is that it is so rare for a medieval cook to set down his reflections on the page. Most were content to let their skills speak for themselves and to reveal their mastery in results, not in words, like those seventeenth-century shipwrights described by Pepys as inarticulate men with 'their knowledge lying in their hands confusedly'.[30]

Official records of professional cooks' guilds date back to the mid-thirteenth century in Paris and the early fourteenth century in London;[31] the rules of these fraternities seem intended to govern the practice of street cooks, in towns, rather than that of cooks in private households. There is some evidence to suggest the possibility

of cross-over movement between the two kinds of job. In Paris, regulations allowed a cook in the royal kitchen to transfer, and enter the Cooks' Guild of the city at the same rank he had held at court; it seems not unlikely that it was just as acceptable to move in reverse, and go from town to court.[32] On the other side of the Channel, John Bec, the Duke of Bedford's master cook in 1421, held in the same year the title of master in London's Cooks' and Pastelers' Company.[33]

Most household cooks probably started their career as boy apprentices in the kitchen, and worked their way up in the school of hard knocks, with painfully acquired hands-on experience. This was certainly the case for Taillevent, the most famous chef in the Middle Ages. Listed in 1326 as a 'child of the kitchen' in the service of Jeanne d'Evreux, wife of King Charles le Bel, he scaled the heights and became master cook to Charles V and Charles VI. By the time he died, *c.* 1395, he had been granted not merely a handsome pension but the right to his own coat of arms.[34]

What a steep, hard climb it must have been, up to the very peak where Taillevent and Chiquart basked in the sunshine of their masters' favour, from the cuffs and contempt faced by the kitchen boys as the lowest of the low, on the bottom rung of the ladder. In Malory's 'Tale of Sir Gareth of Orkney', Sir Gareth's adventures at King Arthur's court get off to a mortifying start when he is hustled away to work as an extra hand in the kitchen quarters. To add insult to injury, he is then taunted by the very lady whose champion he has sworn to be: 'What art thou then but … a turner of brochis [spits], and a ladyll-waysher?'[35]

Ground Rules

THE cook's job was to set before his master and the assembled company a feast whose rich variety would create an atmosphere of luxury and heightened well-being, of life lived to the hilt. Expansive ease was the impression to be aimed for, but the menu itself was pinched into shape by certain constraining imperatives. When the date chosen for the feast fell on one of the many fast days of the year, the dietary rules had to be observed, with fish taking the place of meat, substitutes found for dairy products, and so on. Chiquart offers as an example two matched menus, one for a meat day and one for a fast.[36] Great care has been taken to ensure that the two are equally ample, equally sumptuous. A fast day feast was expected to be a challenge for the cook, not a penance for the diner. Ingenuity and imagination were required. It seems strangely appropriate that, hundreds of years later, the surname of one of the nineteenth century's most daring and creative chefs was Carême ('Lent').

Whatever its ingredients, the feast was, in theory, offered for the delight of everybody present, but the cook could never allow himself to forget that in fact there was only one palate which had to be entirely pleased, and that was his master's. Little notes to this effect are scattered here and there throughout Chiquart's book, and often appear in the collection of recipes compiled by another remarkable cook, Maestro Martino, who earned his reputation while working for Cardinal Trevisan and at the ducal court in Milan, in the mid-fifteenth century. In one of his marzipan recipes, for example, he qualifies the line: 'then take a glass of rose-water and a little verjuice', with the caution: 'as suits your patron's tastes'.[37]

Necessary as it was to respect one's masters whims, it was even more important to pay attention to the dictates of his physicians

about the diet which they had custom-tailored to suit his consti-
tution. They laid down the ground rules; it was left to the cook to
make that diet delightful, and metamorphose medicine into mouth-
watering indulgence.

Medicine at Mealtimes

I N sophisticated circles of the later medieval period, the matter of
health had become a fashionable preoccupation. No longer was
it enough to eat heartily, as in those bad old days, lost in the mists
of time, when the 'King Hardeknout' described in the preface to the
Household Book of Edward IV kept a magnificent table, gorged
to his heart's content and then, after a reign of: 'but ii yeres except
x dayis', dropped dead while: 'drinking at Lambethe'.[38] The time was
ripe for a sterner regime of doctors and diets. The most respected
recipes came with an official seal of approval, like those in the late
fourteenth-century collection entitled *Forme of Cury*, which was
compiled by 'the chef Maister Cokes of Kyng Richard the Secunde
kyng of Englond', with the 'assent and avysement of Maisters [of]
phisik and of philosophie that dwellid in his court'.[39]

Worries about health and diet in any age lead to much anxious
consultation with doctors. In the fourteenth and the fifteenth centu-
ries, anyone who was anybody seems to have had a personal physi-
cian who not only took up residence in his patron's household but
also travelled with him, always close at hand and on call, ready to
give advice and provide medicines wherever that master happened
to be.

Potions and pills may contain dangerous ingredients, so the
making up of the mixture can be hazardous, especially when done in
unfamiliar surroundings. More than one payment had to be sent to
disgruntled citizens by the royal accounting office, in compensation

for the loss of a house which had been destroyed while a court physician was in lodging there. Nicholas de Winterburn of Devizes was mollified with money in October 1301, after his house had gone up in flames on a day when Master Ralph, doctor to the two baby sons of Edward I, was in temporary residence.[40]

Bitter experience might teach the householder to be wary of doctors, but there was always the hope that the dreaded visitors would never come to call. For the cook there was no such possibility of escape. He had to cope every day with the physicians' recommendations about his master's diet, and learn to adjust the menu accordingly. Chiquart's recipes are peppered with warning reminders. At one point he suggests that parsley and a little sage may be added to a dish of peas, and then cautions: 'Don't put in anything else without the doctor's orders; if he should say that a little cinnamon be put in, and a little verjuice, to give it flavour, then put some in; otherwise no.' For a chicken dish, he adds: 'Ask the doctor whether the cook should put in any white ginger.'[41]

The theories on which the doctors based their advice were by no means brand-new. They were very old, with a lifeline which stretched back into classical antiquity.[42] In essence, it was taught that everything in the world was made from four elements: fire, earth, air and water. Each had characteristic qualities: hot and dry, cold and dry, hot and moist, cold and moist. Combined in an infinite variety of ways, these created the 'humour' or temperament of the individual subject. Four humours in the form of fluids flowed within the body of every man and woman: choler (yellow bile), melancholy (black bile), blood and phlegm. Ideally, these were held in perfect balance, but in reality they were combined in different proportions, and gave to each person a defining 'complexion'. The choleric man tended to be hot-tempered, aggressive: the melancholy woman inclined to sullenness and gloom. Everything that humans ate, whether lettuce,

lamb or lentil, also had its own special character. Fish were cold and moist, like the water in which they swam; vegetables sprang from the earth, so a salad green, though damp to the touch, was officially characterized as dry.

The challenge for the cook was twofold. First, he had to choose a dish which would counterbalance his master's idiosyncratic condition. The choleric needed something to calm them down; the melancholy something to cheer them up. His second task was to modify the nature of the chosen dish itself with appropriate adjustments. Seasoning or sauce was added, to temper the character of the main ingredient. Pepper might be paired with fish, for example, so that the hot, dry properties of the one could complement the cold, moist properties of the other.

An unfamiliar theory, set down on paper, can seem very confusing, but a theory which is part of the mental landscape of its time may be readily grasped, with intuition if not with conscious reason. A trained medieval cook knew through instinct, experience and custom what sauces were considered appropriate in which context, what cooking technique was best suited to which ingredient and so, without a second thought, he would reach for his frying pan to fry something whose nature was moist, and for his stewpot to simmer something correspondingly dry.

Naturally enough, the benefits of such customized cooking could be enjoyed only by a select few, the master and his circle of favoured intimates and valued guests. The rest of the company had to set aside the refinements of theory and make the best of whatever happened to be placed before them. The prudent cook, however, kept on hand a selection of all-purpose dishes which might help to comfort anyone (at least among the privileged) who was feeling a little under the weather. Chiquart lists several possibilities, like stewed apples, which were all guaranteed to do no positive harm even to the most

delicate constitution.[43] Many of these recipes include the note: 'put in a good deal of sugar'. Sugar, adored by everyone lucky enough to taste it, had been found, most fortunately, to have impeccable medical credentials, and so its presence added potency as well as pleasure to any diet.

However soothing and simple the ingredients of these recipes for invalids, whether for barley soup or baked pears, Chiquart insists that each prepared item must be served in a beautiful container, preferably one made of precious metal: 'when they are cooked, put them out into fine silver dishes'; 'put it into fine gold or silver bowls'. Chiquart and his contemporaries knew that it was not merely pleasing but appropriate to do so, because the nature of such noble materials matched that of the noble invalids.

Staging the Show

Characteristics and Cross-Currents

IMPERATIVE as it was for the cook to please his master's palate and pay attention to his state of health, it was just as important to make in his name a feast which would do him honour in the eyes of the assembled company. Splendour of presentation was one of the defining features of such an event.

Food itself, though essential to the plan, was only one element in the staging of the affair. Ceremonial and the rituals of service had their parts to play; fine linens and handsome tableware lent their own lustre to the scene. Dignity, decorum and magnificence raised the tone. Dishes prepared in the kitchen had to be deemed worthy of the occasion when they were presented at table.

The rules of courtesy which shaped the conduct of a courtly feast echoed those observed in a religious establishment. Reverence was

paid to the presiding figure of authority, whether abbot, bishop or lord; the monastic ideals of seemliness in table manners and consideration for fellow diners were praised, if not always followed to the letter, in secular households. However enjoyably luxurious a feast might be for its privileged participants, the Church's teachings on the paramount importance of charity were honoured. It was never entirely forgotten that the bounty must be shared with the less fortunate. A sampling of leftovers was ceremonially collected by one household officer, the almoner, and heaped on a special plate which was presented to the master for his approval, before being carried off and distributed to the poor and the sick: 'Then shall the amener go to the lordes borde and take of dyverse metes as it may goodly be forborne and augment therwyth the almes dyshe, and all this in the lordes presence.'[44] Occasional grumbles about the practice bubble to the surface. Henry Grosmont, Duke of Lancaster, confessed in his spiritual self-examination that he rather resented the sight of all the rich foods he loved being wasted on the blunted palates of the poor.[45] From time to time, there was even hopeful speculation as to whether the nourishing of a swarm of rich but very hungry visitors might be judged an act of mercy in the same spiritual league as the feeding of the destitute.[46] In such a situation it was surely the host who was most in need of a little life-support.

Nevertheless, whatever private jokes and reservations there may have been, the filling of the alms dish had a part to play in any proper feast, and it was never cut out of the production. In consequence, the cook had to bear this in mind when calculating his quantities, to make sure that there was abundance for the guests and an ample supply of leftovers for the needy, Both kinds of generosity were seen as reflections of his master's magnanimity.

Just as the discipline and decorum of courtly feasts were modelled on ecclesiastical examples, so the princes of the Church felt no

compunction about enjoying the luxuries which graced the tables of their secular counterparts. Abbots and bishops had their own master cooks and private kitchens, and sampled richer, more refined dishes than those prepared for the less important members of their households. Gerald of Wales, in the late twelfth century, dined one day at the Prior of Canterbury's table, and marvelled at the variety of the menu. There were so many kinds of fish, cooked in a dozen different ways, and: 'so many dishes contrived with eggs and pepper by dexterous cooks, so many flavourings and condiments, compounded with like dexterity to tickle gluttony and awaken appetite'.[47]

Churchmen and laity shared a taste for the trimmings of a feast, the tableware which set the stage for the event. Indeed, there are distinct similarities in style between the design of certain important pieces made for secular use and that for ecclesiastical vessels. The covered cup presented to the master of the household looked remarkably like a chalice, his spice dish like a paten. When paying reverence, whether to God or mortal patron, it was a universally accepted mark of respect to offer up the finest materials, the finest craftsmanship. It is entirely fitting that two saints, Dunstan and Eloi, were goldsmiths, and masters of their craft. Because only the best was good enough, the cook was expected to demonstrate a comparable mastery in his own contribution to the grandeur of the occasion.

Spectacle

No feast could begin until the cooks had done their work. They were key players, and the importance of their role is acknowledged in one quiet stage direction in a fifteenth-century courtesy book. The tables have been laid, the diners seated, the officers of the household with parts to play in the production have taken their

places. There is a sense of occasion, of rising expectation, of a gathering wave about to crest. In this pause, the senior officer sends a messenger to the kitchen: 'to awayte when the cokes be redye'.[48] Only after he has received the signal to go ahead is his master informed that everything is in order and the show can be set in motion.

As we have seen, a feast was the sum of many parts, and its aim was to satisfy many senses. The creations which the cook sent to table were not judged in isolation but in context. They had to reach the same high level of theatre and spectacle achieved by rival contributions to the festivities. In such a situation, 'humble but wholesome' was not the slogan for success. For a few hours, the banal, everyday act of eating was charged with excitement by the magic of stagecraft. Henry Grosmont admitted that a great feast over-stimulated his senses, for every part of it was a distracting temptation. His mind loved the gossip before and after the event, his nose enjoyed the delicious smells, his eyes were dazzled by the setting, the decorations, the look of every dish.[49]

The visual appeal of the food set on the table had to compete for applause with the drama of action and gesture in the ceremony of service. Carving at high table, for example, was a spectator sport, in which the way the carver handled his tools was appraised by knowledgeable, unkindly critical eyes. He had to meet every challenge, know how to carve any creature, from heron to beaver, how to cut delicate, bite-sized portions, lay them in precise patterns on a plate, spoon on the appropriate sauce, present the finished dish in the correct manner to his lord, and then repeat the process for each of those deemed worthy to be honoured with such attentions. Carving was an art which demanded great skill. There was a world of difference, in perception as well as presentation, between the finely sliced portion, cut from the best part of the meat, and the slab of fat and gristle which someone low on the social scale might

be unlucky enough to face on his trencher. Dexterity alone was not enough; there was a need for diplomacy as well. Not every guest was easy to please, and the ladies were notoriously hard to handle: 'Then carve the meat carefully for your lord or lady, and specially for ladies, for they become angry and changeable quickly. Some lords are easily pleased and some are not, depending on temperament.'[50] Absolute concentration was required, for knives were sharp and mistakes were mocked. In the fourteenth-century romance, *Jehan et Blonde*, the hero brings shame on himself with a self-inflicted wound. Lost in daydreams as he carves before the lady he loves, he lets his knife slip, cuts himself badly, and has to be hurried away, covered in blood and confusion.[51]

The drama in the serving of the meat was matched by the visual excitement which grand goblets and handsome platters contributed to the occasion. In their taste for precious metals, medieval connoisseurs joined hands across the centuries with Henry James, who was once heard to murmur as he entered a particularly luxurious room: 'I find one can never have too much gold.' Gold and silver pieces embodied the very idea of magnificence; they were prized possessions, proudly displayed. A calendar picture for January in the early fifteenth-century manuscript, the *De Buz Book of Hours*,[52] shows a servant busy with preparations for the feast ahead, polishing a large round charger.[53]

To vie with such splendour, cooks sometimes added their own finishing touch of gold to a dish, using foil to trim a plate or a piecrust, or to highlight one feature by gilding the claw of a peacock, the beak of a swan. Instructions on how to cover walnut kernels with foil survive in a fifteenth-century recipe. The first steps, to wet a kernel, stick a pin in it and then hold it in one hand seem clear enough, but the climactic stage is shrouded from view. The reader is told to apply gold foil to the kernel with the other hand, by using: 'a thyng

made therfore'.[54] With this exasperating reluctance to name names, the anonymous writer lets the ingenious device slip through the web of words, to be lost beyond recall.

Colour and Pattern

GOLD, the very symbol of nobility, was a favourite colour, chosen by cooks to catch every eye. The use of foil was by no means the only way to achieve the desired effect. A chicken, for example, might be roasted and then, in the last stage of the process, 'endored', brushed with a mixture of egg yolk and saffron to burnish the skin and make it gleam. Threads of saffron, steeped in liquid, release a beautifully rich, deep colour, but saffron was so expensive that it was prudent to have on hand a cheaper substitute. Maestro Martino recommended the petals of the broom plant: 'make it yellow with saffron – which can also be done with broom flowers'.[55]

Strong colour contrasts added visual excitement to any dish. In his menu for a sumptuous fish dinner on a fast day, Chiquart specifies that the shimmering white fish should be displayed on 'great gold dishes', and garnished with slices of orange or spoonfuls of bright green herb sauce.[56] Simple, striking effects were achieved by dividing a mound of cooked rice into three, and then leaving one part white, colouring the second green with chopped herbs and the third yellow with saffron. Even a plain-roasted boar's head, when carried with sufficient ceremony into the hall, was a spectacular entertainment for the assembled company. Glazed and decorated with stripes of bold colour, it became a showpiece. Chiquart gives careful instructions on how to paint the roasted head with brush strokes of gold and green. The gold effect was achieved with a blend of egg yolks and wheat flour, with some saffron to enhance the colour. If the use of yolks alone makes the consistency too stiff, he recommends the

addition of 'whole eggs to thin out the mixture'. The green colour was made from a mixture of egg whites, wheat flour and ground parsley. Once the paint work had been done, the head was ready for the grace-notes, the brilliant highlights of gilding which would complete the transformation of handsome head into heraldic mask. At this point in his instructions, as he does again and again throughout the book, Chiquart shows a fastidious insistence on cleanliness and order. After the glazing has been completed, he says, the head is to be set down: 'on a good, immaculately clean work table to dry', there to await the arrival of the court painters who will do the gilding.[57] This collaboration between court painters and court cooks is significant. Regarded as fellow craftsmen, they were expected to reach comparable heights of excellence in their own kinds of expertise, to pool their skills in the creation of an ephemeral entertainment, a work of art worthy of a great occasion.

The visible triumph of art over nature kindled the medieval imagination. A rainbow of coloured sauces, 'sauces de diverse taincture', is featured on the table of the villain in *Le Tyran*, a poem by Pierre d'Ailly (1350–1420), Chancellor of the University of Paris.[58] Though deplored by moralists like d'Ailly as sure signs of moral depravity and monstrous self-indulgence, such delicacies were regarded by mere mortals in the courtly world as highly desirable examples of elegant artifice. Meat and fish jellies, shining on gold and silver plates, were beautiful enough in their natural state, but thought to be even more enchanting when given a colour not their own. Maestro Martino provides clear instructions on how to achieve the desired effect by adding appropriate colouring agents to the basic broth while it is still warm and liquid: saffron for yellow, 'cornel cherries' for red, 'green wheat or barley shoots together with some well-crushed parsley' for green. To make even the most jaded spectator sit up and take notice, it was entirely possible for an expert to create not

merely a selection of one-colour jellies but a chequerboard of con-
trasts, in which segments of different colours were arranged side by
side, in eye-catching patterns, each piece of the mosaic distinct and
separate with no unfortunate seepage from one to the other. Ever-
helpful, Martino explains how to achieve the effect. Once a jelly has
set, he says, cut out a square from it and slide into the empty space
a square of the same size, cut from a jelly of another colour which is
already cold, firm, and easy to handle: 'You can make this dish using
as many colours as you wish.'[59]

Imitation and Illusion

THE production of multi-coloured jellies was by no means the
only surprise that a conjuror-cook kept up his sleeve. Medieval
men and women, by and large, had a decided partiality for puzzle
jokes, and all the artists whose contributions helped to turn a feast
into an entertainment did their best to amuse them. Liquids might
be brought to table, not in an everyday jug but in that splendid
container-in-disguise, the aquamanile, its function hidden under the
form of a lion, a dragon with a serpent for its handle, a knight on
horseback. Alternatively, the container might be familiar in form but
strange in behaviour, a jug which held its contents safely and poured
them out smoothly, with not a drop spilt, even while it was plain to
every baffled observer that its sides were fretted with large holes.[60]

Cooks rose to the same challenge, and matched the ingenuity of
potters and metal workers with tricks of their own trade. To brighten
the menu on a fast day, when meat and dairy products had to be set
aside, they could contrive an endless series of imitation indulgences,
from mock eggs to mock bacon, each made from blamelessly correct
ingredients, but fashioned to look like one of the forbidden plea-
sures. To add an extra touch of realism, a mould was used sometimes

to contour the mixture into an instantly recognizable form. When Maestro Martino made fish-shaped fritters, he patted the mixture into: 'some wooden moulds that have been carved in the shape of fish of different qualities and in different manners, as you like, and use them to shape the dough with its filling'.[61]

Mock fish, eggs and bacon slices, though amusing enough in their way, were routine productions. A gifted artist, on occasion, could create far more dazzling effects. Indulgent smiles must surely have changed to gasps of amazement when one of Maestro Martino's special party pieces was presented. Disdaining imitation, he took a living, breathing fish and set it to swim serenely in a sea of jelly. Considerate as always, he explains to his readers how to achieve the illusion. A narrow tube, closed at one end with some 'hard dough', is to be placed in a clear-sided bowl, which is then filled with liquid jelly. Once that has set firmly, water is poured carefully into the tube, 'making sure that it does not overflow'. After that: 'put some small fish inside, as small as the hole (the mouth of the tube)', and then, with a flourish: 'you can send it as a gift to anyone you wish'. As Martino remarks while describing an even more elaborate deception, for such sleights of hand: 'the cook must be neither a madman nor a simpleton, but he must have a great brain'.[62]

One of Martino's most ambitious entertainments was his 'Flying Pie', brought in, set on the table and ceremoniously sliced open. As the first wedge of crust was cut and laid aside, a flock of live birds burst through the gap and wheeled around the room: 'This is done to amuse your company.'[63] Another spectacular, though less original, centre-piece was the roast peacock dressed in its own handsome plumage which Chiquart prepared for the Duke of Savoy.[64] This picturesque bird was a traditional favourite, and made its stately appearance on many grand occasions. A scene engraved on the Braunche brass (1364) in St Margaret's church in King's Lynn,

Norfolk, shows a peacock being presented at high table as minstrels play and guests applaud.[65]

However excited by such flights of fancy, the wise cook always tempered creativity with caution. It was imperative to keep in mind that his job was to please his master, not to indulge his own genius. Chiquart, in his instructions on how to roast and dress the peacock, acknowledges the inconvenient truth that, while magnificent in appearance, the peacock was a tough bird to chew. His answer to the problem was both ingenious and diplomatic. He roasted two birds at the same time, the peacock with a far more succulent goose, and afterwards dressed the goose in the peacock's feathers. The pretender in all its finery was then presented to the master, with an instant explanation: 'Then let your lord know about your fraud with the peacock and let him order whatever it is his pleasure to do about it.' In this way, no matter what the master's choice might be, there would be no crisis, because both peacock and goose were cooked and ready to be served at a moment's notice. Frank disclosure would disarm criticism; deception, if detected, might lead to undesirable consequences. 'We are not amused' was a sentence with a cutting edge when it issued from the mouth of a medieval sovereign lord.

Maestro Martino was another cook who understood very well the havoc wrought by a joke which goes astray. In the case of the 'Flying Pie', he realized that while the spectators would laugh and applaud the surprise itself as the pie was opened and the birds whirled out, the burst of excitement might then be clouded with disappointment and grumbles of discontent, when it sank in that the glorious, gigantic pie was in fact a sham, a hollow mockery with nothing left inside to set teeth into and enjoy. Martino's very sensible solution was to bake a smaller pie, packed with good things, and place this inside the empty shell, ready to be pulled out as soon as the birds had flown off and the laughter died down. Then: 'in order that they (the diners)

do not remain disappointed, cut the small pie up and serve'. Helpful as always, Martino takes his readers step by step through the process. A large pie case is formed, and filled with flour to hold its walls in place while it is baked. Once it has cooled down, a hole is cut from the bottom crust and the flour emptied out. The small pie is then inserted through that hole, the birds are packed in around the pie, and the whole creation is carried off to the dining hall for its moment in the spotlight.

Sotelty and Stagecraft

FROM time to time, a feast's stately progress was punctuated by the entry and display of very special table decorations. Known as 'entremets' or 'sotelties', these were, in their simplest form, single figures or objects, brought on in the intervals between courses, or at the conclusion of the meal. At the enthronement feast for the Bishop of Salisbury, in 1417, there were three courses and three sotelties, an Agnus Dei, a leopard and an eagle.[66] A far more ambitious tableau, with scenery and many figures, was constructed for the feast honouring Archbishop Wareham when he became Chancellor of Oxford University in 1503. Eight towers representing the university encircled the figure of the chancellor, flanked by learned scholars, as he knelt to present four Latin tributes to the king.[67] On many occasions the sotelty was offered simply as an entertainment, to amuse or impress, but on some it was designed to convey a message. At the coronation feast for Henry VI in Westminster Hall, on 6th November 1429, a sequence of sotelties drove home the political point that Henry was to be accepted not merely as the King of England but as the legitimate heir to another throne as well. One scene showed him being presented to the Virgin Mary by two sponsors, St George of England and St Denis of France.[68]

In the building of these decorations, any material might be pressed into service to produce the desired effect, whether wood, silk or plaster. Wax was often used, and so were two edible materials, marzipan which could be modelled by hand, and concentrated sugar syrup, which was poured into a mould of the required shape. One such mould (*c.* 1500), of terracotta, made to represent St Catherine with her emblem, a wheel, is now in the Museum of London.[69] This particular example is small, and may have been used to make votive offerings for devotional purposes. Sotelties, whose whole purpose was to impress and catch the eye, were often imposing in size. At the enthronement feast for the Archbishop of Canterbury in 1504, three elaborate tableaux, each with many figures and built from plaster and wood, were so large and heavy that they had to be carried in to the hall on three separate boards.[70] Whatever the materials chosen for the underlying structure of the sotelty might be, the object once built was made brilliant and beautiful with any number of finishing touches. It might be painted and gilded, hung with jewels, garlanded with flowers, draped in rich fabric.

Many kinds of craftsmen, from painters to carpenters, were called on to help; cooks, the masters of illusion and presentation, had their own part to play. Indeed, because it was well known that they could create special effects, they were at times ordered to provide the props needed for other forms of courtly stagecraft. When Henry VII made his ceremonial entry into the city of York, in April 1486, he was welcomed with entertainments as he rode through the streets. At one point he was greeted with a shower of sugar comfits, formed to look like hailstones, and a matching one of wafers representing snow-flakes.[71] A record of cook as architect is preserved in the touching story of the castle which was put together in 1290 by Master John Brodeye, cook to the prince who was to become Edward II. Built to amuse a little boy of six, it so charmed all who saw it that it was

carried off and used as a table decoration at the wedding feast for Edward's sister, Princess Margaret.[72]

Significant events, whether royal weddings or diplomatic treaties, were celebrated at medieval courts with ceremonial entertainments. On such great occasions, the aim was to transform the known, familiar world of everyday actions and ambitions, to transmute the prose of real life into the poetry of life's ideal model. The staging of the show required the services of many experts, from the artists who painted the banners to the tailors who stitched the household liveries. The programme of events might be built from a variety of parts, but feasting always played the central role. With sleight of hand and practised skills a master cook was equipped to take his place in the team and make a major contribution. At Bruges, in 1468, the marriage of another Princess Margaret, this one the youngest sister of Edward IV of England, to Charles the Bold, Duke of Burgundy, was welcomed with days of feasting and festivities. When it was all over, the cooks and their colleagues must have dropped into bed, worn out but well pleased because, quite clearly, they had worked their magic and cast a potent spell. The interlude had been so dazzling that even John Paston III, son of a hard-headed family rarely moved to easy rapture, could find no other way to describe the atmosphere, in the letter he wrote home to his mother on 8th July, than by comparing it to that of romance: 'I herd never of non lyek to it save Kyng Artourys cort.'[73]

6

On the Edge: the Cook in Art

The cook (with) … his longe ladel.

Chaucer, *The Knight's Tale*, l. 2020

The Challenge

THOSE rash enough to set forth in search of cooks in medieval art must pick their way around the twin barriers which block the path, labelled respectively Too Little and Too Much. On the one hand, there is a scarcity of material; not many formal, full-blown representations of cooks, or their kitchens, were ever made. The daily effort to set food on the table was rarely recorded in art which was devoted, by and large, either to the embodiment of spiritual truths or to the celebration of great rulers and great deeds. A rare exception to this fact of life is in the Bayeux Tapestry, where the scene in which William the Conqueror's cooks prepare a meal after the landing at Pevensey is given equal weight with that of every other episode which goes before or follows after as the story unfolds.[1]

On the other hand, there is excess. All too many tiny details of kitchen practice and kitchen equipment lie in wait as trophies for the sharp-eyed hunter. The challenge is to spot them, for they lurk half-hidden in the most unlikely places. There is never a guarantee that any particular kind of context will yield treasure, but always just the sporting chance that a prospector on a lucky day may strike gold. A handful of examples will show what can be caught when the net is cast wide.

Scattered Sightings

STILL standing today in the city of Bourges is the luxurious house which Jacques Cœur, the great French merchant, built for himself in the mid-fifteenth century, as a monument to his success and good fortune. Descriptions of its marvels often mention the lifelike little figures, sculpted in stone, which peep out of windows over the main entrance to watch the passers-by below. What is not spoken of so frequently is that, deep within the private quarters of the house and far from public view, other little figures have been carved over the doorway into the kitchen, each one busy for ever with a daily task: a man pounds spices in a mortar, a woman washes a basin, a boy turns a spit.[2]

At times, some kitchen detail is hidden in plain view, one of a hundred touches in the exuberant decoration of a manuscript page. Amongst the many hybrid creatures in the borders of the early fourteenth-century Ormesby Psalter is a pair of warriors, locked in battle (Fig. 1).[3] Jousting champions are two a penny in this English production, and so at first the eye finds nothing strange about the fight itself. A second glance, however, notes that there is something very odd about the choice of weapons for the fray. One combatant is armed with a formidable kitchen knife, while

Fig. 1 Kitchen knights in combat. The Ormesby Psalter, English, early fourteenth century. Bodleian Library, University of Oxford, MS 366, fol. 109r.

the other protects himself with a shield improvised from a cook-ing-pot, and is poised to thrust at the foe not with a lance but a ladle.

On an earlier page of this psalter (fol. 24), a man has tucked a bellows under his chin, and is coaxing a tune out of it with a pair of fire-tongs. In a Flemish psalter,[4] made near Ghent at about the same time, there is another musician who has sought inspiration in the kitchen. His fiddle is made from a grid-iron, his bow is a pair of tongs, and the hat he has unwisely decided to wear for the per-formance is a cooking-pot so large that it has engulfed his head and slipped down over his eyes.[5]

Just as enterprising artists could find a hundred different ways to slip a piece of kitchen equipment into a design, so they rose with relish to the challenge of placing unlikely cooks in improbable set-tings. In Manchester Cathedral there is a misericord, carved in the early sixteenth century,[6] which shows a fantasy reversal of the nat-ural order, a sweet revenge for a traditional victim. Hares are the cooks here, in a bustle of preparations for a special feast. They are simmering a hound in a stewpot, while the hated enemy, the hunts-man himself, has been trussed on a spit, to be slow-roasted over a hot fire.

Kitchen equipment may be treated, at times, in isolation, with each piece presented as an object to be studied for itself, set against a blank, featureless background. In an early Tudor pattern book, made c. 1520–30 by a Flemish artist working in England,[7] one page shows bold, stylized illustrations of foxgloves and fennel. The empty space below these specimens selected from the natural world has been used to display a group of household objects: a basting spoon (with a lip for easy pouring), a pestle, a spit, each one meticulously recorded (Fig. 2). The border of another page offers for the viewer's inspection one salt-box and a broom.[8]

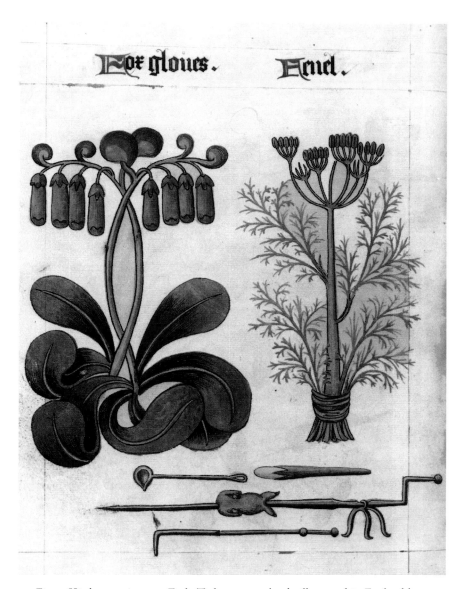

Fig. 2 Kitchen equipment. Early Tudor pattern book, illustrated in England by a Flemish artist, *c.* 1520–30. Bodleian Library, University of Oxford, MS Ashmole 1504, plate 11.

167

These objects, in this manuscript, float free, placed by the artist in no other context than a blank space begging to be filled. Other pieces of kitchen paraphernalia wait to be found in distractingly crowded settings. In Melchior Broederlam's *Flight into Egypt,* one wing of a retable which he painted *c.* 1393–7,[9] Mary and the baby are escorted on the long journey by Joseph, their loving, protective guardian. He walks beside them, loaded with useful provisions. Slung over his shoulder on a carrying-pole is the one essential piece of equipment needed to produce a hot meal at a roadside stop: a small, versatile cooking-pot, made both with legs and a handle, so that it could be set to stand in the heart of a fire or hung over the flames.[10]

High up on the stone vaulting inside Norwich Cathedral is a roof boss, carved in the late fifteenth century, which shows another staple of the medieval kitchen, a large mortar, in which one man is pounding something with a massive pestle.[11] The sculpture itself cannot tell us what is inside that mortar, but its context can. This particular boss is one in a series which highlights significant stages in the story of the Passion. The man has been caught in the act of crushing gall, the ingredient which was about to be mixed with vinegar and made into a bitter brew for Jesus to drink at the Crucifixion (Matthew 27:34). Galls are hard growths in the leaves of certain trees, such as the apple and the oak. They were used in the preparation of both inks and medicines, and it was the accepted practice to grind them in a mortar and then combine the powder with whatever liquid had been chosen for the purpose at hand. On the boss, an assistant stands ready with the sponge which is about to be soaked in the unpleasant mixture.

Kitchen gear can be hunted down in the Old Testament as well as in the New. A manuscript made in France in the mid-thirteenth century[12] is a brilliant retelling in picture form of stories in the books of Samuel and of Kings. One scene (fol. 27v) shows David

arriving with provisions for the Israelites, as their army prepares to join battle with the Philistines (1 Samuel 17:17–22). Hung on the side of the baggage cart, amidst all the military paraphernalia, are three kinds of cooking-pot, of different sizes but each with its own handle and two with legs to stand on (Fig. 3). Strapped on to the cart there is also one soldier's helmet, of the kind known as a 'kettle helm' because its shape reminded everyone of a round kitchen kettle, or cooking-pot. Indeed, like the modern soldier's 'tin hat', it probably came in very handy from time to time as an improvised bowl in which to heat up food when nothing better was within reach.[13]

There is so much busy activity in this picture, and there are so many different kinds of bag and baggage piled on to the cart that it is quite hard at first to spot the cooking-pots. It may come as a surprise that they are there at all in such a setting, but they were in fact essential pieces of military equipment. Hot meals and high

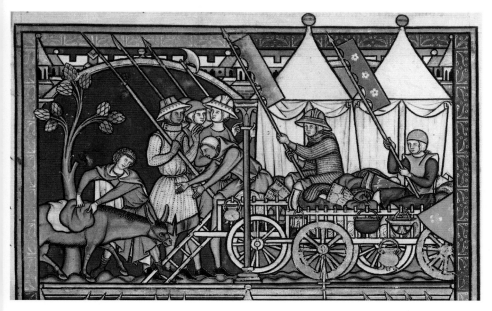

Fig. 3 Cooking pots on a baggage cart. Old Testament picture book, French, mid-thirteenth century. The Pierpont Morgan Library, New York, MS M.638, fol. 27v.

morale go hand in hand. Experienced medieval commanders were well aware of this, and paid attention to the matter. As Christine de Pisan pointed out in *The Book of Deeds of Arms and of Chivalry* (c. 1410): 'The wise commander ... will not wait for foragers, who all too often cannot find anything to take, but will have provided for everything before his departure, not only all the supplies needed for war, but all sorts of victuals that he will have sent before him in carts and bundles.'[14]

Cards of Identity

WHETHER in this Old Testament scene or in the Broederlam *Flight into Egypt* which has just been mentioned, the cooking-pots are incidental details, chosen by the artist to make the story represented in the picture come alive for its viewers. In certain cases, however, a piece of kitchen gear has a far more important part to play. It is placed at centre stage for all to see, and attention is expected to be paid. Saints have their own attributes and emblems, whose presence in official portraits makes each venerated figure instantly recognizable. Just as St Peter carries his keys, so St Lawrence displays the instrument of his martyrdom, the large, workmanlike gridiron on which he was roasted. In a Dutch manuscript, the Hours of Catherine of Cleves (c. 1440),[15] he is holding it by its ring, a practical feature which made it possible to hang the gridiron on a hook, out of the way, when it was not in use. In the same manuscript (fol. 316), St Martha is shown in her role as a good housekeeper. She stands alone, against a plain backdrop, so there is nothing to distract the eye from what she is wearing and what she is holding. She has a fresh white apron, tied at the waist, and in one hand she carries a ladle, in the other a cooking-pot with its own little legs to stand on and its own handle.[16]

Fig. 4 Cook with flesh-hook and ladle. Misericord in All Saints Church, Maidstone, Kent, early fifteenth century. English Heritage, National Buildings Record, London, AA48 / 9506. Reproduced by Permission of English Heritage. NMR.

Cooks had cards of identity too, the familiar tools of their trade. On an early fifteenth-century misericord at the church of All Saints in Maidstone, Kent, one cook holds up the two indispensable pieces of equipment which he uses day in and day out: a flesh-hook for catching hold of solids, and a ladle for sipping and stirring liquids (Fig. 4). At other times, the cook makes himself known to the viewer with a characteristic gesture. He raises one hand, to shield his face from the heat of the kitchen fire. At the church of St Mary's, in Minster-in-Thanet, Kent, a misericord (*c.* 1410) shows a cook stirring a pot with one hand while holding the other up to his cheek.[17] There was not enough space on this carving for any flames to be squeezed in, but the reason for the protective response is made clear in the Hours of Catherine of Cleves, where a little boy turns a spit while vainly trying to shield himself from the blaze (Fig. 5).

Fig. 5 Turnspit boy. The Hours of Catherine of Cleves, Dutch, c. 1440. The Pierpont Morgan Library, New York, MS M.917, fol. 101r. Purchased on the Belle da Costa Greene Fund and with the assistance of the Fellows, 1963.

Portraits from Life

FIGURES like these, with their standard-issue tools and poses, embody the generic cook, instantly recognizable yet totally anonymous. Only in the rarest of cases does a cook with a name and a story leave his mark in the pictorial record. In a manuscript made in Brussels, c. 1410, Jan van Leeuw, a follower of Johannes Ruusbroeck the mystic, is shown dividing his day between service in the kitchen and study in his cell.[18] An English manuscript produced between 1335 and 1340, the Luttrell Psalter,[19] displays several lively kitchen scenes in its margins. Amongst the busy servants preparing dinner one in particular catches the eye. He stands beside a cluster of cauldrons and is armed with the usual equipment, the flesh-hook and the ladle, but some attempt has been made to give him a distinctive physical appearance. He is tall, thin, bald, and bearded (Fig. 6). It is just possible that he is meant to represent John of Bridgford, head cook for the man who commissioned the psalter, Sir Geoffrey Luttrell, whose respect and regard for John are recorded in his will.[20]

There can be no doubt about the identity of one other cook who managed to find a place for himself on a manuscript page. As so often, money helped to smooth the way. In 1380, the *Liber benefactorum*, a book listing all the monastery of St Albans' benefactors, was compiled. In the roll-call of popes and kings, great prelates and great worthies whose contributions are recorded, there is one slightly incongruous entry for Master Robert, the cook who served Abbot Thomas during his term of office, from 1349 to 1396. It was Master Robert's wife, Helena, who took the initiative and made sure that his name would be included in the list by contributing a down payment of three shillings and fourpence to help cover the book's production costs. As a result, one of the illustrations is a double portrait in profile (Fig. 7), with the enterprising Helena well to the fore, and Robert himself in the rear, holding up a favourite knife.[21]

Fig. 6 Cooks at work. The Luttrell Psalter, English, 1335–40. British Library Board, London. All Rights Reserved. Add. MS 42130, fol. 207r.

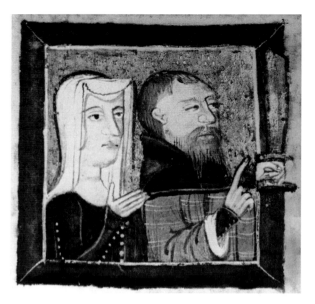

Fig. 7 Master Robert and his wife Helena. The St. Albans *Liber benefactorum*, 1380. British Library Board, London. All Rights Reserved. MS Cotton, Nero D. VII, fol. 109.

The marginal place of cooks and kitchens in medieval art is indicated clearly by the position chosen for them in a given work. They may be found in any medium, from stained glass to sculpted stone, but almost always they have been half-hidden in the shadows of a building, tucked into the corner of a picture, or pushed to the edge of a page. On the one surviving folio from an English Antiphonal of the early fourteenth century, now in an Australian collection,[22] there is a Nativity scene, with Mary holding the baby Jesus in her arms. Outside this picture, and seated on the border, is the tiny figure of St Joseph, cooking dinner for the family in a frying-pan whose weight is supported by a frame set in position over a charcoal brazier. This border vignette has an obvious link with the story shown in the main image, but in most cases no such connection can be found. At the bottom of one page in a Flemish psalter, made

near Ghent in the early fourteenth century,[23] there sits a harassed young mother, stirring the contents of a cooking-pot with one hand, while clutching a large, wriggling baby in the other (Fig. 8). The image is vivid, touching, funny, and seems to have been added to the page by the artist on a whim, for the best of all reasons: he felt like doing so.

In certain contexts, however, cooks had an important part to play and so were moved to a suitably prominent position. They acquired dignity by association when their work was chosen as the pictorial example to illustrate a lesson which was being taught.

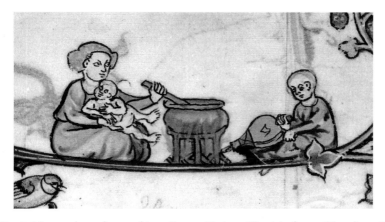

Fig. 8 Harassed mother making dinner. Psalter, Flemish (near Ghent), early fourteenth century. Bodleian Library, University of Oxford, MS Douce 6, fol. 22r.

Hell's Kitchen

No lesson was hammered home with more energy than the one which demonstrated what happened throughout eternity to those who had failed to use their time wisely while on earth. The torments of the damned in Hell were depicted with brutal relish, and cooking was one of the many ways guaranteed to inflict as much misery as possible. In the early fourteenth-century Holkham

Bible Picture Book,[24] a dishonest baker and an equally disreputable ale-wife have been hung up to stew in a pot suspended over the flames which belch forth from the mouth of Hell. Other sinners bubble in a cauldron set to stand in the heart of that ferocious fire.[25] In another example, on a fourteenth-century wall painting of the Last Judgement in the church at Beckley, Oxford, a damned soul is being roasted on a spit, while one devil bastes him and a second works the bellows to raise the temperature.[26]

To be simmered in Hell's kitchen is the punishment chosen for gluttony in the pictorial scheme devised for an influential didactic treatise, *Somme le Roi*, which was written in 1279 by Friar Lorens, the Dominican confessor to Philip III, King of France. The author's aim was to teach his readers what they needed to know about such matters as the Ten Commandments and the seven deadly sins. To illustrate the lessons, a cycle of fifteen pictures was created by Honoré, the foremost artist of the day in Paris.[27] The design for each of the virtues places a virtue in the top left compartment, its matching vice in the top right one, and examples of appropriately good and bad behaviour in the space below. On the page for Sober Moderation, that virtue is contrasted with Gluttony. The picture chosen to show gluttony in action presents Dives, the heartless rich man who refused to share even one crumb from his feast with the beggar Lazarus (Luke 16:19–24). An extra scene has been added for good measure, to underline the lesson. In this, Dives, tormented with thirst, can be found, stewing for ever in one of Hell's capacious cauldrons.[28]

The blessed, like the damned, had to be prepared to put up with considerable discomfort in the kitchen from time to time, but their tormentors were not always as skilled as those master cooks, the devils themselves. In the Hours of Henry VIII, a manuscript made in France *c.* 1500,[29] one scene shows St John

the Evangelist being boiled in oil on the orders of the Emperor Domitian (Fig. 9). Flames are shooting up around the cauldron, more fuel is being added to the fire, and the cooks are flinching from the heat, with hands held high, but the saint himself is relaxed and entirely at ease. He leans back in the bubbling oil as though in his bathtub at home, and raises his hands in calm, infuriating prayer.[30]

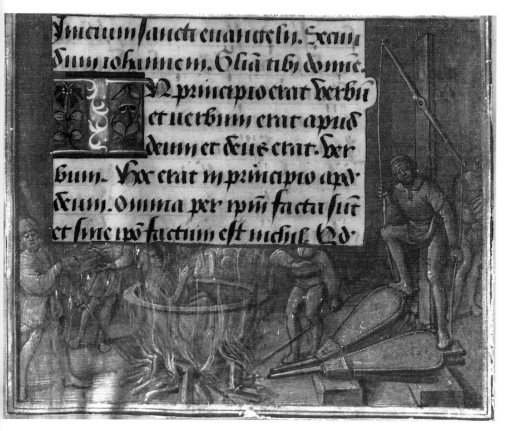

Fig. 9 St John the Evangelist boiled in oil. The Hours of Henry VIII, French, *c.* 1500. The Pierpont Morgan Library, New York, MS H.8, fol. 7r. The Dannie and Hettie Heineman Collection, gift of the Heineman Foundation, 1977.

Teaching Tools

A KITCHEN scene finds a home in another kind of instruction manual, this one designed to help priests to teach their parishioners the rudiments of the faith. It began to be produced in the fifteenth century, first in the Netherlands and later on in Germany. Known as the *Biblia pauperum*, it was a picture book, in which each page was divided into three distinct compartments. The large one in the centre showed a scene from the life of Christ, and this was flanked by two smaller ones, each with an episode from the Old Testament which had been chosen to reinforce the lesson embodied in the main image.

On one page of a *Biblia pauperum* which was made in the Netherlands *c.* 1450–60, the central compartment presents Jesus in the wilderness. Although famished after his forty days of fasting, he still has the strength of mind to reject with a stern rebuke the Devil's suggestion that he could use his special powers to turn the stones lying around him into food: 'Man shall not live by bread alone' (Matthew 4:3–4).

By contrast, in the Old Testament scene set beside this woodcut Esau, hot and hungry after a day of hunting, recklessly sells his birthright to his brother Jacob, in exchange for the instant gratification of one sustaining 'mess of pottage' (Genesis 25:29–34). He has just stepped into a well-appointed kitchen, where Jacob stands ready to hand him his bowl and spoon. The pot in which the meal has been cooked hangs by a hook over the fire, and several joints of meat are being smoked nearby. This tiny but detailed representation of a kitchen is one example of the pleasant surprises in store when cooking scenes are stumbled upon in very unexpected places.[31]

Encyclopaedias

ENCYCLOPAEDIAS are valiant attempts to sum up the current state of knowledge about the world and its inhabitants. A much-revered and often cited example in the Middle Ages was *De proprietatibus rerum*, written *c.* 1245 by Bartholomaeus Anglicus, a Franciscan teacher in Paris. The first copies, intended for the eyes of scholars and preachers, had no pictures, but once the book had been translated from Latin into French in 1372, a number of luxurious versions were made for royal patrons and other grand connoisseurs. Pages of plain, workmanlike text, with no trace of decoration to relieve the monotony, could scarcely be expected to satisfy such readers, and so a series of illustrations was devised to brighten the sober narrative. Once again, a cook managed to find a toehold in the scheme. In a fifteenth-century copy,[32] at the point where Bartholomaeus considers the senses, Taste is personified by a trim little cook, caught in the act of raising a ladle to his lips to sample the contents of one of the stew-pots set to simmer in a row beside a glowing fire.[33]

Mercury's Children

COOKS found themselves in very good company in yet another decorative scheme, this one designed to introduce the viewer to a different way of thinking about the forces which govern life and shape destiny. Throughout the fifteenth and sixteenth centuries there was, in sophisticated circles, a growing interest in the idea of the planets' power over every created being in the known world. To express the relationship between those heavenly bodies and life on earth in clear, bold images, a new kind of pictorial composition was devised. In this, each planet was displayed, surrounded by its 'children', men and women engaged in those occupations which were

considered to be specially under that planet's influence. Mercury, for instance, presided over artists and skilled craftsmen, and amongst these a cook is sometimes to be found. In *De sphaera*,[34] a manuscript written and illuminated in Milan *c.* 1450–60, on the page devoted to Mercury's followers there appear a painter, a sculptor, one man building an organ, two men piecing together armour, two others making clocks, and one scribe. Right in the centre of the design, in the most prominent position, two cooks are busily baking and roasting in their kitchen, while just above them, at the top of the page, there can be seen the finished work of art they have created, the feast itself.[35]

Life Lessons

IN any household, the quality of the cooking and the skill of the cook affect the mood of its members. A good meal and a full larder make life feel stable, safe, and well worth the living. An indifferent meal and an empty shelf are signs that something has gone badly wrong in the establishment. The humblest domestic arrangements can be used to teach important moral lessons when the conventional wisdom of the day finds a link between the outer state of the kitchen and the inner state of its owner.

A cautionary tale, told with grim relish throughout the Lowlands in the late Middle Ages, charts the downward path of a prodigal son, Sorgheloos (the medieval Dutch word for 'Careless'), as he recklessly throws away every advantage, ignores every warning from his elders and betters, and ends his life in gloomy destitution. His rake's progress is depicted in a series of stained glass roundels, made in the early sixteenth century.[36] The last of these shows Sorgheloos sitting hunched on the hearth, trying to cook some herrings in a pot hung over a feeble fire which he is feeding with wisps of straw, the only

fuel left in the house. The kitchen itself is large, and there is plenty of equipment ranged along the walls, from brooms and bellows to spits and spoons, but none of this will ever be of use to him again. He has stripped his own cupboard bare.

By contrast, a well-ordered domestic scene can be made to represent the well-ordered life. A woodcut printed in Paris in 1505 for Pierre Gringore's book, *Le Chasteau de Labour*,[37] carries the caption 'La maison de repos'. It shows a man eating his dinner at a neatly laid table, while his wife, or housekeeper, ladles out a helping of soup from a stew-pot standing in the fire, and an attentive dog waits for a tasty morsel from his master's plate. In this household there is order, and enough for everyone. The link between inner and outward harmony in the conduct of personal life is crystal-clear in another woodcut, this one in a collection of rhymed proverbs put together *c.* 1480–4 in eastern France. To illustrate the saying, 'the house shows its owner', the good master is pictured as he is about to step inside his own substantial house, where a bright fire burns on the hearth, fine dinnerware is on display, and a loving dog stands at the door, eager to welcome him home.[38]

Kitchen Chaos

In the rough-and-tumble world of farce, however, the kitchen is no emblem of peace but the battleground where henpecked husbands and hot-tempered wives struggle for mastery. The fight is lopsided, yet leads to no decisive victory. In this distorted mirror-image of society, the natural order has been reversed. The wife almost invariably has the upper hand, but she never manages to land the knock-out punch. When the two foes meet again in this unending comedy, her battered opponent is on his feet once more, reeling but ready for another round.

Jokes about domestic discord were tucked by artists into many a blank space begging to be filled. The settings vary, but all the stories spring from the same age-old stock. Passions have flared in a kitchen setting carved in 1520 on a misericord in Bristol Cathedral.[39] A foolhardy husband has been caught in the act, as he lifts the lid off the stewpot to see what is cooking for dinner. His outraged wife pulls his beard to make him yelp with pain while a pot, shown in midflight as it sails past the culprit's ear, is silent testimony to female bad temper and worse aim (Fig. 10). In a sequence of small scenes set out along the borders of the Smithfield Decretals,[40] illuminated in London in the second quarter of the fourteenth century, a broken husband has been bullied by his wife into doing the housework. This

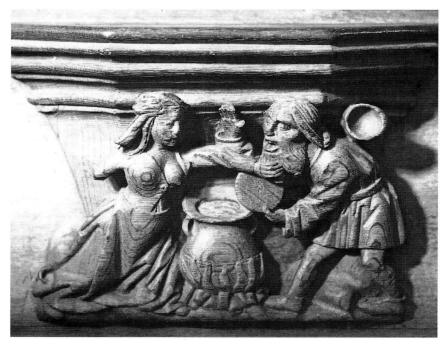

Fig. 10 Kitchen quarrel. Misericord, Bristol Cathedral, 1520. English Heritage, National Monuments Record, BB 68/3981. Reproduced by Permission of English Heritage. NMR.

is hard on the husband but a boon for the present study, because his dispiriting duties include such necessary back-up kitchen tasks as hauling home buckets of water (fol. 141v, Fig. 11), and then washing the dishes (fol. 143v).

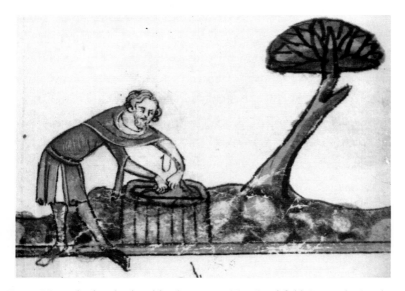

Fig. 11 House-broken husband hauling water. The Smithfield Decretals, London, second quarter of the fourteenth century. British Library Board, London. All Rights Reserved. MS Royal 10 E. IV, fol. 141v.

By the Bedside

Not all cooking took place in the kitchen. Soothing potions and sustaining soups were stirred or kept warm by the fireplace in the bedrooms of the sick and dying. In the Egmont Breviary, a Dutch manuscript made c. 1435–40,[41] there is a deathbed scene in which the patient lies on his high, curtained bed while a woman sits by a bright fire and heats something in a long-handled pan.[42]

The same kind of bedroom cookery also takes place in more cheerful scenes of childbirth. In an account of Marco Polo's adventures, illuminated c. 1400 in England,[43] one picture shows the celebrations

after the birth of that very special baby, Alexander the Great.[44] As women friends file in to bring their congratulations and their presents to the proud new mother sitting up in bed, an attendant kneels on the floor, bent over a saucepan set to warm on a tiny charcoal brazier.

Alexander and his mother, born to privilege, are pampered here with all the comforts due to their exalted station in society. Jesus and Mary, invisible to the eyes of an indifferent world, could expect no such consideration. Nevertheless, artists made sure that the bleak conditions in which the miraculous birth took place were softened by a hundred small kindnesses. In a devotional practice developed over the centuries, the faithful were encouraged to follow the life of Jesus with far more than casual attention, and to share its joys and pains in their imagination. As a result, many pictures of the Nativity present the stable as a hive of domestic activity, where the bit-players in the drama try to make its setting as cosy as they can for Mary and her new-born son. Midwives warm cloths by the fire and, on an oak-panel painting, made *c.* 1410–15 in Northern Guelders or the Duchy of Cleves,[45] angels plod purposefully in and out, with pails of water for the baby's bath.[46]

Joseph himself is pressed into service on occasion. Sometimes he uses his skills as a carpenter to weather-proof the draughty shed. At others, he tries his hand at a little cooking. In the Bedford Hours, made in France *c.* 1420,[47] he blows up a fire with a pair of bellows, to heat a stew-pot which has been hung over the flames. On an altar-piece at Ortenberg, in Germany, painted *c.* 1420,[48] he is busy, stirring a tiny saucepan while the Three Kings sweep in to the stable to pay stately homage to their new-found Lord.[49] In yet another sighting, this time in a Book of Hours made in Paris *c.* 1430,[50] he is a heavily muffled old man, warming his own hands while keeping an eye on the contents of a cauldron which hangs over the fire. (Fig. 12)

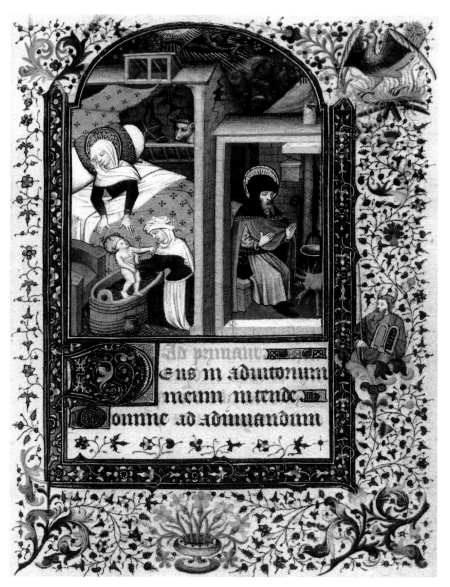

Fig. 12 St Joseph cooking. Book of Hours, Paris, *c.* 1430. British Library Board, London. All Rights Reserved. Add. MS 18192, fol. 52r.

Calendar Cooks

WATCH-DOG cookery of this kind, in which some fortunate figure enjoys the comforts of home and the prospects of dinner as he shares the warmth of a fireplace with the bubbling pots and pans, can be found as well in that calendar convention which is known to us today as the Labours, or Occupations, of the Months. In this ancient tradition, whose roots stretch far back into the classical world, each month of the year is represented by its zodiac sign and an image of some activity appropriate for the season. The cycle celebrates the ceaseless, endlessly repeated round of agricultural tasks, from seed-time to harvest, which put food on the tables of society. Because the emphasis is on the production of the raw materials from which a meal can be made, and not on the meal itself, the action takes place in the field or the farm, the vineyard or the orchard; there is little need for the artist to step inside the kitchen.

At three points in the year's progress, however, there is a chance to catch a glimpse of cooks in action. In the dead of winter, work outside comes almost to a standstill, and so the traditional figure for January or February is a tired old man warming himself by the fire. Occasionally, the artist decides to give him something useful to do as he sits there and, like Joseph in the Nativity scenes, he can then be found watching the progress of dinner as it simmers in its pot over the glowing brands. Sometimes sausages, or a side of bacon, share the same space, hung up on a pole to be cured in the smoky warmth of the fireplace, as they do in an English calendar of the late thirteenth century.[51] February's zodiac sign is Pisces, the Fish; in the *Belles Heures*, made for Jean, Duke de Berry by the Limbourg brothers *c.* 1406–8, those fish are being grilled on a grid-iron by a bright, hot fire.[52]

February, too, usually marks the beginning of Lent, a season

during which eggs and milk were forbidden foods. What more enjoyable way could be devised to dispose of them than to gorge on pancakes on Shrove Tuesday, the day before the dismal season of penance began? Calendar scenes for the month may show the delectable art of making pancakes. There is a lively example in a French Book of Hours of the second quarter of the sixteenth century.[53] Happy, hungry customers, seated round a table, wait expectantly for their special treat while the production-team gets down to work by the open fireplace. A woman stirs the batter in its bowl and her partner holds the frying pan over the flames (Fig. 13).

The other point of entry for cooking in the calendar convention is December, where, from time to time, baking is chosen as the representative occupation for the month. In most cases, the baker is presented as an isolated figure, thrusting loaves into an oven or drawing them out again, but every now and then, particularly in the late medieval period, the artist provides more context and setting for the work. In the Flemish manuscript known as the 'Golf' Hours, made *c.* 1500,[54] the bakery is a separate department on a private estate, set up at some distance from the house itself. It consists of two sheds, one in which dough is being kneaded in a big trough, and another where the actual baking takes place. There, a woman breaks up branches to keep the oven hot, a tray of just-baked bread has been set to cool at one side, and a man is carrying in another batch of raw dough, shaped into loaves and ready to be slipped into the oven.

This is a rare example of a private bakehouse. More often, the artist shows a commercial establishment bustling with activity, as harried bakers cope with hopeful customers. In the December scene of a Flemish Book of Hours, made *c.* 1500,[55] one man slides a tray of pies into the oven, another stands at a counter, taking orders and the money, and a woman customer is about to walk home with her prize, a piping-hot pie on a plate.

Februarius vii d Fauſtini mr̄is
habet dies e Iuliane virgis
xxviii. Luna.xxix. xv f Conſtātie vir
d Brigide vgis. iiii g Simeois mr̄is.
xi e Purifica.ma. A Sabini presby
xix f Blaſii epiſco xii b Galli presbyte.
viii g Gilberti epi. i c Lxx. noue mr̄e
A Agathe virgi d Cathe. Petri.
xvi b Dorothee vg. ix e vigilia.
v c Moyſeti epi. f Mathie apli.
d Salomois mr̄. xvii g Alexandri epi.
xiii e Apoline virg vi A victoris mr̄e
ii f Scolaſtice vg. b Leandri epi.
g Euphroſine v. xiiii c Romani abb.
x A Eulalie virgis
b Fuſcæ virgis.
xviii c Valentini pape.

Fig. 13 Making pancakes. Calendar picture for February in a book of hours, French, second quarter of the sixteenth century. Bodleian Library, University of Oxford, MS Douce 135, fol. 2v.

Health Handbooks

THERE are interesting sidelights on cooking practice to be found in the copies of a respected health handbook, *Tacuinum sanitatis*, which were made in northern Italy in the late fourteenth and the fifteenth centuries. The treatise itself had been composed long before that time, by an Arab physician who studied in Baghdad and died *c.* 1064 in Antioch. In due course it was translated into Latin for King Manfred of Sicily in the mid-thirteenth century, and later into Italian.

The book's subject is the healthy life, and it offers advice on how to maintain health with the proper diet for every constitution, and how to cure sickness with the appropriate medicine. All kinds of food, both animal and vegetable, are surveyed, and hints are offered on the best ways to prepare them, together with warnings about the pitfalls to be avoided: 'Chicken Eggs: an excellent way to cook them in their shells is to boil them until just set, as hard-boiled eggs cause obstructions. The best way to cook them without their shells is to break them into boiling water; fried in butter or oil, they cause belching.'

The sumptuously illustrated manuscripts contain a number of kitchen scenes in which quite specific materials are being handled. In one, the liquid whey is pressed out of fresh cheese. In another, tripe is scraped from the sides of a cow's stomach, and then simmered in a pan 'for a long time in a rich broth with mint and abundant herbs'. A third example shows the making of spaghetti (Fig. 14). One woman kneads a big ball of dough, while her assistant separates the long strands of pasta which have been formed from such a ball, and stretches them out to dry over a wooden rack.[56]

This survey, though far from exhaustive, forms a lightly sketched map of those territories in the world of medieval art where cooks and their workplaces are most likely to be found.

Fig. 14 Making pasta. *Tacuinum sanitatis*, northern Italy, *c.* 1405. Österreichische Nationalbibliothek, Vienna, Picture Archive, Cod. Ser. Nov. 2644, fol. 45v.

The Kitchen Scene: Inclusions and Omissions

By and large, kitchen activities and kitchen equipment were used as decorative details to brighten a page, or as teaching tools to sharpen a point. The images are small in scale and offer room for no more than one or two telling details. Designed to signal 'cook' and 'kitchen' to any viewer, they were never intended to provide a record of complicated cooking practice.

This being so, the emphasis falls on basic, everyday techniques: stewing and spit-roasting, frying and grilling, stirring and basting, kneading and baking. Only occasionally is there a glimpse of some more unusual activity, such as the pancake-making already noted in some calendar scenes for March. Perched on the border of a Flemish psalter, produced in the early fourteenth century,[57] a tiny woman holds up in triumph the piping-hot trophy she has just slipped out of her wafer-irons.[58]

Like so many of her fellow cooks in art, she is an isolated figure, presented out of context. Even when a kitchen setting has been provided it rarely seems, on close inspection, to be a fully functional workplace. One miniature, in the Hours of Catherine of Cleves (fol. 151), shows us the comfortable kitchen in which Mary, Joseph and the baby Jesus sit companionably by the fire (Fig. 15).[59] This is an exceptionally well-furnished example, with pots simmering on the hearth, bellows, tongs and hand-grill conveniently close at hand, and lots of useful storage space. Even so, one essential piece of equipment is missing from the scene. Plates and provisions can be seen, but they have been set out on a shelf, a cupboard or a rack, all hung up high on the walls. There is nothing to indicate how any of these items could be lifted down when needed, no sign of any ladder, stool, or long-handled fork. Logistical problems like this are only occasionally addressed. The best place to look for answers is

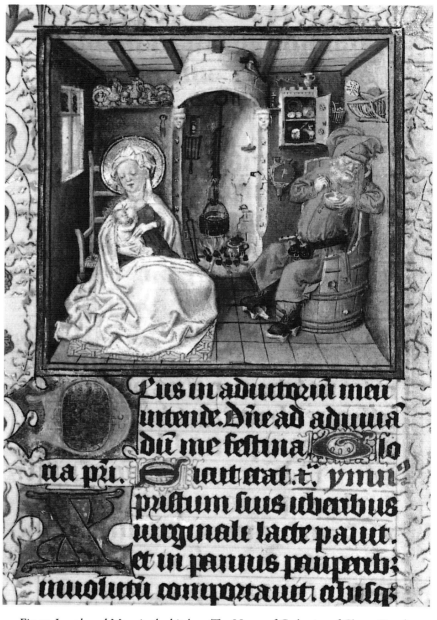

Fig. 15 Joseph and Mary in the kitchen. The Hours of Catherine of Cleves, Dutch, *c.* 1440. The Pierpont Morgan Library, New York, MS M.917, fol. 151r. Purchased on the Belle da Costa Greene Fund and with the assistance of the Fellows, 1963.

in the *Tacuinum sanitatis* group of manuscripts, in which the artists pay more attention than usual to the details of the kitchen world. One illustration does indeed show a woman, in search of vinegar, climbing up a ladder to fill her little jug from a gigantic barrel which has been lodged right under the roof beams.[60]

A less elegant, but very useful, guide to kitchen equipment is to be found in a single sheet of hand-coloured woodcuts, published *c.* 1480 by Hans Paur in Nuremberg.[61] The title of the cut is 'The Household Utensils Necessary to Married Life', and in the centre of the design sits the young couple, their happiness still unshadowed by the storm clouds of domestic life. Around them are ranged twenty-four small compartments, each filled with the brand-new wedding presents for their first home together. Many of these are intended for the kitchen, and so there are boxes, barrels, baskets, jugs and jars, for provisions, racks for storage, a salt-box, an adjustable hook and chain for hanging a pot over the fire, firewood, candles, a trivet and a grill.[62]

Even in this generous assortment no room is made for those essential items in the modern kitchen, the rolling-pin and the protective glove. Baking scenes for December in medieval calendars sometimes show dough being kneaded, or a tray of pies, shaped and ready for the oven, but they never give a hint that a flour mixture has to be smoothed and flattened before it can be transformed into a pastry crust. Although they find no place in the pictorial record, rolling-pins were certainly in use and called for in recipes, as in this fourteenth-century example, in which the cook is instructed to make a paste of flour and eggs and then 'rolle on a bord ase thanne [thin] ase parchemin [parchment]'.[63]

The absence of gloves from the inventory is even more surprising, for heavy metal pots and pans must have been dangerously hot to handle. Sometimes we find a trim little cook with a towel slung

over one shoulder, and presumably that could be used to provide some protection for the hands, but considering that thick gloves were worn for rough work outdoors it is a puzzle that they did not find their way into the kitchen. One fifteenth-century scrap of conspiratorial advice to servers who had to carry hot metal dishes to the table was to use slices of bread to shield their hands.[64] This, though kindly meant, 'I teche hit … for thyn ese [comfort]', hardly seems an adequate solution to the problem of heat hazards in the kitchen itself.

Back-Up and Clean-Up Jobs

FROM time to time we are granted a glimpse of kitchen routines, as the crew busies itself with the cook's daily demands. In the pictorial record, a considerable amount of pounding and chopping goes on, as in that well-known border scene in an English manuscript produced *c.* 1335–40, the Luttrell Psalter.[65] In this, as in most other examples, the particular nature of the object which is being attacked with such vigour is not made plain. It is enough for the viewer to grasp that it is some kind of meat or fish (Fig. 16).

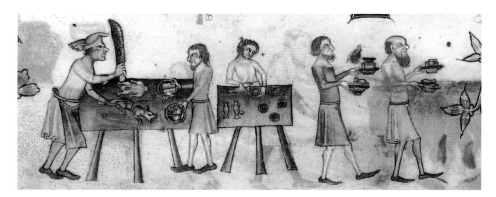

Fig. 16 Kitchen preparations. The Luttrell Psalter, English, 1335–40. British Library Board, London. All Rights Reserved. Add. MS 42130, fol. 207v.

Only in the *Tacuinum sanitatis* group of manuscripts is there a conscious effort to be more specific, and provide a handful of scenes which show the treatment of different animal parts, like one in which tripe is being stripped from a carcass and then stirred slowly in a big pan over the fire.[66]

Ladles and skimmers, pestles and tongs can be found quite often, but now and then an artist will draw attention to some other piece of equipment. In a Bohemian manuscript of *c.* 1340, the Velislav Picture Bible,[67] St Wenceslas, the King of Bohemia who established Christianity in that country, is shown as a crowned and competent cook, shaking the flour for a batch of mass wafers through a large round sieve.[68]

Water is needed all day long in any kitchen, both for cooking and for cleaning. When there are no pipes through which it can flow from source to sink it has to be carried in, pail by pail. In the Holkham Bible Picture Book, created in England in the mid-fourteenth century,[69] one image shows Jesus as a helpful little boy, drawing water from a well for his parents' kitchen. One of water's many uses is for the disheartening job of washing dishes, a task which becomes slightly more enjoyable when companionably shared, as it is on a fifteenth-century French misericord in the Cathedral of Notre-Dame at Rouen, where a woman scrubs the plates in a big bowl and a man wipes them dry with a cloth.[70]

Cooking is a messy business. Working surfaces have to be wiped and floors swept clean. Not much attention is paid by artists to these never-ending chores, but an occasional broom may be spotted from time to time. One stands propped, ready for action, against a wall in a portrait of St Petronilla as a particularly pretty kitchen maid (Fig. 17), which appears in a late fifteenth-century Book of Hours.[71]

St Petronilla is wearing the usual uniform for kitchen staff and food handlers in general, a fresh white apron. In art at least, if not

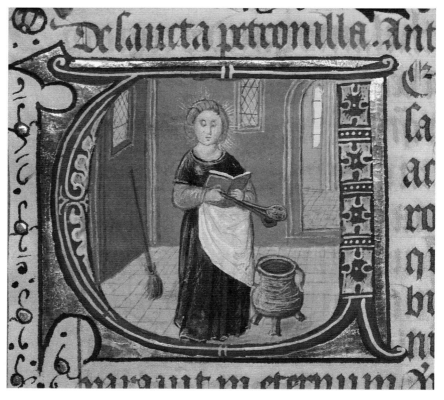

Fig. 17 St Petronilla as a kitchen-maid. Book of Hours, made in Flanders for the English market, *c*. 1490. The Queen's College, Oxford, MS 349, fol. 56v. By Permission of the Provost, Fellows and Scholars of The Queen's College.

in life, this is always invitingly clean and spotless (Fig. 18). Medieval examples, which vary in length from dowdily long to dashingly short usually, but not invariably, have no upper bib, and are tied at the waist.[72] Pockets never seem to be part of the design, but apron strings made very good substitutes. Any small tool or instrument could be kept close at hand, held in place at the waist by those knotted strings. The December calendar scene in a late fifteenth-century Flemish Book of Hours[73] shows a butcher at work in his shop, with a bunch of sharp knives tied in this way behind his back.[74] In another

December scene, this one in the calendar of a French, Franciscan missal of the same period,[75] a baker's assistant has his back to the viewer as he bends down to reach into the depths of a storage chest, so we have a clear view of the neat little tool-kit which he keeps in his apron strings.[76]

Aprons proved their worth in another way, as improvised carrier bags. A woman picks up kindling sticks from the frozen ground and stores them in a fold of her apron, in a January calendar scene found in an early sixteenth-century Flemish Book of Hours.[77] In

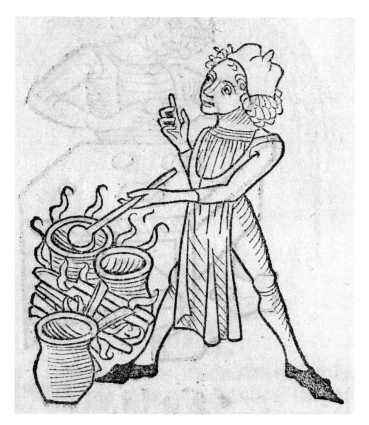

Fig. 18 Kitchen boy. Woodcut from *Hortus sanitatis*, 1491, ink on paper. Printed by Jacob Meydenbach, Mainz. Walters Art Museum, Baltimore. Acc. no. 91.621, unpaginated. Photo © The Walters Art Museum, Baltimore.

this picture, while the woman gleans small scraps of wood to start a fire, her male companion is hard at work on the all-important task of chopping the big logs which will keep that fire alight for hours.

However well chosen the wood and well stacked the logs, a fire demands constant, alert attention if it is to be coaxed into burning steadily for the length of time required. Another picture, on the same page of the Holkham Bible Picture Book which has been mentioned already, shows the little boy Jesus being helpful once again, this time blowing up the fire with a pair of bellows. He is working hard, but even so he is luckier than those less-privileged kitchen boys who were not handed any bellows but simply told to keep the fire going, come what may, by puffing away with their own breath. Chaucer, in his *Canon's Yeoman's Tale* (l. 753), makes just such a harassed assistant sigh: 'I blowe the fir til that myn herte feynte', and shudder when his masters complain that their work has been ruined because the fire did not burn properly: 'Thanne was I fered [afraid], for that was myn office [job]' (l. 924).

Heavy Lifting

ONE of the many charms of manuscript art is that most of it is very small in scale. Scenes conjured up within these narrow confines are diminutive, and encourage the viewer to enjoy the illusion that medieval life was lived in a delightful doll's house. Real cooks, in the real world, in fact had to cater often for large numbers, cope with large quantities, and handle large equipment. The sheer bulk of the gigantic cast bronze cooking-pot which was made in 1500 for a community of nuns and still stands today in Lacock Abbey in Wiltshire tells more about the logistical puzzles posed by such conditions than do a hundred tiny pictures.[78]

Artists rarely addressed the problems of weight and size, although

occasionally they will include in the image some kind of iron frame or support, set in place under the heavy pan which a cook has to hold for long periods over a hot fire.[79] Only when cooking is pictured as a form of torture do artists sometimes seize the chance to emphasize the agony and show the effects of heavy machinery in action. Devil cooks like to inflict as much pain as possible on their victims, and so their kitchens are filled with cutting-edge equipment, designed by highly skilled engineers. The vision of Hell on one page of the *Très Riches Heures* (1413–15) of the Duke de Berry,[80] shows a devil enjoying himself as he sprawls on an enormous grill, trampling small victims underfoot and squeezing others in his fists. On either side, teams of worker-demons pump huge bellows, to fan the fire and raise the misery level of the damned souls heaped around the grill.[81] The hapless tormentors of St John the Evangelist in a scene, already mentioned, in the Hours of Henry VIII (fol. 7), blow up the flames around their cooking-pot with bellows so large that they have to be worked by pulleys (see Fig. 9).[82] The need for such mechanical assistance in the real world is indicated by a 1570 illustration which records the lifting gear required to help a kitchen crew to manhandle an immense cauldron on and off the stand on which it had to be set to heat over the fire.[83]

Meals on Wheels

FIRE is important, for comfort and cooking alike. In a medieval household, big fires in hall or kitchen were the main sources of the heat supply, but individual creature needs were best served by small, mobile fires which could be set down wherever wanted for any given purpose. Several ingenious solutions to a common problem can be found from time to time, tucked as incidental details, tiny grace-notes in a crowded scene.

The January calendar picture in a mid-fifteenth-century Book of Hours from the south of France[84] shows a solitary diner, enjoying his meal on a cold winter's day while he warms his toes at a little charcoal brazier, discreetly placed under the table. The image is small, but it is just possible to see the two handles on the brazier by which it could be carried to and fro. The dinner which is recorded in the Bayeux Tapestry[85] was cooked in the open air, and both the large pieces of equipment on view are portable. The stove has handles, and the large brazier stands on legs by which it could be lifted and then set down on any surface, however uneven.

A composite representation of the year's seasons appears in a French translation of the Bartholomaeus Anglicus encyclopaedia, *De proprietatibus rerum*, copied in Maine or Anjou *c.* 1440–50.[86] In this, Winter is an old man warming himself by a charcoal brazier which has been rolled into place on a little wooden platform mounted on

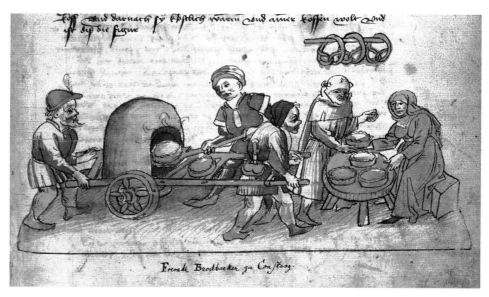

Fig. 19 Mobile oven in Constance. Ulrich Richental, *Richentalchronik*, 1465. Rosgartenmuseum, Constance, MS Hsl, fol. 23a.

wheels.[87] The same kind of arrangement, that is of a brazier set on its own small, movable platform, can be found in some of the scenes of bedside cookery which have been discussed already.

Most striking of all, in a 1465 copy of Ulrich Richental's book, *Das Konzil zu Konstanz*,[88] there is a marginal illustration in which a mobile oven, mounted on wheels, is pulled through the streets of Constance (Fig. 19). It is loaded with warm pies, which are being delivered to a market-woman for brisk sale at her open-air stall.[89]

Improvisations

INGENUITY takes many forms. Even in the pictorial record there are traces of improvisation to be found, hints on how to make a meal in less than ideal conditions. The dishes for the dinner which is cooked in the Bayeux Tapestry are assembled on a makeshift serving-table, contrived from shields. Each of these is too narrow to be of practical use as a countertop, so width has been achieved by laying the shields together in such a way that one overlaps the other.[90]

Exceptional circumstances oblige great men to accept, on occasion, some informality of this kind in the way their dinner is served. Less exalted figures find themselves called on to exercise ingenuity every day to solve life's knotty problems. Angels tell shepherds the good news about the birth of Jesus on a painted page in a Spanish missal, made in the Porta Coeli monastery, Valencia, *c.* 1468.[91] These shepherds have devised a way to cook their supper while far from the comforts of home, by tying together three of their own crooks, or staves, to make a little wigwam. This they have set up over a small fire on the open pasture where their flocks are grazing. A hook hangs from the apex of this structure, and holds in place over the flames the all-important stewpot. A hot meal will be ready soon; whether

there will be time to relish it before the race to Bethlehem is left to each viewer's imagination.

Cooks were not considered sufficiently important to merit systematic treatment by medieval artists and their patrons. Nevertheless, food itself is far too precious, and far too enjoyable, for there to be any chance that those who prepared it could ever be entirely left out of the picture. Somehow, with a hundred different excuses, cooks were allowed to squeeze through the gap between theory and practice and elbow their way into the scene. Once on stage, they were given many tiny, varied parts to play. With patience and close attention, it is possible to form a vivid, if not entirely coherent, impression of their craft, a patchwork pieced together from bright scraps and stray sightings.

Notes

1 The Cook in Context

1 M. R. James, ed., *Vulgaria, by William Horman, Fellow and Vice-Provost of Eton College. First Printed by Richard Pynson in 1519* (Oxford: Roxburghe Club, 1926), p. 164.

2 G. R. Owst, *Literature and the Pulpit in Medieval England* (Oxford: Basil Blackwell, 1961), p. 442.

3 Helen Waddell, trans., *Mediaeval Latin Lyrics* (Harmondsworth: Penguin Books, 1952), pp. 34, 126–7.

4 Georges Duby, *William Marshal, the Flower of Chivalry*, trans. Richard Howard (New York: Pantheon Books, 1985), p. 16.

5 Norman Davis, ed., *Paston Letters*, Clarendon Medieval and Tudor Series (Oxford: Clarendon Press, 1958), pp. 9–10, letter no. 8, Margaret Paston to John Paston I, 1448.

6 M. Powicke, ed. and trans., *The Life of Ailred of Rievaulx, by Walter Daniel* (Oxford: Clarendon Press, 1978), p. lxxiv.

7 J. R. R. Tolkien, and E. V. Gordon, eds., *Sir Gawain and the Green Knight* (Oxford: Clarendon Press, 1949), l. 694.

8 Owst, *Literature and the Pulpit in Medieval England*, p. 34.

9 Nigel Saul, *Death, Art, and Memory in Medieval England: The Cobham Family and their Monuments, 1300–1500* (Oxford: Oxford University Press, 2001), p. 96.

10 K. B. McFarlane, *Lancastrian Kings and Lollard Knights* (Oxford: Clarendon Press, 1972), p. 203.

11 J. G. Nichols, trans., *Life of Dante, by Giovanni Boccaccio* (London: Hesperus Press, 2002), p. 15.

12 Owst, *Literature and the Pulpit in Medieval England*, pp. 447–8.

13 E. J. Arnould, ed., *Le Livre de Seyntz Medicines: The Unpublished Devotional Treatise of Henry of Lancaster*, Anglo-Norman Texts 2 (Oxford: Basil Blackwell, 1940), pp. 149–50, 194.

14 H. F. M. Prescott, *Friar Felix at Large: A Fifteenth Century Pilgrimage to the Holy Land* (New Haven: Yale University Press, 1950), p. 30.

15 B. White, ed., *Alexander Barclay: The Eclogues*, EETS, os 175 (London, 1928), p. 184: Fifth Eclogue, ll. 93–4.

16 N. Orme, *Medieval Children* (New Haven: Yale University Press, 2001), pp. 4–5 (fig. 2), 172–3.

17 S. Shahar, *Childhood in the Middle Ages* (London: Routledge, 1990), p. 103.

18 James, *Vulgaria, by William Horman*, p. 158.

19 M. B. Salu, trans. and ed., *The Ancrene Riwle* (London: Burns & Oates, 1955), part VI, 'Penance', p. 163.

20 P. Hunter Blair, *The World of Bede* (Cambridge: Cambridge University Press, 1970, pbk ed. 1990), p. 300.

21 Gower, *Confessio amantis*, IV, 2731–3.

22 Constance Bullock-Davies, *Menestrellorum Multitudo: Minstrels at a Royal Feast* (Cardiff: University of Wales Press, 1978), p. 57.

23 John W. Conlee, ed., *Middle English Debate Poetry: A Critical Anthology* (East Lansing, MI: Colleagues Press, 1991), p. 23.

24 G. N. Garmonsway, ed., *Aelfric's Colloquy* (London: Methuen & Co., 1939, reprint 1965), p. 37.

25 J. C. B. Lowe, 'Cooks in Plautus', *Classical Antiquity*, 4 (1985), pp. 72–102; John Wilkins, *The Boastful Chef: The Discourse of Food in Ancient Greek Comedy* (Oxford: Oxford University Press, 2001), chap. 8, 'The Comic Cook', pp. 369–414.

26 Christopher St John, *The Plays of Roswitha* (New York: Cooper Square Publishers, 1966), 'Dulcitius', pp. 38–40.

27 Peter Brears, *All the King's Cooks: The Tudor Kitchens of Henry VIII at Hampton Court Palace* (London: Souvenir Press, 1999), pp. 22–3.

28 Brears, *All the King's Cooks*, pp. 111–12.

29 Chaucer, *The Knight's Tale*, l. 2020.

30 Owst, *Literature and the Pulpit in Medieval England*, p. 38.

31 M. S. Ogden, ed., *The Cyrurgie of Guy de Chauliac*, EETS, os 265 (London, 1971), p. 27.

32 Chaucer, *The Summoner's Tale*, ll. 22–3.

33 E. K. Chambers, *The Mediaeval Stage* (Oxford: Clarendon Press, 1903; republished in 1 vol. New York: Dover Publications, 1996), book 3, chap. 21, p. 118.

34 Christopher de Hamel, *A History of Illuminated Manuscripts* (Boston: David R. Godine, 1986), p. 185; Wilkins, *The Boastful Chef*, pp. 369–414.

35 Gower, *Confessio amantis*, V, l. 4072.

36 Enid Welsford, *The Fool: His Social and Literary History* (London: Faber & Faber, 1935; republished, Garden City, NY: Anchor Books, Doubleday & Co., 1961), p. 164.

37 W. O. Hassall, *How They Lived: An Anthology of Original Accounts, Written before 1485* (Oxford: Basil Blackwell, 1962), p. 155.

38 John Norton-Smith, ed., *John Lydgate's Poems* (Oxford: Clarendon Press, 1966), 'A Tale of Froward Maymond', pp. 12–13.

39 Brears, *All the King's Cooks*, p. 112.

40 E. C. Thomas, trans., *The Love of Books: The Philobiblon of Richard de Bury* (London: Alexander Moring, 1903), chap. 17, p. 108.

41 Salu, *The Ancrene Riwle*, part VI, 'Penance', p. 168.

42 Maria Perry, *The Sisters of Henry VIII* (New York: Da Capo Press, 2000), p. 7.

43 Dorothy Sayers, trans., *The Song of Roland* (Harmondsworth: Penguin Books, 1957), p. 121, 'Laisse' 137.

44 J. Gairdner, ed., *Three Fifteenth-Century Chronicles, with Historical Memoranda by John Stowe*, Camden Society, NS 28 (London: 1880), p. III.

45 Maurice Keen, *Chivalry* (New Haven: Yale University Press, 1984), p. 176.

46 Terence Scully, ed. and trans., *Chiquart's 'On Cookery': A Fifteenth-Century Savoyard Culinary Treatise*, American University Studies, Series IX, History, vol. 22 (New York: Peter Lang, 1986), pp. 23, 107, 109, 110, 112, 36–7.

47 Mary Ella Milham, ed. and trans., *Platina: On Right Pleasure and Good Health* (Asheville, NC: Pegasus Press, 1999), book I, chap. II, pp. 14–15.

48 M. Rodinson, A. J. Arberry, and C. Perry, *Medieval Arab Cookery* (Totnes: Prospect Books, 2001), pp. 38–9, 302.

49 Alison Sim, *Food and Feast in Tudor England* (Stroud: Sutton Publishing, 1997), p. 87, quoting Thomas Cogan (1584).

50 Gower, *Confessio amantis*, IV, ll. 2433–4.

51 Weiss and Pérez, *Beginnings and Discoveries: Polydore Vergil's 'De Inventoribus Rerum'*, pp. 199–200.

52 Jean Seznec, *The Survival of the Pagan Gods* (New York: HarperTorch Books, 1961), pp. 70f.

53 Priscilla Bawcutt, ed., *The Shorter Poems of Gavin Douglas*, The Scottish Text Society (Edinburgh: William Blackwood & Sons, 1967), p. 79, 'The Palice of Honour' (c. 1501), l. 1231, and note on p. 197.

54 Terence Scully, *The Art of Cookery in the Middle Ages* (Woodbridge: Boydell Press, 1995), p. 71.

55 Eileen Power, ed. and trans., *The Goodman of Paris: A Treatise on Moral and Domestic Economy* (London: George Routledge & Sons, 1928), pp. 309–10.

56 Scully, *The Art of Cookery in the Middle Ages*, p. 236.

57 Michael Messent, *A Short History of the Worshipful Company of Cooks of London* (London: Worshipful Company of Cooks, 2001), unpaginated.

58 Sim, *Food and Feast in Tudor England*, p. 86.

59 Colum Hourihane, ed., *Virtue and Vice: The Personifications in the Index of Christian Art*, Index of Christian Art, Department of Art and Archaeology, Princeton University (Princeton: Princeton University Press, 2000), pp. 368–9.

60 Jennifer Lang, *Pride without Prejudice: The Story of London's Guilds and Livery Companies* (London: Perpetua Press, 1975), Introduction, p. 14.

61 Richard Firth Green, *Poets and Princepleasers: Literature and the English Court in the Late Middle Ages* (Toronto: University of Toronto Press, 1980), p. 55.

62 Phyllis Pray Bober, *Art, Culture and Cuisine: Ancient and Medieval Gastronomy* (Chicago: University of Chicago Press, 1999), p. 231, fig. 127.

63 Anthony Wagner, *Heraldry in England* (Harmondsworth: Penguin Books, 1946), p. 30, plate VI.

64 Paul Murray Kendall, *The Yorkist Age* (Garden City, NY: Anchor Books, Doubleday & Co., 1965), p. 327.

65 John Harvey, *Mediaeval Craftsmen* (London: B. T. Batsford, 1975), p. 186.

66 Michael Camille, *Mirror in Parchment: The Luttrell Psalter and the Making of Medieval England* (Chicago: University of Chicago Press, 1998), p. 83.

67 Louis A. Barbé, *Sidelights on the History, Industries and Social Life of Scotland* (London: Blackie & Son), 1919, p. 268.

68 Orme, *Medieval Children*, p. 174.

69 John Britton, *An Historical and Architectural Essay relating to Redcliffe Church* (London: Longman, 1813), p. 22; Brears, *All the King's Cooks*, p. 105 (fig. 22).

70 A. C. Gibbs, *Middle English Romances* (London: Edward Arnold, 1966), 'Havelok', p. 60, ll. 153f.

71 Gordon Home, *Medieval London* (London: Ernest Benn, 1927; republished London: Bracken Books, 1994, pp. 165–8.

2 The Cottage Cook

1 G. L. Remnant, *A Catalogue of Misericords in Great Britain* (Oxford: Clarendon Press, 1969), p. 107, no. 30.

2 Eileen Power, *Medieval Women*, ed. M. M. Postan (Cambridge: Cambridge University Press, 1975), p. 72.

3 Salu, *The Ancrene Riwle*, Part VIII, 'External Rule', p. 185.

4 Charlotte D'Evelyn and Anna J. Mill, eds., *The South English Legendary*, vol. I, EETS, os 235 (London, 1956), p. 39, ll. 65–6.

5 James, *Vulgaria, by William Horman*, p. 154.

6 Celia Sisam, ed., *The Oxford Book of Medieval English Verse* (Oxford: Clarendon Press, 1970), p. 560, no. 307.

7 Gwyn Jones and Thomas Jones, trans. *The Mabinogion* (London: J. M. Dent & Sons, 1949), pp. 137–8.

8 Walter W. Skeat, ed., *The Lay of Havelok the Dane* (Oxford: Clarendon Press, 1902), ll. 642–5.

9 Bridget Ann Henisch, *The Medieval Calendar Year* (University Park: Penn State University Press, 1999), chap. 2, pp. 29–49, figs. 2-5, 2-8, and colour plate 6-6.

10 Brian Woledge, ed., *The Penguin Book of French Verse*, vol. I: *To the Fifteenth Century* (Harmondsworth: Penguin Books, 1961), pp. 216–17.

11 G. Paris and E. Langlois, eds., *Chrestomathie du Moyen Âge* (Paris: Librairie Hachette, 1897), pp. 344–5.

12 Sisam, *The Oxford Book of Medieval English Verse*, p. 159, no. 63, ll. 102–4.

13 James, *Vulgaria, by William Horman*, pp. 155, 157.

14 D'Arcy Power, ed., *John Arderne: Treatises of Fistula in Ano*, EETS, os 139 (London, 1910), p. 72.

15 Erwin Panofsky, *Early Netherlandish Painting*, 2 vols. (Cambridge, MA: Harvard University Press, 1958), vol. 1, p. 70, and text illustration no. 30; vol. 2, figs. 132, 157, 180, 181.

16 H. Deimling, ed., *The Chester Plays*, EETS, ES 62 (London, 1892), *The Shepherds' Play*, ll. 584–5.

17 Erik Dal and Paul Skårup, *The Ages of Man and the Months of the Year* (Copenhagen: The Royal Danish Academy of Sciences and Letters, 1980), fig. 56.

18 Orme, *Medieval Children*, p. 72.

19 Barbara Hanawalt, *The Ties that Bound: Peasant Families in Medieval England* (New York: Oxford University Press, 1986), p. 27.

20 Orme, *Medieval Children*, p. 176.

21 Lydgate, *Testament*, l. 638.

22 Carleton Brown, ed., *Religious Lyrics of the XVth Century* (Oxford: Clarendon Press, 1939), no. 149, p. 236.

23 Mary F. Williamson, 'Seasonings and Flavourings in Canada before 1840', *Petits Propos Culinaires*, 75 (March 2004), pp. 16–26 (reference on p. 22).

24 Woledge, *The Penguin Book of French Verse*, vol. 1, p. 328.

25 Luisa Cogliati Arano, *The Medieval Health Handbook: Tacuinum sanitatis* (London: Barrie & Jenkins, 1976), colour plate v.

26 James, *Vulgaria, by William Horman*, p. 156.

27 Geoffrey Grigson, intro., *Thomas Tusser: Five Hundred Points of Good Husbandry* (Oxford: Oxford University Press, 1984), p. 95.

28 Scully, *The Art of Cookery in the Middle Ages*, p. 71.

29 Dorothy Hartley, *Food in England* (London: Macdonald & Co., 1954), p. 389.

30 Judith Spencer, trans., *The Four Seasons of the House of Cerruti* (New York: Facts on File Publications, 1984), p. 74.

31 W. Nelson, ed., *A Fifteenth Century School Book* (Oxford: Clarendon Press, 1956), p. 74, no. 307.

32 Chaucer, *Miller's Tale*, ll. 3261–2

33 C. Anne Wilson, *Food and Drink in Britain* (Harmondsworth: Penguin Books, 1976), p. 130.

34 James, *Vulgaria, by William Horman*, p. 166.

35 C. H. Talbot, ed. and trans., *The Life of Christina of Markyate, a Twelfth Century Recluse* (Oxford: Clarendon Press, 1959), p. 191.

36 Christopher Dyer, *Standards of Living in the Later Middle Ages: Social Change in England, c. 1200–1520* (Cambridge: Cambridge University Press, 1989), p. 157.

37 Sir William Ashley, *The Bread of Our Forefathers* (Oxford: Clarendon Press, 1928), p. 119.

38 Judith M. Bennett, *Women in the Medieval English Countryside* (New York: Oxford University Press, 1987), pp. 56–7.

39 Nicholas Orme, 'Grammatical Miscellany of 1427–1465 from Bristol and Wiltshire', *Traditio*, 38 (1982), p. 323, no. 94.

40 Geoffrey Brereton, ed. and trans., *Froissart Chronicles'* (Harmondsworth: Penguin Books, 1968), pp. 46–7.

41 Simon Keynes and Michael Lapidge, trans., *Alfred the Great*, Harmondsworth: Penguin Books, 1983, Appendix I, pp. 200–1.

42 T. Erbe, ed., *Mirk's Festial*, EETS, ES 96 (London, 1905), p. 254.

43 Henisch, *The Medieval Calendar Year*, chap. 1, pp. 16–17 and fig. 1–8.

44 Jonathan Bate, *John Clare* (New York: Farrar, Straus & Giroux, 2003), p. 63.

45 Langland, *Piers Plowman*, C Passus VIII, ll. 304–5.

46 James, *Vulgaria, by William Horman*, p. 162.

47 Alan Davidson, *The Oxford Companion to Food* (Oxford: Oxford University Press, 1999), s.v. 'posset'.

48 C. A. Sneyd, trans., *A Relation of the Island of England about the Year 1500*, Camden Society, OS 37 (London, 1847), p. 11.

49 F. J. Furnivall, ed., *Andrew Boorde: Dyetary of Helth*, EETS, ES 10 (London, 1870), p. 330, note.

50 James, *Vulgaria, by William Horman*, p. 153.

51 Spencer, *The Four Seasons of the House of Cerruti*, p. 114.

52 Florence White, *Good Things in England* (London: Jonathan Cape, 1932), pp. 191–2.

53 Davidson, *The Oxford Companion to Food*, s.v. 'caudle'.

54 Orme, 'Grammatical Miscellany of 1427–1465 from Bristol and Wiltshire', p. 326, no. 112.

55 Davidson, *The Oxford Companion to Food*, s.v. 'pancake'.

56 James, *Vulgaria, by William Horman*, p. 155.

57 Hartley, *Food in England*, pp. 36–7.

58 Owst, *Literature and Pulpit in Medieval England*, p. 164.

59 Henisch, *The Medieval Calendar Year*, chap. 2, p. 38, figs. 2-5.

60 Sisam, *The Oxford Book of Medieval English Verse*, p. 514, no. 243, l. 23.

61 Langland, *Piers Plowman*, C Passus VIII, ll. 307–8.

62 Grigson, *Thomas Tusser: Five Hundred Points of Good Husbandry*, p. 172.

63 James, *Vulgaria, by William Horman*, p. 162.

64 James, *Vulgaria, by William Horman*, p. 162.

65 Spencer, *The Four Seasons of the House of Cerruti*, p. 105.

66 Scully, *The Art of Cookery in the Middle Ages*, p. 71.

67 James, *Vulgaria, by William Horman*, p. 166.

68 Hartley, *Food in England*, pp. 112–13.

69 Hartley, *Food in England*, pp. 111–12.

70 Henisch, *The Medieval Calendar Year*, chap. 7, pp. 171–2 and fig. 7-2.

71 Katharine M. Briggs, *The Anatomy of Puck* (London: Routledge & Kegan Paul, 1959), p. 226.

72 Constance B. Hieatt, ed., *An Ordinance of Pottage* (London: Prospect Books, 1988), p. 37, no. 6.

73 Lynette R. Muir, *Literature and Society in Medieval France: The Mirror and the Image, 1100–1500* (London: Macmillan, 1985), p. 88.

74 Rossell Hope Robbins, ed., *Secular Lyrics of the XIVth and XVth Centuries* (Oxford: Clarendon Press, 1955), p. 43, no. 48, ll. 21–2.

75 Peter Happé, ed., *Tudor Interludes* (Harmondsworth: Penguin Books, 1972), John Heywood, *The Play of the Wether*, pp. 172–3. ll. 1010–20.

76 Charles Elliott, ed., *Robert Henryson Poems* (Oxford: Clarendon Press, 1963), *The Preiching of the Swallow*, p. 56, l. 1880.

77 Dyer, *Standards of Living in the Later Middle Ages*, p. 157.

78 H. S. Bennett, *Life on the English Manor* (Cambridge: Cambridge University Press, 1960; 1st ed. 1937), p. 95.

79 Hassall, *How They Lived*, p. 140.

80 Richard Leighton Greene, ed. *A Selection of English Carols* (Oxford: Clarendon Press, 1962), p. 53, no. 1, ll. 13–14.

81 Orme, 'Grammatical Miscellany of 1427–1465 from Bristol and Wiltshire', p. 316, no. 23.

82 Elliott, *Robert Henryson Poems*, *The Taill of the Uponlandis Mous and the Burges Mous*, p. 7, l. 222, p. 8, l. 248.

83 Hassall, *How They Lived*, p. 137.

84 Wilson, *Food and Drink in Britain*, p. 50.

85 Izaak Walton, *The Compleat Angler* (1653) (London: Folio Press/J. M. Dent, 1973), chap. 18, p. 173.

86 Hanawalt, *The Ties that Bound*, p. 148.

87 Langland, *Piers Plowman*, C Passus IX, ll. 94–5.

88 Owst, *Literature and Pulpit in Medieval England*, p. 435.

89 Greene, *A Selection of English Carols*, p. 186, note.

90 A. C. Cawley, ed., *The Wakefield Pageants in the Towneley Cycle* (Manchester: Manchester University Press, 1958), *Prima Pastorum*, p. 35, ll. 215–39.

91 P. Bawcutt and F. Riddy, eds., *Longer Scottish Poems*, vol. 1: *1375–1650* (Edinburgh: Scottish Academy Press, 1987), *The Taill of Rauf Coilyear*, p. 103, l. 201.

92 Ashley, *The Bread of Our Forefathers*, pp. 108, 126–8.

93 Dyer, *Standards of Living in the Later Middle Ages*, pp. 158–9.

94 Grigson, *Thomas Tusser: Five Hundred Points of Good Husbandry*, p. 172.

95 Joel T. Rosenthal, *Telling Tales: Sources and Narration in Late Medieval England* (University Park: Penn State University Press, 2003), p. 26.

96 Bennett, *Women in the Medieval English Countryside*, p. 94.

97 Hanawalt, *The Ties that Bound*, p. 59.

98 James, *Vulgaria, by William Horman*, p. 154.

99 Dorothy and Henry Kraus, *The Hidden World of Misericords* (London: Michael Joseph, 1976), p. 32, plate 18.

100 James, *Vulgaria, by William Horman*, p. 154.

101 Bennett, *Women in the Medieval English Countryside*, pp. 83–4.

102 Elliott, *Robert Henryson Poems*, *The Taill of the Cock and the Jasp*, p. 3, ll. 71–3.

103 Sisam, *The Oxford Book of Medieval English Verse*, p. 452, no. 204, ll. 1–11.

104 Katharine M. Briggs, *The Fairies in Tradition and Literature* (London: Routledge & Kegan Paul, 1967), p. 31.

105 Hanawalt, *The Ties that Bound*, pp. 40–1.

106 Robert W. Frank Jr., 'Shrine Rivalry in the North Sea World', in *The North Sea World in the Middle Ages*, ed. Thomas R. Liszka and Lorna E. M. Walker (Dublin: Four Courts Press, 2001), pp. 241–2.

107 Langland, *Piers Plowman*, C Passus VIII, l. 310.

108 Sarah Lawson, trans., *Christine de Pisan, The Treasure of the City of Ladies* (Harmondsworth: Penguin Books, 1985), part 3, chap. 12, 'Of the wives of labourers', p. 177.

109 Judith M. Bennett, *Ale, Beer, and Brewsters in England: Women's Work in a Changing World, 1300–1600* (New York: Oxford University Press, 1996), pp. 17, 19.

110 Chaucer, *The Reeve's Tale*, ll. 4136–7.

111 D'Evelyn and Mill, *The South English Legendary*, vol. 1, pp. 42–3, ll. 142–59.

3 Fast Food and Fine Catering

1 Chris Cole, 'Generations follow in Maud Heath's footsteps', *The Countryman*, October 2002, pp. 83–4; Sara Goodwin, 'Pillars of the Community', *The Countryman*, June 2003, pp. 39–40.

2 Owst, *Literature and Pulpit in Medieval England*, pp. 24–5.

3 Virginia Wylie Egbert, *On the Bridges of Mediaeval Paris: A Record of Early Fourteenth Century Life* (Princeton: Princeton University Press, 1974), pp. 42–3, 70–1.

4 Dyer, *Standards of Living in the Later Middle Ages*, p. 156.

5 Martha Carlin, 'Fast Food and Urban Living Standards in Medieval England', in *Food and Eating in Medieval Europe*, ed. Martha Carlin and Joel T. Rosenthal (London: Hambledon Press, 1998), p. 40.

6 J. C. Drummond and Anne Wilbraham, *The Englishman's Food: Five Centuries of English Diet*, revised by D. F. Hollingsworth (London: Jonathan Cape, 1957), p. 22.

7 Jenny Uglow, *A Little History of British Gardening* (New York: North Point Press, 2004), p. 28.

8 Erika Uitz, *The Legend of Good Women: Medieval Women in Towns and Cities*, trans. Sheila Marnie (Mt. Kisco, NY: Moyer Bell, 1988), p. 33.

9 Arano, *The Medieval Health Handbook: Tacuinum sanitatis*, plates XXIII, XXV.

10 John Porter, *Anglo-Saxon Riddles* (Hockwold cum Wilton: Anglo-Saxon Books, 2003), pp. 119, 136.

11 Skeat, *The Lay of Havelok the Dane*, pp. 28–9, ll. 749–84.

12 Richard Loomis and Dafydd Johnston, *Medieval Welsh Poems* (Binghamton, NY: Medieval and Renaissance Studies, 1992), no. 93, pp. 175–6.

13 Priscilla Bawcutt, ed., *The Poems of William Dunbar* (Glasgow: Association for Scottish Literary Studies, 1998), vol. 1, no. 55, ll. 22–4.

14 Langland, *Piers Plowman*, C Passus IX, ll. 94–5.

15 Barbara A. Hanawalt, *Growing Up in Medieval London* (New York: Oxford University Press, 1993), p. 38.

16 Langland, *Piers Plowman*, C Prologue, l. 227.

17 F. Donald Logan, Introduction to *William Fitz Stephen: Norman London* (New York: Italica Press, 1990), p. 52.

18 Alison Hanham, *The Celys and their World: An English Merchant Family of the Fifteenth Century* (Cambridge: Cambridge University Press, 1985), p. 79.

19 William Stirling, trans., *From Machault to Malherbe: 13th to 17th Century* (London: Allan Wingate, 1947), p. 74: Villon, 'Ballade de la Héaulmiere', verse 2, l. 1.

20 Owst, *Literature and Pulpit in Medieval England*, pp. 425–41.

21 Langland, *Piers Plowman*, C Passus VI, l. 420.

22 Waddell, *Mediaeval Latin Lyrics*, pp. 188–91.

23 Owst, *Literature and Pulpit in Medieval England*, p. 435.

24 Jane B. Dozer-Rabedeau, 'Rusticus: Folk-Hero of Thirteenth Century Picard Drama', in *Agriculture in the Middle Ages*, ed. Del Sweeney (Philadelphia: University of Pennsylvania Press, 1995), p. 208.

25 Langland, *Piers Plowman*, C Passus VI, ll. 358–60.

26 Nicole Crossley-Holland, *Living and Dining in Medieval Paris: The Household of a Fourteenth Century Knight* (Cardiff: University of Wales Press, 1996), p. 78.

27 Greene, *A Selection of English Carols*, p. 149, no. 86, ll. 32–3.

28 Bruno Laurioux, *Le Moyen Âge à table* (Paris: Adam Biro, 1989), pp. 116–17.

29 F. J. Furnivall and W. G. Stone, eds., *The Tale of Beryn*, EETS, ES 105 (London, 1909), ll. 289–94.

30 Robert R. Edwards, ed., *John Lydgate: The Siege of Thebes* (Kalamazoo, MI, Medieval Institute Publications, 2001), ll. 99–101.

31 Woledge, *The Penguin Book of French Verse*, vol. 1, Deschamps, 'Ballade', p. 240.

32 Home, *Medieval London*, p. 288.

33 Egbert, *On the Bridges of Mediaeval Paris*, pp. 76–7.

34 Egbert, *On the Bridges of Mediaeval Paris*, p. 76.

35 Eileen Power, *Medieval People* (London: Methuen & Co., 1924; republished Garden City, NY: Anchor Books, Doubleday & Co., 1954), chap. 5, 'Thomas Betson', p. 134.

36 Scully, *The Art of Cookery in the Middle Ages*, pp. 12–14.

37 Bibliothèque Nationale, Paris, MS lat. 1171, fol. 4v.

38 John H. Harvey, ed., *William Worcestre's 'Itineraries'* (Oxford: Clarendon Press, 1969), pp. 264–5.

39 Viollet Le Duc, ed., *Ancien théâtre françois* (Paris: P. Jannet, 1854), vol. 1, p. 294.

40 Musée Condé, Chantilly, MS lat. 1362, fol. 1r.

41 Henisch, *The Medieval Calendar Year*, pp. 160–1, fig. 6-18.

42 M. C. Seymour, ed., *Selections from Hoccleve* (Oxford: Clarendon Press, 1981), 'La Male Regle', pp. 15–16, ll. 145–56.

43 Laurioux, *Le Moyen Âge à table*, p. 115.

44 Egbert, *On the Bridges of Mediaeval Paris*, pp. 82–3.

45 Laurioux, *Le Moyen Âge à table*, p. 114.

46 Uitz, *The Legend of Good Women*, p. 32.

47 Del Elson, 'Pyes de Pares', *Medieval History Magazine*, 6 (February 2004), pp. 12–17.

48 Mary Dormer Harris, ed., *The Coventry Leet Book*, EETS, OS 134–5 (London, 1907–8), p. 26.

49 British Library, London, Add. MS 18852, fol. 13.

50 Carlin, 'Fast Food and Urban Living Standards in Medieval England', p. 41.

51 Hassall, *How They Lived*, p. 143.

52 Terence Scully, ed., *The 'Viandier' of Taillevent* (Ottawa: University of Ottawa Press, 1988), p. 283.

53 Scully, *The Art of Cookery in the Middle Ages*, p. 237.

54 Rossell Hope Robbins, ed., *Historical Poems of the XIVth and XVth Centuries* (New York: Columbia University Press, 1959), no. 50, 'London Lickpenny', pp. 130–4, ll. 52–6.

55 Robbins, *Historical Poems of the XIVth and XVth Centuries*, no. 50, pp. 130–4, ll. 59–60, 74–5, 79.

56 Scully, *The Art of Cookery in the Middle Ages*, p. 13.

57 Susan F. Weiss, 'Medieval and Renaissance Wedding Banquets and Other Feasts', in *Food and Eating in Medieval Europe*, ed. Martha Carlin and Joel T. Rosenthal (London: Hambledon Press, 1998), p. 163.

58 Crossley-Holland, *Living and Dining in Medieval Paris*, pp. 220–6.

59 Scully, *The Art of Cookery in the Middle Ages*, p. 104.

60 Brears, *All the King's Cooks*, p. 152.

61 K. L. Wood-Legh, ed., *A Small Household of the XVth Century* (Manchester: Manchester University Press, 1956), p. xxx.

62 Carlin, 'Fast Food and Urban Living Standards in Medieval England', p. 35.

63 Crossley-Holland, *Living and Dining in Medieval Paris*, pp. 3–10.

64 Power, *The Goodman of Paris*.

65 Power, *The Goodman of Paris*, pp. 282–3.

66 Crossley-Holland, *Living and Dining in Medieval Paris*, pp. 16–17.

67 Power, *The Goodman of Paris*, p. 207.

68 R. W. Chambers and M. Daunt, eds., *A Book of London English* (Oxford: Clarendon Press, 1931), pp. 179–80.

69 Hanham, *The Celys and their World*, pp. 312–15.

70 Hanham, *The Celys and their World*, pp. 255–9.

71 Power, *The Goodman of Paris*, pp. 194, 237–46, 330, note.

72 Lawson, *Christine de Pisan: The Treasure of the City of Ladies*, p. 170.

73 Malcolm Thick, 'A Close Look at the Composition of Sir Hugh Plat's *Delights for Ladies*', in *The English Cookery Book: Historical Essays*, ed. Eileen White (Totnes: Prospect Books, 2004), p. 62.

4 The Comforts of Home

1 W. A. Pantin, 'Medieval English Town-House Plans', *Medieval Archaeology*, 6–7 (1962–3), pp. 202–39.

2 Iris Origo, *The Merchant of Prato: Francesco di Marco Datini, 1335–1410* (Boston: David R. Godine, 1986), p. 205.

3 Power, *The Goodman of Paris*, pp. 205–6.

4 Lawson, *Christine de Pisan: The Treasure of the City of Ladies*, part 3, chap. 9, pp. 170–1.

5 Davis, *Paston Letters*, p. 29.

6 Origo, *The Merchant of Prato*, p. 210.

7 Orme, *Medieval Children*, p. 316.

8 Power, *The Goodman of Paris*, p. 220.

9 Origo, *The Merchant of Prato*, p. 320.

10 Hanawalt, *The Ties that Bound*, p. 162.

11 Davis, *Paston Letters*, p. 54.

12 Eamon Duffy, *Marking the Hours: English People and their Prayers, 1240–1570* (New Haven: Yale University Press, 2006), p. 64.

13 Power, *Medieval People*, p. 135.

14 Origo, *The Merchant of Prato*, p. 378.

15 Origo, *The Merchant of Prato*, p. 379.

16 Hanham, *The Celys and their World*, pp. 80, 215.

17 Tolkien and Gordon, *Sir Gawain and the Green Knight*, l. 694.

18 Origo, *The Merchant of Prato*, p. 317.

19 Origo, *The Merchant of Prato*, p. 319.

20 Power, *The Goodman of Paris*, p. 260.

21 Power, *The Goodman of Paris*, p. 208.

22 W. Butler-Bowdon, *The Book of Margery Kempe* (London: Oxford University Press, 1954), p. 11.

23 Davis, *Paston Letters*, pp. 9–10.

24 Power, *The Goodman of Paris*, p. 194.

25 Lawson, *Christine de Pisan: The Treasure of the City of Ladies*, part 3, chap. 1, p. 147.

26 F. J. Furnivall, ed., *The Babees Book*, EETS, os 32 (London, 1868), 'How the Good Wife Taught Her Daughter' (c. 1430), pp. 36–47, ll. 116–19.

27 Frances and Joseph Gies, *A Medieval Family: The Pastons of Fifteenth Century England* (New York: Harper Collins Publishers, 1998), p. 338.

28 G. A. J. Hodgett, ed., *Stere Hit Well: Medieval Recipes and Remedies from Samuel Pepys's Library* (London: Cornmarket Reprints, 1972), p. 37.

29 Power, *The Goodman of Paris*, p. 171.

30 Origo, *The Merchant of Prato*, p. 316.

31 Thomas Wright, ed., *The Book of the Knight of La Tour-Landry*, EETS, os 33 (London, 1868), chap. cv, pp. 140–1.

32 Origo, *The Merchant of Prato*, p. 316.

33 Salu, *The Ancrene Riwle*, Part v, 'Confession', p. 152.

34 Lawson, *Christine de Pisan: The Treasure of the City of Ladies*, part 3, chap. i, p. 146.

35 Origo, *The Merchant of Prato*, p. 179.

36 I. Gollancz, ed., *Wynnere and Wastoure* (Cambridge: D. S. Brewer; Totowa, NJ: Rowman & Littlefield, 1974), l. 365.

37 Power, *The Goodman of Paris*, p. 238.

38 Power, *The Goodman of Paris*, p. 289.

39 Hanham, *The Celys and their World*, p. 258.

40 Power, *The Goodman of Paris*, p. 218.

41 Dyer, *Standards of Living in the Later Middle Ages*, p. 65.

42 Grigson, *Thomas Tusser: Five Hundred Points of Good Husbandry*, 'Dinner Matters', p. 172.

43 Janetta Rebold Benton, *Medieval Mischief: Wit and Humour in the Art of the Middle Ages* (Stroud: Sutton Publishing, 2004), pp. 57–8, Fig. II.12.

44 C. Anne Wilson, ed., *The Appetite and the Eye: Visual Aspects of Food and its Presentation within their Historic Context* (Edinburgh: Edinburgh University Press, 1987), 'Ideal Meals and their Menus from the Middle Ages to the Georgian Era', pp. 101–2.

45 Power, *The Goodman of Paris*, p. 291.

46 Rosenthal, *Telling Tales*, p. 31.

47 Christopher Dyer, *Making a Living in the Middle Ages: The People of Britain, 850–1520* (New Haven: Yale University Press, 2002), p. 345.

48 Eileen Power, *The Paycockes of Coggeshall* (London: Methuen & Co., 1920), p. 53.

49 Wood-Legh, ed., *A Small Household of the XVth Century*, pp. xxvi, xxviii.

50 E. M. Carus-Wilson, 'The Medieval Trade of the Ports of the Wash', *Medieval Archaeology*, 6–7 (1962–3), p. 199 and plate XXII.

51 Hanham, *The Celys and their World*, p. 329.

52 Hanham, *The Celys and their World*, p. 259.

53 Power, *The Goodman of Paris*, pp. 242–3.

54 Power, *The Goodman of Paris*, p. 218.

55 Bibliothèque Nationale, Paris, Ms. lat. 7939A, fol. 48r.

56 Odile Redon, Françoise Sabban, and Silvano Serventi, *The Medieval Kitchen: Recipes from France and Italy*, trans. Edward Schneider (Chicago: University of Chicago Press, 1998), unnumbered colour plate between pp. 94 and 95.

57 Spencer, *The Four Seasons of the House of Cerruti*, pp. 25, 105, 133.

58 Hodgett, *Stere Hit Well*, p. 9.

59 Power, *The Goodman of Paris*, p. 217.

60 F. J. Furnivall, ed., *Political, Religious and Love Poems from the Archbishop of Canterbury's Lambeth MS no. 306*, EETS, os 15 (London, 1866), John Lydgate, 'Debate of the Horse, Goose and Sheep' (after 1436), ll. 120–1.

61 Butler-Bowdon, *The Book of Margery Kempe*, p. 110.

62 Bibliothèque Nationale, Paris, Ms. fr. 2090–2092.

63 Egbert, *On the Bridges of Mediaeval Paris*, pp. 44–5, plate XI; pp. 48–9, plate XIII.

64 Harvey, *William Worcestre's 'Itineraries'*, p. 295.

65 Power, *The Goodman of Paris*, p. 219.

66 Morgan Library, New York, MS H.8, fol. 1r.

67 Morgan Library, New York, MS S.7, fol. 2v.

68 Colum Hourihane, ed., *Time in the Medieval World: Occupations of the Months and Signs of the Zodiac in the Index of Christian Art* (University Park: Penn State University Press, 2007), p. 62, fig. 18, p. 70, fig. 37.

69 Dyer, *Making a Living in the Middle Ages*, p. 342.

70 Power, *The Goodman of Paris*, p. 264.

71 Hartley, *Food in England*, pp. 36–8.

72 Wood-Legh, *A Small Household of the XVth Century*, p. xxviii.

73 Hanham, *The Celys and their World*, pp. 272, 259.

74 Gollancz, *Wynnere and Wastoure*, ll. 449–51.

75 Wright, *The Book of the Knight of La Tour-Landry*, chap. LXXII, pp. 94–5.

76 Power, *The Goodman of Paris*, p. 269.

77 Brears, *Wynkyn de Worde: The Boke of Keruynge*, pp. 18, 83, fig. 4.

78 Hugo Blake, 'Everyday Objects', in *At Home in Renaissance Italy*, ed. Marta Ajmar-Wollheim and Flora Dennis (London: V&A Publications, 2006), p. 336.

79 John M. Steane, *The Archaeology of Power* (Stroud: Tempus Publishing, 2001), p. 258.

80 F. J. Furnivall, ed., *The Fifty Earliest English Wills in the Court of Probate, London*, EETS, os 78 (London, 1882), p. 102.

81 Ann Hagen, *A Handbook of Anglo-Saxon Food: Processing and Consumption* (Pinner: Anglo-Saxon Books, 1992), p. 56.

82 John Hurst, 'The Kitchen Area of Northolt Manor, Middlesex', *Medieval Archaeology*, 5 (1961), p. 278, fig. 73, no. 2.

83 Carus-Wilson, 'The Medieval Trade of the Ports of the Wash', p. 201.

84 Peter Weinrich, 'An Inventory from the Abbey of Coggeshall, 1295', *Petits Propos Culinaires*, 76 (August 2004), p. 127.

85 Woolgar, *The Great Household in Late Medieval England*, p. 117.

86 Origo, *The Merchant of Prato*, p. 323.

87 Power, *The Goodman of Paris*, p. 223.

88 Scully, *The Art of Cookery in the Middle Ages*, p. 71.

89 Power, *The Goodman of Paris*, p. 223.

90 Thomas Austin, ed., *Two Fifteenth-Century Cookery-Books*, EETS, os 91 (London, 1888), p. 72.

91 Power, *The Goodman of Paris*, p. 288.

92 Austin, *Two Fifteenth-Century Cookery-Books*, pp. 75, 73.

93 Hodgett, *Stere Hit Well*, p. 15.

94 Austin, *Two Fifteenth-Century Cookery-Books*, p. 87.

95 Origo, *The Merchant of Prato*, p. 320.

96 Power, *The Goodman of Paris*, p. 291.

97 Power, *The Goodman of Paris*, pp. 224, 269.

98 Power, *The Goodman of Paris*, pp. 250–1.

99 Origo, *The Merchant of Prato*, p. 320.

100 Power, *The Goodman of Paris*, pp. 309–10.

101 British Library, London, Add. MS 42130, fols. 207v, 208r.

102 Woolgar, *The Great Household in Late Medieval England*, pp. 164–5, plates 52, 53.

103 Woledge, *The Penguin Book of French Verse*, vol. 1, pp. 244–5, Ballade, 'Si comme on dit'.

104 Michael W. Thompson, *The Medieval Hall* (Aldershot: Scolar Press, 1995), p. 151.

105 Brears, *Wynkyn de Worde: The Boke of Keruynge*, pp. 5–6.

106 Tolkien and Gordon, *Sir Gawain and the Green Knight*, l. 883.

107 Fitzwilliam Museum, Cambridge, MS 1058-1975, f. 1r.

108 Henisch, *The Medieval Calendar Year*, p. 146, fig. 6-8.

109 Milham, *Platina: On Right Pleasure and Good Health*, pp. 183, 180–1.

110 Morgan Library, New York, MS H.8, fol. 1v.

111 Hourihane, ed., *Time in the Medieval World*, p. 75, fig. 49.

112 Woledge, *The Penguin Book of French Verse*, vol. 1, pp. 160–2, Chanson, 'Sire cuens'.

5 The Staging of a Feast

1 Muir, *Literature and Society in Medieval France*, pp. 214–15.

2 Skeat, *The Lay of Havelok the Dane*, ll. 867–908.

3 Bullock-Davies, *Menestrellorum Multitudo*, pp. xvii, xxvii–xxviii.

4 Scully, *Chiquart's 'On Cookery'*.

5 Henisch, *The Medieval Calendar Year*, p. 97.

6 Scully, *Chiquart's 'On Cookery'*, p. 9.

7 Scully, *Chiquart's 'On Cookery'*, p. 9.

8 Scully, *Chiquart's 'On Cookery'*, p. 12.

9 Scully, *Chiquart's 'On Cookery'*, p. 14.

10 Scully, *Chiquart's 'On Cookery'*, p. 16.

11 Scully, *Chiquart's 'On Cookery'*, p. 15.

12 Scully, *Chiquart's 'On Cookery'*, p. 14.

13 Scully, *Chiquart's 'On Cookery'*, p. 16.

14 Scully, *Chiquart's 'On Cookery'*, pp. 38–9.

15 Scully, *Chiquart's 'On Cookery'*, p. 14.

16 Scully, *Chiquart's 'On Cookery'*, p. 97.

17 Scully, *Chiquart's 'On Cookery'*, p. 12.

18 Margaret Wood, *The English Mediaeval House* (London: Bracken Books, 1983), p. 247.

19 Scully, *Chiquart's 'On Cookery'*, p. 16.

20 C. M. Woolgar, *The Great Household in Late Medieval England* (New Haven: Yale University Press, 1999), p. 137.

21 Tolkien and Gordon, *Sir Gawain and the Green Knight*, ll. 128–9.

22 Gollancz, *Wynnere and Wastoure*, ll. 346–51.

23 Scully, *Chiquart's 'On Cookery'*, pp. 38–9.

24 A. R. Myers, ed., *The Household of Edward IV: The Black Book and the Ordinance of 1478* (Manchester: Manchester University Press, 1959), p. 173.

25 Myers, *The Household of Edward IV*, pp. 171, 193.

26 Kate Mertes, *The English Noble Household, 1250–1600* (Oxford: Basil Blackwell, 1988), pp. 98–100.

27 Myers, *The Household of Edward IV*, p. 167.

28 Redon, Sabban, and Serventi. *The Medieval Kitchen*, p. 210.

29 Wood, *The English Mediaeval House*, p. 375.

30 Richard Ollard, *Pepys* (New York: Atheneum, 1984), p. 107.

31 Scully, *The Art of Cookery in the Middle Ages*, p. 236; Michael Messent, *A Short History of the Worshipful Company of Cooks of London* (London: Worshipful Company of Cooks, 2001), p. 1.

32 Barbara Wheaton, *Savoring the Past: the French Kitchen and Table from 1300 to 1789* (Philadelphia: University of Pennsylvania Press, 1983), p. 73.

33 C. M. Woolgar, 'Fast and Feast: Conspicuous Consumption in the Diet of the Nobility in the Fifteenth Century', in *Revolution and Consumption in late Medieval England*, ed. Michael Hicks (Woodbridge: Boydell Press, 2001), p. 18 and n. 44.

34 C. Anne Wilson, 'The French Connection: Part I', *Petits Propos Culinaires*, 2 (August 1979), p. 11.

35 E. Vinaver, ed., *The Works of Thomas Malory* (London: Oxford University Press, 1964), p. 218.

36 Scully, *Chiquart's 'On Cookery'*, pp. xxix–xxxi,.

37 Luigi Ballerini, ed., *The Art of Cooking: the First Modern Cookery Book by Maestro Martino of Como*, trans. Jeremy Purzen (Berkeley: University of California Press, 2005), pp. 17–18, 120.

38 Myers, *The Household of Edward IV*, p. 83.

39 Constance B. Hieatt and Sharon Butler, eds., *Curye on Inglysch: English Culinary Manuscripts of the Fourteenth Century*, EETS, ss 8 (London, 1985), p. 20.

40 Malcolm Vale, *The Princely Court: Medieval Courts and Culture in North-West Europe* (Oxford: Oxford University Press, 2001), pp. 142–3.

41 Scully, *Chiquart's 'On Cookery'*, p. 110.

42 Ken Albala, *Eating Right in the Renaissance* (Berkeley: University of California Press, 2002), chaps. 2 and 3, pp. 48–114; Milham, *Platina: On Right Pleasure and Good Health*, p. xix; Terence Scully, *The Art of Cookery in the Middle Ages* (Woodbridge: Boydell Press, 1995), pp. 41–50.

43 Scully, *Chiquart's 'On Cookery'*, pp. 108–10, 112.

44 R. W. Chambers, ed., *A Fifteenth-Century Courtesy Book*, EETS, os 148 (London, 1914), p. 13.

45 Arnould, *Le Livre de Seyntz Medicines*, pp. 48–9.

46 Margaret Wade Labarge, *Medieval Travellers* (London: Phoenix, 2005), p. 28.

47 Hassall, *How They Lived*, p. 152.

48 Chambers, *A Fifteenth-Century Courtesy Book*, p. 11.

49 Arnould, *Le Livre de Seyntz Medicines*, pp. 48–9.

50 Peter Brears, ed., *Wynkyn de Worde: The Boke of Keruynge* (Lewes: Southover Press, 2003), p. 56.

51 D. R. Sutherland, 'The Love Meditation in Courtly Literature', in *Studies in Medieval French presented to Alfred Ewert*, ed. E. A. Francis (Oxford: Clarendon Press, 1961), p. 190.

52 Houghton Library, Harvard University, MS Richardson 42, fol. 1r.

53 Henisch, *The Medieval Calendar Year*, p. 37, fig. 2-4.

54 Hieatt, *An Ordinance of Pottage*, p. 90.

55 Ballerini, *The Art of Cooking*, p. 120.

56 Scully, *The Art of Cookery in the Middle Ages*, p. 126.

57 Scully, *Chiquart's 'On Cookery'*, p. 23.

58 Woledge, *The Penguin Book of French Verse*, vol. 1, p. 219.

59 Ballerini, *The Art of Cooking*, pp. 109–10, 132.

60 Bridget Ann Henisch, *Fast and Feast: Food in Medieval Society* (University Park: Penn State University Press, 1976), p. 214, fig. 43. Exeter Puzzle Jug, Saintonge, southwest France, late thirteenth century. Exeter City Museum.

61 Ballerini, *The Art of Cooking*, p. 94.

62 Ballerini, *The Art of Cooking*, pp. 125, 130.

63 Ballerini, *The Art of Cooking*, p. 114.

64 Scully, *Chiquart's 'On Cookery'*, pp. 34–7.

65 Carus-Wilson, 'The Medieval Trade of the Ports of the Wash', p. 196.

66 C. Anne Wilson, 'Ritual, Form and Colour in the Mediaeval Food Tradition', in *The Appetite and the Eye: Visual Aspects of Food and its Presentation within their Historic Context*, ed. C. Anne Wilson (Edinburgh: Edinburgh University Press, 1991), pp. 14–15.

67 June Freeman, *The Sugared Imagination*, exhibition catalogue (Lincoln: Usher Gallery, 1989), p. 5.

68 Ivan Day, *Royal Sugar Sculpture: 600 Years of Splendour* (Barnard Castle: Bowes Museum, 2002), pp. 17–19.

69 Brears, *All the King's Cooks*, p. 80, fig. 14.

70 Wilson, 'Ritual, Form and Colour in the Mediaeval Food Tradition', pp. 14–15.

71 Sydney Anglo, *Spectacle, Pageantry, and Early Tudor Policy* (Oxford: Clarendon Press, 1969), pp. 26–7.

72 Orme, *Medieval Children*, p. 174.

73 Davis, *Paston Letters*, p. 66.

6 On the Edge: the Cook in Art

1 David M. Wilson, ed., *The Bayeux Tapestry* (London: Thames & Hudson, 1985), plates 46–7.

2 Paul Murray Kendall, 'The World of Jacques Cœur', in *The Age of Chivalry*, ed. Merle Severy (Washington: National Geographic Society, 1969), p. 311.

3 Bodleian Library, Oxford, MS 366, fol. 109r.

4 Bodleian Library, Oxford, MS Douce 5, fol. 164v.

5 Lilian M. C. Randall, *Images in the Margins of Gothic Manuscripts* (Berkeley: University of California Press, 1966), plate CVII, fig. 513, plate CVIII, fig. 518.

6 Remnant, *A Catalogue of Misericords in Great Britain*, p. 82.

7 Bodleian Library, Oxford, MS Ashmole 1504, plate 11.

8 Clare Putnam, *Flowers and Trees of Tudor England* (Greenwich, CT: New York Graphic Society, 1972), plates 11, 13.

9 Musée des Beaux-Arts, Dijon.

10 Millard Meiss, *French Painting in the Time of Jean de Berry: The Limbourgs and their Contemporaries* (New York: George Braziller, 1974), p. 98, fig. 378.

11 Martial Rose and Julia Hedgecoe, *Stories in Stone: The Medieval Roof Carvings of Norwich Cathedral* (New York: Thames & Hudson, 1997), pp. 109–10.

12 Morgan Library, New York, MS M.638.

13 William Noel and Daniel Weiss, eds., *The Book of Kings: Art, War, and the Morgan Library's Medieval Picture Bible* (London: Third Millennium Publishing; Baltimore: Walters Art Museum, 2002), pp. 82, 91–2, 176.

14 Charity Cannon Willard, ed., *Christine de Pizan, The Book of Deeds of Arms and of Chivalry* [c. 1410], trans. Sumner Willard (University Park: Penn State University Press, 1999), chap. 14, p. 41.

15 Morgan Library, New York, MS M.917, fol. 266.

16 John Plummer, ed., *The Hours of Catherine of Cleves* (New York: George Braziller, 1966), plates 128, 155.

17 Remnant, *A Catalogue of Misericords in Great Britain*, pp. 72, 74 (and plate 28c).

18 Panofsky, *Early Netherlandish Painting*, vol. 1, p. 108.

19 British Library, London, Add. MS 42130, fol. 207r.

20 Janet Backhouse, *The Illuminated Manuscript* (Oxford: Phaidon Press, 1979), p. 50.

21 British Library, London, MS Cotton, Nero D.VII, fol. 109.

22 Margaret Manion and Vera F. Vines, *Medieval and Renaissance Illustrated Manuscripts in Australian Collections* (London: Thames & Hudson, 1984), p. 98, plate 25.

23 Bodleian Library, Oxford, MS Douce 6, fol. 22.

24 British Library, London, Add. MS 47682, fol. 42v.

25 Hassall, *How They Lived*, plate xxxii.

26 C. David Benson, *Public Piers Plowman* (University Park: Penn State University Press, 2003), pp. 197–9, fig. 17.

27 Eric G. Millar, *The Parisian Miniaturist, Honoré* (London: Faber & Faber, 1959), p. 20.

28 Camille, *Mirror in Parchment*, pp. 91–2, fig. 25.

29 Morgan Library, New York, MS H.8, fol. 7.

30 Roger S. Wieck, William M. Voelkle, and K. Michelle Hearne, eds., *The Hours of Henry VIII* (New York: George Braziller, 2000), pp. 78–9.

31 Elizabeth Mongan and Edwin Wolf 2nd. *The First Printers and Their Books* (Philadelphia: Free Library of Philadelphia, 1940), pp. 10–11, fig. 2.

32 Bibliothèque Nationale, Paris, MS fr. 9140, fol. 361v.

33 Redon, Sabban, and Servanti. *The Medieval Kitchen*, colour plate between pp. 94–5.

34 Biblioteca Estense, Modena, MS Lat. 209, fol. 11r.

35 Jonathan J. G. Alexander, ed., *The Painted Page: Italian Renaissance Book Illumination, 1450–1550* (London: Royal Academy of Arts; New York: Pierpont Morgan Library, 1995), pp. 75–6, Catalogue entry 18.

36 Timothy B. Husband, *The Luminous Image: Painted Glass Roundels in the Lowlands, 1480–1560* (New York: Metropolitan Museum of Art, 1995), p. 97, no. 37.

37 Spencer Collection, The New York Public Library.

38 J. L. Schrader, ed., *The Waning Middle Ages* (Lawrence: University of Kansas Museum of Art, 1969), p. 20, item 16, plate lvii.

39 Remnant, *A Catalogue of Misericords in Great Britain*, p. 47.

40 British Library, London, Royal MS 10 E IV, fols. 137–48.

41 Morgan Library, New York, MS M.87, fol. 3r.

42 James H. Marrow, ed., *The Golden Age of Dutch Manuscript Painting* (New York: George Braziller, 1990), p. 76, fig. 31.

43 Bodleian Library, Oxford, MS Bodley 264, fol. 2v.

44 Orme, *Medieval Children*, p. 31, fig. 12.

45 Deutsches Museum, Berlin.

46 Panofsky, *Early Netherlandish Painting*, vol. 1, p. 70, fig. 30.

47 Österreichischen Nationalbibliothek, Vienna, Cod. 1855.

48 Landesmuseum, Darmstadt.

49 Panofsky, *Early Netherlandish Painting*, vol. 1, p. 95, fig. 110.

50 British Library, London, Add. MS 18192, fol. 52r.

51 Bodleian Library, Oxford, in association with Corpus Christi College, MS Corpus Christi College 285, fol. 3v. Henisch, *The Medieval Calendar Year*, p. 38, fig. 2-5.

52 Metropolitan Museum of Art, New York, The Cloisters Collection, 1954, MS 54.1.1, fol. 3.

53 Bodleian Library, Oxford, MS Douce 135, fol. 2v. Henisch, *The Medieval Calendar Year*, p. 174, fig. 7-4.

54 British Library, London, Add. MS 24098, fol. 29v.

55 Österreichische Nationalbibliothek, Vienna, cod. 1887, fol. 11v.

56 Spencer, *The Four Seasons of the House of Cerruti*, pp. 49, 105, 106.

57 Bodleian Library, Oxford, MS Douce 6, fol. 119r.

58 Henisch, *Fast and Feast*, p. 76, fig. 10.

59 Plummer, *The Hours of Catherine of Cleves*, plate 93.

60 Spencer, *The Four Seasons of the House of Cerruti*, p. 62.

61 Staatliche Graphische Sammlung, Munich.

62 Rainer Schoch et al. *Gothic and Renaissance Art in Nuremberg, 1300–1550* (New York: Metropolitan Museum of Art, 1986), p. 96, fig. 106.

63 Hieatt and Butler, *Curye on Inglysch*, pp. 49–50, no. 34.

64 Furnivall, *The Babees Book*, 'The Boke of Curtasye', p. 324, ll. 757–62.

65 British Library, London, Add. MS 42130, fol. 207. Backhouse, *The Illuminated Manuscript*, p. 50.

66 Spencer, *The Four Seasons of the House of Cerruti*, p. 105.

67 University Library, Prague, MS XXIII C.124, fol. 184a.

68 Henisch, *Fast and Feast*, p. 139, fig. 24.

69 British Library, London, Add. MS 47682, fol. 18.

70 Kraus, *The Hidden World of Misericords*, plate 18.

71 Queen's College, Oxford, MS 349, fol. 56v. ffiona Swabey, *Medieval Gentlewoman: Life in a Gentry Household in the Later Middle Ages* (New York: Routledge, 1999), colour plate 7.

72 Dorothy Hartley, *Medieval Costume and How to Recreate It* (London: B. T. Batsford, 1931; repr. New York: Dover Publications, 2003), pp. 69–73.

73 British Library, London, Add. MS 18852, fol. 13.

74 Henisch, *The Medieval Calendar Year*, p. 173, fig. 7-3.

75 Municipal Library, Lyon, MS 514.

76 Claire Clifton, *The Art of Food* (Leicester: Windward, 1988), pp. 22–3.

77 British Library, London, Add. MS 24098, fol. 18b.

78 Lawrence Stone, *Sculpture in Britain: The Middle Ages* (Harmondsworth: Penguin Books, 1955), p. 213.

79 Manion and Vines, *Medieval and Renaissance Illustrated Manuscripts in Australian Collections*, p. 98, plate 25.

80 Musée Condé, Chantilly, MS 65, fol. 108r.

81 Jean Longnon and Raymond Cazelles, eds., *The 'Très Riches Heures' of Jean, Duke de Berry* (New York: George Braziller, 1969), plate 91.

82 Wieck et al. *The Hours of Henry VIII*, pp. 78–9.

83 Brears, *All the King's Cooks*, p. 120.

84 Morgan Library, New York, MS M.358, fol. 2.

85 Wilson, *The Bayeux Tapestry*, plates 46–7.

86 Bibliothèque Nationale, Paris, MS fr. 135, fol. 327.

87 Perrine Mane, 'Le calendrier et les travaux des mois', in *Paysages, paysans: l'art et la terre en Europe du Moyen Âge au XX^e siècle*, ed. Emmanuel Le Roy Ladurie (Paris: Bibliothèque Nationale de France / Réunion des Musées Nationaux, 1994), p. 48, no. 15.

88 Rosgartenmuseum, Constance, fol. 23r.

89 Uitz, *The Legend of Good Women*, p. 32.

90 Wilson, *The Bayeux Tapestry*, plates 46–7.

91 Morgan Library, New York, MS M.450, fol. 3v.

Select Bibliography

Adamson, Melitta Weiss. 'Imitation Food Then and Now', *Petits Propos Culinaires*, 72 (March 2003), pp. 83–102.

Ajmar-Wollheim, Marta, and Flora Dennis, eds. *At Home in Renaissance Italy*. London: V&A Publications, 2006.

Albala, Ken. *Eating Right in the Renaissance*. Berkeley: University of California Press, 2002.

Arano, Luisa Cogliati. *The Medieval Health Handbook: Tacuinum sanitatis*. London: Barrie & Jenkins, 1976.

Arnould, E. J., ed. *Le Livre de Seyntz Medicines: The Unpublished Devotional Treatise of Henry of Lancaster*. Anglo-Norman Texts 2. Oxford: Basil Blackwell, 1940.

Ashley, Sir William. *The Bread of Our Forefathers*. Oxford: Clarendon Press, 1928.

Austin, Thomas, ed. *Two Fifteenth-Century Cookery-Books*. EETS, os 91. London, 1888.

Ballerini, Luigi, ed. *The Art of Cooking: The First Modern Cookery Book, by Maestro Martino of Como*, trans. Jeremy Purzen. Berkeley: University of California Press, 2005.

Burnet, Peter, and Pete Dandridge, eds. *Lions, Dragons, and Other Beasts: Aquamaniles of the Middle Ages, Vessels for Church and Table*. New Haven: Yale University Press, 2006.

Bennett, Judith M. *Ale, Beer, and Brewsters in England: Women's Work in a Changing World, 1300–1600*. New York: Oxford University Press, 1996.

—— *Women in the Medieval English Countryside*. New York: Oxford University Press, 1987.

Brears, Peter. *All the King's Cooks: The Tudor Kitchens of King Henry VIII at Hampton Court Palace*. London: Souvenir Press, 1999.

——, ed. *Wynkyn de Worde: The Boke of Keruynge (Book of Carving)* [1508]. Lewes: Southover Press, 2003.

Bullock-Davies, Constance. *Menestrellorum Multitudo: Minstrels at a Royal Feast.* Cardiff: University of Wales Press, 1978.

Butler-Bowdon, W. *The Book of Margery Kempe.* London: Oxford University Press, 1954.

Carlin, Martha. 'Fast Food and Urban Living Standards in Medieval England', pp. 27–51, in *Food and Eating in Medieval Europe*, ed. Martha Carlin and Joel T. Rosenthal. London: Hambledon Press, 1998.

—— *Medieval Southwark.* London: Hambledon Press, 1996.

Crossley-Holland, Nicole. *Living and Dining in Medieval Paris: The Household of a Fourteenth Century Knight.* Cardiff: University of Wales Press, 1996.

Drummond, J. C., and Anne Wilbraham. *The Englishman's Food: Five Centuries of English Diet*, rev. D. F. Hollingsworth. London: Jonathan Cape, 1957 (first pub. 1939).

Dyer, Christopher. *Making a Living in the Middle Ages: The People of Britain, 850–1520.* New Haven: Yale University Press, 2002.

—— *Standards of Living in the later Middle Ages: Social Change in England, c. 1200–1520.* Cambridge: Cambridge University Press, 1989.

Egbert, Virginia Wylie. *On the Bridges of Paris: A Record of Early Fourteenth Century Life.* Princeton: Princeton University Press, 1974.

Frank, Jr., Robert Worth. 'The "Hungry Gap", Crop Failure and Famine; the fourteenth century Agricultural Crisis', in *Agriculture in the Middle Ages*, ed. Del Sweeney. Philadelphia: University of Pennsylvania Press, 1995, pp. 227–46.

Furnivall, F. J., ed. *The Babees Book*, EETS, os 32. London, 1868.

——, ed. *The Fifty Earliest English Wills in the Court of Probate, London.* EETS, os 78. London, 1882.

Gollancz, I., ed. *Wynnere and Wastoure.* Cambridge: D. S. Brewer; Totowa, NJ: Rowman & Littlefield, 1974 (reprint of 1921 ed.).

Grigson, Geoffrey. Introduction to Thomas Tusser, *Five Hundred Points of Good Husbandry.* Oxford: Oxford University Press, 1984.

Hagen, Ann. *A Handbook of Anglo-Saxon Food: Processing and Consumption.* Pinner: Anglo-Saxon Books, 1992.

—— *A Second Handbook of Anglo-Saxon Food and Drink: Production and Distribution.* Hockwold cum Wilton: Anglo-Saxon Books, 1995.

Hammond, P. W. *Food and Feast in Medieval England.* Stroud: Sutton Publishing, 1993.

Hanawalt, Barbara A. *Growing Up in Medieval London.* New York: Oxford University Press, 1993.

—— *The Ties that Bound: Peasant Families in Medieval England.* New York: Oxford University Press, 1986.

Hanham, Alison. *The Celys and their World: An English Merchant Family of the Fifteenth Century.* Cambridge: Cambridge University Press, 1985.

Hartley, Dorothy. *Food in England.* London: Macdonald & Co., 1954.

—— *Water in England.* London: Macdonald & Jane's, 1964.

Hassall, W. O. *How They Lived: An Anthology of Original Accounts, Written before 1485.* Oxford: Basil Blackwell, 1962.

Henisch, Bridget Ann. *Fast and Feast: Food in Medieval Society.* University Park: Penn State University Press, 1976.

——*The Medieval Calendar Year.* University Park: Penn State University Press, 1999.

—— 'Unconsidered Trifles; the Search for Cookery Scenes in Medieval Sources', in *A Conference on Current Research in Culinary History: Sources, Topics, and Methods, Proceedings: A Conference Sponsored by the Schlesinger Library of Radcliffe College and The Culinary Historians of Boston, Radcliffe College, June 14–16, 1985.* Hingham, MA: Culinary Historians of Boston, 1986.

Hieatt, Constance, ed. *An Ordinance of Pottage.* London: Prospect Books, 1988.

—— and Sharon Butler, eds. *Curye on Inglysch: English Culinary Manuscripts of the Fourteenth Century,* EETS, ss 8. London, 1985.

Hurst, John G. 'The Kitchen Area of Northolt Manor', *Medieval Archaeology,* 5 (1961), pp. 211–99.

James, M. R., ed. *Vulgaria, by William Horman, Fellow and Vice-Provost of Eton College. First Printed by Richard Pynson in 1519.* Oxford: Roxburghe Club, 1926.

Kraus, Dorothy and Henry. *The Hidden World of Misericords.* London: Michael Joseph, 1976.

Laurioux, Bruno. *Manger au Moyen Âge.* Paris: Hachette, 2002.

—— *Le Moyen Âge à table.* Paris: Adam Biro, 1989.

Logan, F. Donald. Introduction to William Fitz Stephen, *Norman London*. New York: Italica Press, 1990.

Mertes, Kate. *The English Noble Household, 1250–1600*. Oxford: Basil Blackwell, 1988.

Meredith, Peter. 'The Language of Medieval Cookery', in *The English Cookery Book: Historical Essays*, ed. Eileen White. Totnes: Prospect Books, 2004, pp. 28–54.

Milham, Mary Ella, trans. and ed. *Platina: On Right Pleasure and Good Health*, Asheville, NC: Pegasus Press, 1999.

Mintz, Sidney W. *Sweetness and Power: The Place of Sugar in Modern History*. New York: Penguin Books USA, 1986.

Moisa Maria. 'The Food of the Medieval Poor', *Petits Propos Culinaires*, 74 (December 2003), pp. 96–105.

Myers, A. R., ed. *The Household of Edward IV: The Black Book and the Ordinance of 1478*. Manchester: Manchester University Press, 1959.

Nelson, W., ed. *A Fifteenth Century School Book, from a Manuscript in the British Museum*. Oxford: Clarendon Press, 1956.

Nicholls, J. *The Matter of Courtesy: Medieval Courtesy Books and the Gawain-Poet*. Woodbridge: D. S. Brewer, 1985.

Origo, Iris. *The Merchant of Prato: Francesco di Marco Datini, 1335–1410*. Boston: David R. Godine, 1986 (1st pub. 1957).

Orme, Nicholas. *Medieval Children*. New Haven: Yale University Press, 2001.

Owst, G. R. *Literature and Pulpit in Medieval England*. Oxford: Basil Blackwell, 1961 (1st pub. 1933).

Panofsky, Erwin. *Early Netherlandish Painting*. 2 vols. Cambridge, MA: Harvard University Press, 1958.

Pantin, W. A. 'The Merchants' Houses and Warehouses of King's Lynn', *Medieval Archaeology*, 6–7 (1962–3), pp. 173–81.

—— 'Medieval English Town-House Plans', *Medieval Archaeology*, 6–7 (1962–3), pp. 202–39.

Pollington, Stephen. *The Mead-Hall: Feasting in Anglo-Saxon England*. Hockwold cum Wilton: Anglo-Saxon Books, 2003.

Power, Eileen, trans. and ed. *The Goodman of Paris: A Treatise on Moral and Domestic Economy*. London: George Routledge & Sons, 1928.

Randall, Lilian M. C. *Images in the Margins of Gothic Manuscripts*. Berkeley: University of California Press, 1966.

Redon, Odile, Françoise Sabban, and Silvano Serventi. *The Medieval Kitchen: Recipes from France and Italy*, trans. Edward Schneider. Chicago: University of Chicago Press, 1998.

Remnant, G. L. *A Catalogue of Misericords in Great Britain*. Oxford: Clarendon Press, 1969.

Scully, Terence. *The Art of Cookery in the Middle Ages*. Woodbridge: Boydell Press, 1995.

——, trans. and ed. *Chiquart's 'On Cookery': A Fifteenth-Century Savoyard Culinary Treatise*, American University Studies, Series IX, History, vol. 22. New York: Peter Lang, 1986.

Spencer, Judith, trans. *The Four Seasons of the House of Cerruti*. New York: Facts on File Publications, 1984.

Steane, John M. *The Archaeology of Power: England and Northern Europe, AD 800–1600*. Stroud: Tempus Publishing, 2001.

Strong, Roy. *Feast: A History of Grand Eating*. London: Jonathan Cape, 2002.

Swabey, ffiona. *Medieval Gentlewoman: Life in a Gentry Household in the Later Middle Ages*. New York: Routledge, 1999.

Thompson, Michael W. *The Medieval Hall: The Basis of Secular Domestic Life, 600–1600*. Aldershot: Scolar Press, 1995.

Thrupp, Sylvia L. *The Merchant Class of Medieval London, 1300–1500*. Ann Arbor: University of Michigan Press, 1962 (first pub. 1948).

Vale, Malcolm. *The Princely Court: Medieval Courts and Culture in North-West Europe*. Oxford: Oxford University Press, 2001.

Wilson, C. Anne, ed. *The Appetite and the Eye: Visual Aspects of Food and its Presentation within their Historic Context*. Edinburgh: Edinburgh University Press, 1991.

——, ed. *Banquetting Stuffe: The Fare and Social Background of the Tudor and Stuart Banquet*. Edinburgh: Edinburgh University Press, 1991.

—— 'Blancmange: A Tale of Seven Centuries', in *The English Kitchen: Historical Essays*, ed. Eileen White. Totnes: Prospect Books, 2007, pp. 43–55.

—— *Food and Drink in Britain*. Harmondsworth: Penguin Books, 1976.

—— 'The French Connection', Part I, *Petits Propos Culinaires*, 2 (August 1979), pp. 10–17.

—— 'The Saracen Connection: Arab cuisine in the mediaeval west', Parts I and 2, *Petits Propos Culinaires*, 7 (March 1981), pp. 13–22, and 8, June 1981, pp. 19–27.

Wood, Margaret. *The English Mediaeval House*. London: Bracken Books, 1983 (1st pub. 1965).

Wood-Legh, K. L., ed. *A Small Household of the XVth Century*. Manchester: Manchester University Press, 1956.

Woolgar, Christopher M. 'Fast and Feast; Conspicuous Consumption and the Diet of the Nobility in the Fifteenth Century', in *Revolution and Consumption in Late Medieval England*, ed. Michael Hicks. Woodbridge: Boydell Press, 2001.

—— *The Great Household in Late Medieval England*. New Haven: Yale University Press, 1999.

A Selection of Medieval Recipes

A handful of recipes from *The Goodman of Paris: A Treatise on Moral and Domestic Economy*, trans. and ed. Eileen Power (London: George Routledge & Sons, 1928)

Helpful Hints

How to Cook Dried Peas or Beans without Spoiling them

Item, wot you well that pea or bean pottages or others burn easily, if the burning brands touch the bottom of the pot when it is on the fire. *Item*, before your pottage burns and in order that it burn not, stir it often in the bottom of the pot, and turn your spoon in the bottom so that the pottage may not take hold there. And *note* as soon as thou shalt perceive that thy pottage burneth, move it not, but straightway take it off the fire and put it in another pot. (p. 223)

The Right Order in which to Grind Breadcrumbs and Spices

Primo, in all sausages and thick pottages, wherein spices and bread be brayed, you should first bray the spices and take them out of the mortar, because the bread which you bray afterwards requires that which remaineth from the spices; thus naught is lost that would be lost if 'twere done otherwise. (p. 223)

Spices for Soups and for Sauces

Primo, note that all spices that be for putting into pottages must be well brayed and not strained, save it be for a jelly; and into all pottages behoveth it to put the spices as late as may be, for the sooner they be put in, the more they lose their savour; and the bread crumbs should be strained. (p. 258)

Item, spices and bindings put into pottages ought not to be strained; nathless do so for sauces, that the sauces may be clearer and likewise the more pleasant. (p. 223)

The Medieval Cook

Presentation, and the Importance of Appearance

Bacon which is fair and white is much better to be served up than that which is yellow, for however good be the yellow, it is too much condemned and discourages one to look upon it. (p. 250)

Enrich the flavour of dried peas by cooking them with bacon, but be sure to rinse the bacon in the broth before serving the dish at table 'so that it be not covered with bits of the peas'. (p. 251)

Recipes

Mushroom Pasties, Baked in an Improvised Oven

MUSHROOMS of one night be the best and they be little and red within and closed at the top; and they must be peeled and then washed in hot water and parboiled and if you wish to put them in a pasty add oil, cheese and spice powder. *Item*, put them between two dishes on the coals and then add a little salt, cheese and spice powder. They be found at the end of May and June. (p. 269)

Chicken in an Egg Sauce

Take the chicken and pluck it, then set it to boil with salt until it be cooked, then take it off and put in quarters to get cold; then put hard boiled eggs to cook in water, and put some bread to soak in wine and verjuice or vinegar, as much of one as of the other; then take parsley and sage then bray ginger and grain [of Paradise] and run it through the strainer and run in yolks of eggs and set the hard boiled eggs in quarters on the chicken and cover it with your sauce. (p. 278)

Cheese and Herb Tart

TO MAKE A TART (TOURTE), take four handfuls of beets, two handfuls of parsley, a handful of chervil, a sprig of fennel and two handfuls of spinach, and pick them over and wash them in cold water, then cut them up very small; then bray with two sorts of cheese, to wit a hard and a medium, and then add eggs thereto, yolks and whites, and bray them in with the cheese; then put the herbs into the mortar and bray all together and also put therein some fine powder. Or instead of this have ready brayed in the mortar two heads of ginger and onto this bray your cheese, eggs and herbs and then cast old cheese scraped or grated

onto the herbs and take it to the oven and then have your tart made and eat it hot. (pp. 278–9)

Bacon and Mackerel

Boil a little bacon in a pot and when it is half cooked take a fresh mackerel and cut it into pieces and set them to cook with the bacon and then take it all out and set minced parsley to boil until it bubbles once and serve. (p. 257)

Meatball 'Apples'

POMMEAULX. Take the lean part of a leg of mutton raw and as much of the leg of a lean pig; and let them be minced together very small. Then bray in a mortar ginger, grain [of Paradise] and cloves and scatter the powder on your mincemeat, and moisten it with white of egg without the yolk; then knead the spices and the raw meat with your hands into the shape of an apple, then when the shape is well done, set them to cook in water with salt, then take them off, and have skewers of hazelwood and skewer them and set them to roast; and when they be roasted have parsley brayed and passed through a strainer and flour mixed therewith, neither too thin nor too thick, and take your pommeaulx off the fire and put a dish under them, and grease your pommeaulx by turning the spit over the dish; then put them to the fire as often as need be until the pommeaulx be quite green. (p. 281)

Herb Omelettes

ONE HERBOLACE (ARBOULASTRE) or two of eggs. Take of dittany two leaves only, and of rue less than the half or naught, for know that it is strong and bitter; of smallage, tansey, mint and sage, of each some four leaves or less, for each is strong; marjoram a little more, fennel more, parsley more still; but of porray, beets, violet leaves, spinach, lettuces and clary, as much of the one as of the others, until you have two large handfuls. Pick them over and wash them in cold water, then dry them of all the water, and bray two heads of ginger; then put your herbs into the mortar two or three times and bray them with the ginger. And then have sixteen eggs well beaten together, yolks and whites, and bray and mix them in the mortar with the things abovesaid, then divide it into two, and make two thick omelettes, which you shall fry as followeth. First you shall heat your frying pan very well with oil, butter, or such other fat as you will, and when it is very hot all over and especially towards the handle, mingle and spread your eggs over the pan and turn them often over and over with a

flat *palette*, then cast good grated cheese on the top; and know that it is so done, because if you grate cheese with the herbs and the eggs, when you come to fry your omelette, the cheese at the bottom will stick to the pan; and thus it befalls with an egg omelette if you mix the eggs with the cheese. Wherefore you should first put the eggs in the pan, and put the cheese on the top and then cover the edges with eggs; and otherwise it will cling to the pan. And when your herbs be cooked in the pan, cut your herbolace into a round or a square and eat it not too hot nor too cold. (pp. 274–5)

Thick Pea Soup, with the Goodman's Running Commentary

(CRETONNÉE OF NEW PEAS OR BEANS CRETONNÉE DE POIS NOUVEAULX OU FÈVES NOUVELLES). Cook them until they become a purée and then pour away the liquid, then take cow's milk very fresh – and say to the woman who shall sell it to you that she give it not to you if she have put water therein, for often they add to their milk and it is not fresh if there be water in it, it will turn. – And first boil this milk before putting anything into it, for again it will turn [if you do not]; then bray first ginger to give appetite, and saffron to colour it yellow; nathless if you would thicken it with yolks of eggs dropped slowly therein, the same yolks of eggs will suffice to colour it and also to thicken it, but milk turneth more quickly with yolks of eggs than with a thickening of bread and saffron for colouring. Wherefore, if you would thicken it with bread, it must be white bread and not risen and it must be put to soak in a bowl with milk and broth of meat, then brayed and run through a strainer. And when your bread is strained and your spices not so, set all to boil with your peas; and when all be cooked, add thereto your milk and some saffron. Again you may use another thickening, to wit peas or beans, brayed and then strained; and do you take whatsoever thickening best pleaseth you. When the thickening is of yolk of eggs, it behoveth to beat them, put them through the strainer and run them very slowly into the milk, after it hath been well boiled with the new peas or beans and the spices, and hath been take off the fire. The safest way is to take a little milk and moisten the eggs in the bowl and then [do so] again and again, until the yolks be well mixed with plenty of milk by the spoon; then put it into a pot away from the fire and the pottage will not turn. And if the pottage is thick moisten it with the sewe of the meat. This done, behoveth it to have chickens quartered, or veal, or a gosling boiled and then fried and do you put two or three pieces in each bowl and the pottage over them. (pp. 260–1)

A Selection of Medieval Recipes

Sauces

Home-made Mustard

MUSTARD. If you would make provision of mustard to keep for a long time, make it in the harvest season and of soft pods. And some say that the pods should be boiled. *Item*, if you would make mustard in the country in haste, bray mustardseed in a mortar and moisten it with vinegar and run it through the strainer and if you would prepare it at once, set it in a pot before the fire. *Item*, if you would make good mustard and at leisure, set the mustardseed to soak for a night in good vinegar, then grind it in a mill and then moisten it little by little with vinegar; and if you have any spices left over from jelly, clarry, hippocras or sauces, let them be ground with it and afterwards prepare it. (p. 286)

Garlic Sauce

Bray a clove of garlic and some white breadcrumbs untoasted, and moisten with white verjuice; and if you would have it green, for fish, then bray also some parsley and sorrel, or one of them, or rosemary. (p. 287)

Sauce for a Capon or Hen

Set a very small quantity of breadcrumbs to soak in verjuice and saffron and bray them; then put them in the dripping pan, with four parts of verjuice and the fifth part of the fat of the hen or capon and not more, for more would be too much, and boil it in the dripping pan and serve it forth in bowls. (p. 292)

Grape Sauce for All Seasons

Take new and black grapes and crush them in a mortar and boil them once and then run them through a strainer; and then sprinkle spice powder over them, a little ginger and more cinnamon, or cinnamon alone, because that is better, and mix a little in a silver spoon and throw therein little crusts, or brayed bread, or eggs or chestnuts to bind it; brown sugar and serve forth. *Item*, if you want to make this sauce after St John's Day and before that there be any grapes, you must make it of cherries, wild cherries, quinces, mulberry wine, with powder of cinnamon and no ginger or very little, boil as above and then sprinkle sugar thereon. *Item*, after that no more grapes are to be had, *scilicit* in November, the must is made of wild sloes, with the stones taken out, then brayed or broken up in the mortar, boiled with the shells, strained, spice powder added and the rest as above. (p. 291)

Conclusion: Reality Check

FARCED CHICKENS, COLOURED OR GLAZED. They be first blown up and all the flesh within taken out, then filled up with other meat, then coloured or glazed as above; but there is too much to do, it is not a work for a citizen's cook, nor even for a simple knight's; and therefore I leave it. (pp. 309–10)

✦ ✦
✦

Suggestions for Further Reading

Each of these books offers adaptations of medieval recipes for modern cooks.

Brears, Peter. *All the King's Cooks: The Tudor Kitchens of King Henry VIII at Hampton Court Palace*. London: Souvenir Press, 1999.

Brears, Peter. *Cooking and Dining in Medieval England*. Blackawton, Totnes: Prospect Books, 2008.

Hieatt, Constance B. *An Ordinance of Pottage*. London: Prospect Books, 1988.

Hieatt, Constance B., and Sharon Butler. *Pleyn Delit: Medieval Cookery for Modern Cooks*. Toronto: University of Toronto Press, 1976.

Hodgett, G. A. J. *Stere hit Well: Medieval Recipes and Remedies from Samuel Pepys's Library*. London: Cornmarket Reprints, in association with the Master and fellows of Magdalene College, Cambridge, 1972.

Redon, Odile, Françoise Sabban, and Silvano Serventi. *The Medieval Kitchen: Recipes from France and Italy*, trans. Edward Schneider. Chicago: University of Chicago Press, 1998.

Sass, Lorna J. *To the King's Taste: Richard II's Book of Feasts and Recipes Adapted for Modern Cooking*. New York: The Metropolitan Museum of Art, 1975.

Scully, D. Eleanor, and Terence Scully. *Early French Cookery: Sources, History, Original Recipes and Modern Adaptations*. Ann Arbor: University of Michigan Press, 1995.

✦ ✦
✦

Index

Index

Index

Index

Index

✦ ✦
✦